Art and Life in Renaissance Venice

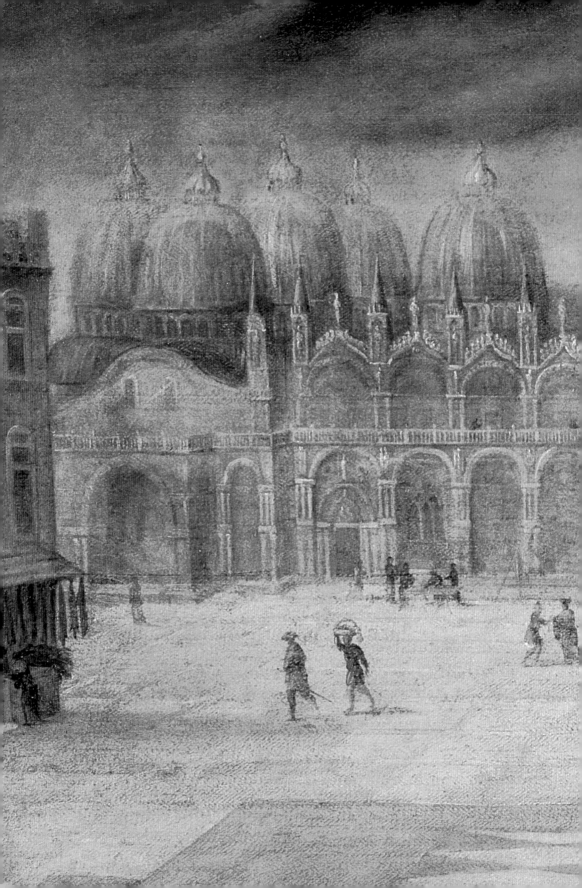

Art and Life in Renaissance Venice

Patricia Fortini Brown

PERSPECTIVES

HARRY N. ABRAMS, INC., PUBLISHERS

Acknowledgments

My primary aim in this book has been to reconstruct the visual world experienced by Venetians themselves during the Renaissance. Accordingly, I have emphasized works of art made for patrons close to home and have given little attention to commissions executed by Venetian artists, most notably Titian, for foreign kings, princes, and emperors, about which much has been written elsewhere.

I am particularly indebted to my students at Princeton University whose enthusiasm for Venetian art inspired me to take on what proved to be a challenging task of synthesis. Among them I wish to give special thanks to Blake de Maria for her insights on Veronese's *Presentation of the Cuccina Family to the Madonna* and to Emily Hoover for invaluable assistance in preparing the manuscript for publication.

I am also most grateful to Anne Christine Junkerman for allowing me to summarize her compelling analysis of Giorgione's *Laura*. It has been a singular pleasure to work with the staff at Calmann & King: Lee Ripley Greenfield, Susan Bolsom-Morris, Jacky Colliss Harvey, and Celia Jones. Each in her own way helped to make this a better book. Finally, I also wish to thank Walter Winslow for his continuing encouragement and support.

This book is dedicated to the memory of my parents, Mary Wells and Jack Gino Fortini, with whom I encountered the "other world" of Venice more than twenty years ago and from whom I learned that all things were possible.

Frontispiece
Bonifazio de'Pitati (Bonifazio Veronese) *God the Father above the Piazza San Marco,* page 92 (detail)

Series Consultant Tim Barringer (University of Birmingham)
Series Manager, Harry N. Abrams, Inc. Eve Sinaiko
Senior Editor Jacky Colliss Harvey
Designer Karen Stafford, DQP, London
Cover Designer Judith Hudson
Picture Editor Susan Bolsom-Morris

Library of Congress Cataloging-in-Publication Data

Brown. Patricia Fortini, 1936–
 Art and Life in Renaissance Venice / Patricia Fortini Brown.
 p. cm. — (Perspectives)
 Includes bibliographical references and index.
 ISBN 0-8109-2747-0
 1. Art, Italian — Italy — Venice. 2. Art, Renaissance — Italy — Venice.
3. Art patronage — Italy — Venice — History — 16th century.
4. Venice (Italy) — Social life and customs. I. Title. II. Series:
Perspectives (Harry N. Abrams, Inc.)
N6921.V5B75 1997
945'.3105 — dc21 96–49514

This book was produced by Calmann & King, Ltd, London
Printed in Hong Kong

Harry N. Abrams, Inc.
100 Fifth Avenue
New York, N.Y. 10011
(212) 206-7715
http://www.abramsbooks.com

Contents

98602

KEY:

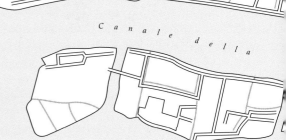

RENAISSANCE

N

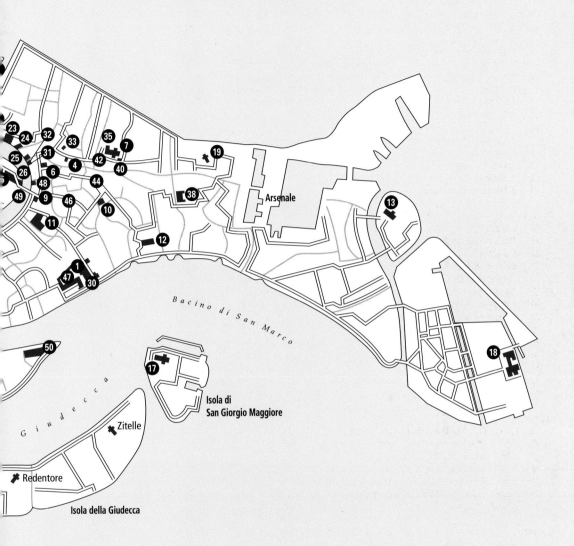

23 24 32 33 35 7
31 42 19
25 4 40
26 6
48 44
49 9 46 38 Arsenale 13
10
11
12
1
47 30

Bacino di San Marco

50
18
17
Isola di
San Giorgio Maggiore

Giudecca

Zitelle

Redentore

Isola della Giudecca

VENICE

0 1000yds
0 1000m

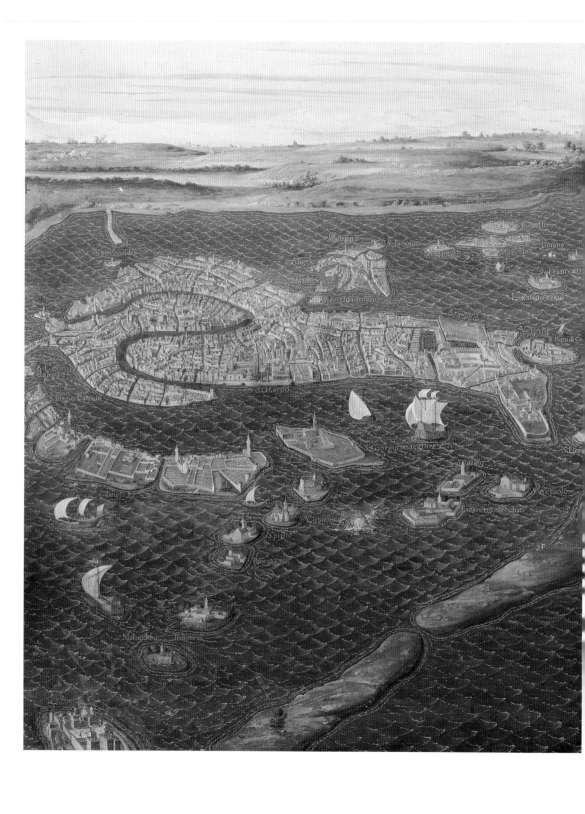

ONE

Venezianità: *The Otherness of the Venetians*

1. Egnazio Danti (1536–86) *Venice*, 1580–81. Fresco, 10′2″ x 58″ (3.1 x 1.5 m). Galleria delle Carte Geografiche, Vatican Palace, Rome.

The most distant island in the background is Torcello, the site of earliest settlement in the lagoon. The Lido and Pellestrina, to the southeast, are largely uninhabited. Many of the other islands contained monasteries or hospitals. The snow-covered Alps are visible to the north.

A center of trade and an embarkation point for pilgrimages to the Holy Land since the Middle Ages, Venice was a tourist attraction long before the term was invented. The city wrapped herself in a multi-layered "myth," spun out and shared by native and visitor alike. Certain themes continually emerge from pilgrims' diaries and other early accounts: the city's singular location and miraculous survival, her enormous wealth, the mixture of every race and religion, magnificent ceremonial, impressive churches and notable piety, and a uniquely stable and just government that endured nearly a millennium without foreign invasion, revolution, or exceptional civic unrest. The philosopher-poet Francesco Petrarch (1304–74) called it *mundus alter*, another world.

Venice was also a world apart in the nature of her participation in the Renaissance in Italy: a period beginning in the mid-fourteenth century with Petrarch's discovery of a "dark age" that separated antiquity from his own time and ending in the later sixteenth century with the Counter-Reformation. Intellectually, the Renaissance was defined by the humanist movement: a program of secular education involving the study of classical languages and literature – the *studia humanitatis* – that eventually became the core of the present-day university liberal arts curriculum. Artistically, it was defined by the emergence of a new artistic style based upon classical models that sought a harmonious balance between naturalism and idealism.

Our own understanding of the Renaissance has largely been determined by the revival of antiquity in Florence, with the humanist ideals of individualism, originality, and all-roundedness that came to define "the Renaissance man;" and the aesthetic ideals of the Florentine artists Donatello (c. 1385/86–1466), Masaccio (1401– c. 1428), and Leon Battista Alberti (c. 1404–72), who accorded a new dignity to humankind in art and a new rationality to the pictorial world.

Venetian artists and intellectuals also participated in the recovery of the ancient world, but in a distinctive way, with their own values and intentions. It is important to note that they did not see Florence as their major rival – such a comparison is essentially a nineteenth-century invention – but rather the great civilizations of antiquity. Indeed, Venetians saw themselves not as peripheral, but as central, players on a European world stage in which they were unique and superior even to Rome.

By the beginning of the fifteenth century, when a French miniaturist tried to imagine how Venice must have looked during Marco Polo's time (1254–1324), the myth of Venice's superiority was firmly in place (FIG. 2). The artist's conception, surely based upon verbal description rather than direct observation, shows a city that is unquestionably rich, with a mass of gleaming white buildings; undeniably pious, with numerous churches and campaniles punctuating the urban fabric; and serene enough to have swans gliding through the waters of the lagoon. Felix Faber, a German priest passing through the city in 1480, would confirm the plausibility of such a reconstruction. In an eyewitness account, he marveled at "the famous, great, wealthy, and noble city of Venice, the mistress of the Mediterranean, standing in wondrous fashion in the midst of the waters, with lofty towers, great churches, splendid houses and palaces."

The islands were probably first settled in a consequential way in the sixth century by mainland refugees seeking protection from the Lombards, a Germanic tribe who invaded the Italian peninsula in 568 AD. In the early years, the city was under the political domination of Byzantium and the spiritual protection of a Byzantine patron saint, St. Theodore. By the end of the seventh century, Venetians were electing their own doge (local dialect for *duca* or duke), and in 807–14 AD the center of government – the *dogado* – was established on the island of Rialto. The displacement of St. Theodore as the patron saint by St. Mark, whose relics were brought to Venice in 828/29, signaled the city's growing independence from Byzantium, and the centuries that followed saw the expansion of trade in the eastern Mediterranean.

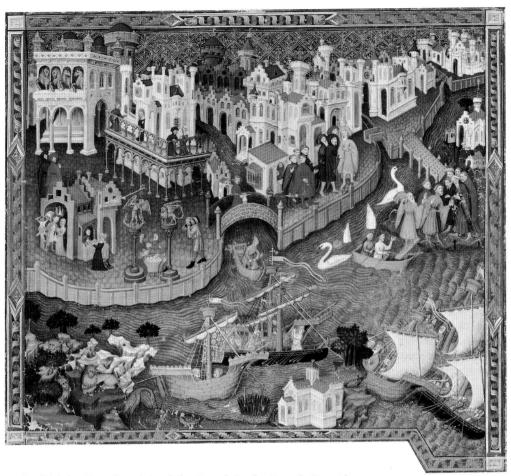

In 1204 the Venetians joined the French in the Fourth Crusade, and, instead of going to the Holy Land, made a detour to sack Constantinople, the ancient capital of Byzantium. The enterprise brought the Venetians a fortune in booty and the doge a new if short-lived title that he held until 1261: "Lord of a Quarter and Half a Quarter of the Byzantine Empire." Elected for life by a sizable oligarchy who sat in the Great Council, the doge was the centerpiece of a unique political system – a true and proper Republic – that would be perfected over the course of the thirteenth century with the addition of the Senate and other governmental bodies.

Although the period was marred by sea battles with the Genoese over control of the Adriatic and the rich Levantine trade, Venice consolidated its colonial empire in the Aegean with the addition of Crete to its other island possessions (FIG. 3). It was also a time of urban beautification and consolidation. San Marco was embellished with Byzantine spoils, and the first Rialto bridge was

2. Marco Polo's departure from Venice, from the *Travels of Marco Polo*, c. 1400. Illumination on parchment, 6¼ x 7½" (16 x 19cm). Bodleian Library, Oxford.

The Venetian merchant Marco Polo claimed to have traveled to China in 1271–95. A copy of *Il Milione*, the written account of his adventures, was attached by a chain to a map of the world in a loggia – a portico or arcaded gallery where merchants and noblemen congregated – at Rialto in 1325.

3. The Venetian *stato da mar* and sea trade routes at the end of the fifteenth century.

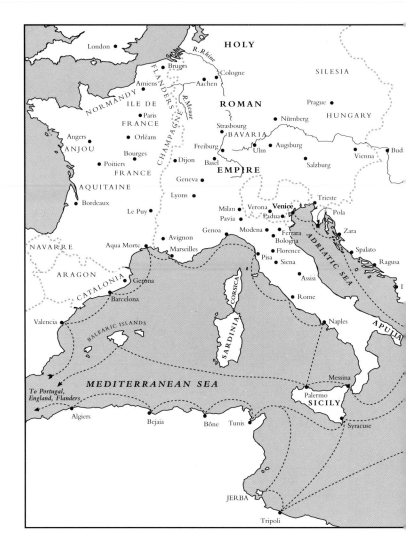

constructed across the Grand Canal. In 1297, the Great Council passed a law called the Serrata, or "lock-up." Later judged to be "the foundation of the eternity of this republic," it made membership in the Great Council hereditary and created a stable ruling class. The greatest challenges of the fourteenth century came with the Black Death in 1347–48, when up to sixty percent of the population died, and the War of Chioggia in 1378–81 when Venice finally defeated Genoa to dominate the Mediterranean.

The fifteenth century was a time of territorial expansion onto the mainland. In 1404–06 Padua, Vicenza, Verona, and other cities were added to Treviso to form a new *stato da terra* – nation of the land – in the west to balance the *stato da mar* in the east. To Venetians, it was simply the Terraferma, a source of food

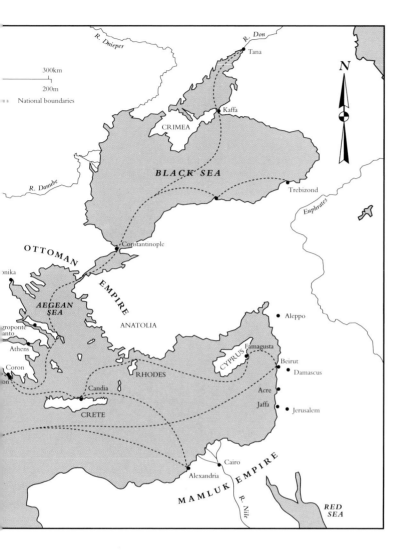

supplies and a boundary zone protecting them from states with imperialistic ambitions of their own. An aggressive military policy, with land armies captained by *condottieri* – mercenary captains who were not Venetian – expanded the Terraferma as far as Brescia, Bergamo, and Ravenna by mid-century (FIG. 4).

In 1453 the fall of Constantinople to the Ottoman Turks sounded the death knell of Byzantium and turned Venetian military attentions once again to the Aegean, where long-secure possessions were now at risk. Although a peace treaty with the Ottoman Sultan Mehmed II in 1479 secured shipping routes for a time with Venice acquiring Cyprus ten years later, the Turkish fleet became aggressive once again and Venice lost the important colonies of Lepanto, Modon, and Corone by the end of the century.

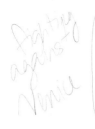

During the same period, Venice was at war with Ercole d'Este, Duke of Ferrara (r. 1471–1505) whose territories abutted the southeast border of the Terraferma. Venice's aggressive stance gave rise to the League of Cambrai in 1508, with Pope Julius II (r. 1503-13), the Holy Roman Emperor Maximilian I (r. 1493-1519), France, and Spain joining in a military alliance to counter what was seen as Venetian imperialism. Defeating Venice in the devastating Battle of Agnadello in 1509, the League pushed back the boundaries of the Terraferma to the shores of the Lagoon. But by 1517 Venice had regained her lost territories and stability returned. In the later 1520s, Doge Andrea Gritti (r. 1523–38) launched an initiative to rebuild the political center of Venice around the Piazzetta as "the new Rome." Over the next half-century, Jacopo Sansovino constructed the Loggetta at the base of the Campanile, the Marciana Library, and a new mint called the Zecca. In 1571, Venice was again at war with the Turks. Now allied with the Pope and Spain, the Venetians defeated the Turkish fleet in the Battle of Lepanto in that year, but lost the island of Cyprus, one of their most important possessions in the Aegean.

Although the old political structures remained in place through the seventeenth and eighteenth centuries, much of the spirit of early Venice – the celebration of consensus, personal sacrifice

4. The Venetian Terraferma at the end of the fifteenth century. The dotted line shows the extent of Venetian territories at this date.

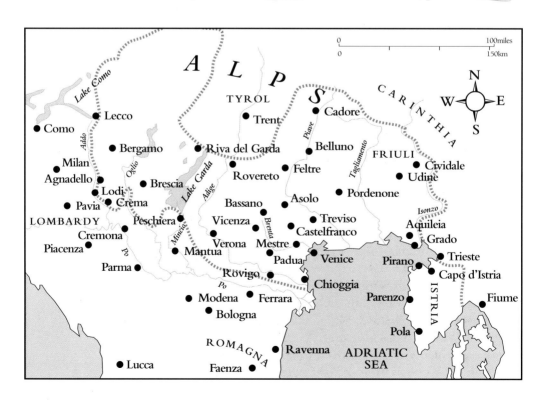

for the common good, the active participation of the patriciate in trade – was much diminished. In 1797, just five hundred years after the Serrata, the Great Council met for the last time, the doge stepped down, and the Republic yielded without a battle to the armies of Napoleon.

A certain otherness, often called *venezianità*, characterized the art and architecture of the city. Whatever the medium – paint or mosaic; stone, marble, or wood; glass or ceramic – Venetian artists and artisans fabricated a visual world whose formal characteristics can often be immediately distinguished from those of other Italian centers: a chromatic richness, an emphasis on patterns and surfaces, an engagement with light, a penchant for circumstantial detail, a taste for the pastiche, and an often noted, and persistent, conservatism. While the specifics of *venezianità* were redefined in each generation, these principles remained constant. In order to understand their origins and lasting appeal, it is necessary to look more closely at the contextual matrix of Venetian art: those unique qualities that, in combination, distinguished Venice from virtually every other city.

Venice's particularity resided in at least four significant circumstances: a singular setting, a vast trading empire, a tenacious Byzantine heritage, and a cohesive political and social structure with a cosmopolitan character. Each played a role in forming the visual world of the Venetians and in the evolution of a Venetian aesthetic.

An Opportune Position

A cluster of islands scattered across the waters of a vast lagoon at the head of the Adriatic Sea and improbably melded into a civic entity, Venice invariably inspired hyperbole (FIG. 1, page 9). In the early years of the sixteenth century, a Venetian patrician affirmed that "for a certain novelty of placement and opportune position, it was by itself the only form in all the universe so miraculously disposed." Some years later, a visitor exclaimed: "I have seen the impossible in the impossible."

Completely detached from the mainland until the middle of the nineteenth century when a causeway was constructed, Venice was approachable only by water. The visual effect of arrival is quite unlike that in entering other cities, where one passes through suburbs, then enters city gates and, moving through city streets, gradually approaches the center. Venice, by contrast, is experienced first as panorama, and then, moving across the waters unimpeded (rather like the focusing down of a telescopic lens of a cam-

era), the traveler arrives directly in the heart of the city. But quite often things are not what they seem in Venice. An easy slip between the fictive and the real begins with the physical setting, as the traveler looks back to find the glistening waters melting into an indistinct horizon of misty light and air. Turning toward the city, colors and even solid forms seem but a function of the ever-changing atmosphere. And what appeared at first glance to be a single land mass is revealed to be a number of tiny islands that are linked together by bridges over narrow canals. It is not a miracle of nature, but a miracle of man, constructed from the mudflats up.

It has often been argued that Venice's very lack of a verdant landscape was one of the factors that made the city the birthplace of pastoral painting toward the end of the fifteenth century. Even traditional religious themes were recast in pastoral terms by Venetian artists, with the landscape playing a dominant role in a striking number of devotional images. One is reminded that art not only reflects reality; it also augments it.

Indeed, the city's unique topographical situation was often cited as proof of her divinely sanctioned origins. It had been built, the diarist Marin Sanudo (1466–1536) averred, "more by divine than human will." The natural environment itself thereby became a powerful source of propitious signs. For Venetians saw the city's protected position within the enclosure of the lagoon as a sign of her virginal and inviolate status; her encirclement by churches and monasteries, rather than by the walls typical of other contemporary cities, as a sign of her holiness; her emergence out of the sea as a sign of her domination over it. Pero Tafur, a Spaniard who visited Venice in the 1430s, wrote: "The city has no walls, nor any fortress, except those two castles which enclose the harbour, since its defence lies in the sea. They draw a chain across from one side to the other so that they may be secure, and if the whole world came up against the city, the Venetians could sink a ship between the two castles in the canal and be safe." Venice's secure position also had practical consequences for art. The very real safety and security of the city allowed a rich artistic tradition to build up and develop over time.

Even the objective judgment of the mapmaker Benedetto Bordone (1450/55–1530) was compromised by the notion of a protective lagoon. His noticeably distorted view of 1528 shows the urban archipelago surrounded by an imaginary circle formed by the outer island of the Lido and other islands and the mainland: these were the "walls" of the city (FIG. 5). And despite its unscientific schema, the map remained the standard cartographic model for plans of Venice well into the next century.

Map labels:
VINEGIA
meftre, merghera, s. giuliano, s. fegondo, s. chiara, s. marta, s. zorzi d'alega, lazafufina, s. agnolo de la concordia, giudeca, chiozza, terra ferma, porto di malamocco, malamocco, poueggia, s. fpirito, s. clemente, lazaretto uecchio, s. maria di gratia, s. zorzi maggiore, s. michiele, s. christophalo, murano, s. iae di paludo, torcello, buran, mazzorbo, s. nicolo, l'arfenal, lazaretto nouo, s. franc dal deferto, s. craffmo, il lito, s. pietro, la certofa, s. helena, s. feruolo, s. lazaro, il lito, palificada, tre porti, lito maggiore

Venice was the only major city in Italy that was not built upon foundations dating back to the classical period. By the later Middle Ages, a growing and ever more prosperous population had become sensitive about the lack of a Roman imperial past and fabricated for itself a more distinguished lineage. According to one tradition, the islands were originally settled by a band of noble Trojans just after the fall of Troy. Venice was thus older than (and superior to) Rome, it was claimed, and her people had cherished liberty from the very beginning. Another legend augmented the claim of ancient roots with one of more spiritual resonance. In this version, the official foundation of the city was placed on the feast day of the Annunciation in 421 AD when the cornerstone was laid for the church at Rialto. Thus Venice could also claim a primordial Christian past. During the Renaissance, Venice's artistic participation in the revival of antiquity was marked by a romantic and nostalgic approach that grew out of this dual heritage of mythic origins.

The early settlers gained their livelihood by harvesting and selling fresh fish and salt, the two most abundant – and inexhaustible – natural resources of the lagoon. Upon the substance of such mundane commodities a trading empire was in the making. The city flourished, initially as part of the Byzantine empire, and by

5. BENEDETTO BORDONE Perspective plan of Venice and the lagoon, from the *Isolario di Benedetto Bordone* (Venice, 1528). Woodcut, 9 x 13″ (23 x 33 cm). Museo Civico Correr, Venice.

Venice proving itself better than Rome

the beginning of the ninth century the urban center was established on the cluster of islands surrounding the area called Rialto, from the Latin *rivus altus*, or high bank.

At the center of most of the islands was a parish church with its *campo*, or piazza, around which the houses and shops were built. Since each island was a self-contained unit, and most transport was by boat, the streets had no logical pedestrian routes from one island to the other. When bridges were eventually built to link the principal thoroughfares, they crossed canals at odd angles; and a narrow alley often led to a dead-end in a courtyard or on the bank of a canal. The result was a pervasive asymmetry. It embraced not only the labyrinthine street system, but also the ground plans of buildings, and pertained as well to Venetian "Gothic" palace facades which often resisted Renaissance principles of bilateral symmetry used elsewhere. Even

6. Rio di S. Canciano from the Ponte del Piovan on a sunny day. Palazzo Widmann, designed by Baldassare Longhena (1598–1682) is the tall building in the background. To the right of it is Palazzo Loredan (16th century).

the Piazza San Marco is a trapezoid and not a rectangle or square. Significantly, the city was divided not into quarters like Florence, but into six unequal sections called *sestieri*. The city grew as landfills were added for new construction around the periphery, its shape determined not by a Roman grid plan of streets set at right angles but by the silt deposited from the ebb and flow of tidal waters in the irregular pattern of a coastline. A taste for the asymmetrical or counterbalanced composition so evident in Venetian painting throughout the Renaissance was thus well-rooted in the immediate physical environment.

Likewise, clues to the Venetian approach to color can be found within the narrow confines of the city's canals, as well as on the glittering expanse of the lagoon. Two views of the same canal at different times of day offer compelling testimony to the chromatic effects of light on water (FIGS 6 and 7). At one moment the sky is bright and sunny, the colors are jewel-like, and reflections in the water are bright and clear, albeit muted versions of the original objects. Only a few hours later, a boat moves through the water, setting it into motion and giving it a new range of subtle hues: grays, whites, misty blues, mottled greens. With the sun-

light now filtered through a haze, the flat light makes the buildings gain in tangibility just as the water loses it. The light is no longer reflected in the water; it is absorbed by it. It is in these ineluctable plays between light, air, and substance that the observer begins to experience the Venetian aesthetic.

A Favored Emporium

But there were other influences that also played a role in the evolution of *venezianità*. Jacopo de' Barbari's (c. 1450–after 1511) woodcut view of Venice of 1500 introduces a second factor (FIG. 8). Seated on a cloud in the skies above the city, Mercury, the patron of commerce and trade, looks down into its heart and promises, "I Mercury shine favorably on this above all other emporia." Down below, astride a dolphin and riding the waves of the lagoon, another Olympian god pledges his own protection, "I Neptune reside here, smoothing the waters at this port." On axis between them are located San Marco and Rialto. Together with the Arsenal shipyard, these areas were the defining locales of Venetian urban culture.

7. Rio di S. Canciano with an overcast sky.

First and foremost is the architectural complex around Piazza San Marco. Two monumental antique columns topped by statues of Venice's Christian protectors, St. Theodore and the Lion of St. Mark, rose on the Piazzetta near the water's edge and constituted the formal entrance to the city. Bounded by the south facade of San Marco, the Doge's Palace (the Palazzo Ducale), and other government buildings, the Piazzetta opened out into the Piazza San Marco. The area as a whole was a powerfully condensed center of political, judicial, religious, and ceremonial life.

Directly above the piazza in Barbari's view and connected to it by a twisting and turning shopping street called the Merceria was Rialto, the second key component in the urban equation. Not only the center of commerce and banking, it was also the only point at which the Grand Canal was spanned by a bridge, thus providing a critical link – both physical and symbolic – between the two sides of the city. The Arsenal, or shipyard, as the third defining site was no less essential to civic fortunes. The great galleys built

8. JACOPO DE' BARBARI

View of Venice, 1500 (detail). Woodcut, whole work 4′5″ x 9′3″ (1.4 x 2.8 m). Museo Civico Correr, Venice.

The city is seen from a bird's-eye perspective from the southwest and was printed from separate blocks on six large sheets of paper. It is one of the first such views of this size published in woodcut. The Arsenal shipyard, located on the east side of the city, was to the right of the detail shown here.

there with state subsidies supplied the motive power for the trading activities that were the source of Venice's prosperity. Already in the tenth century, a customs official in Pavia had written with amazement, "These people neither plow nor sow, but can buy corn and wine everywhere."

The importance of Venice's mercantile activities in creating a special view of the world cannot be overestimated. Venice had been trading with the Islamic world, as well as with Byzantium, as early as the ninth century, when two Venetian merchants stole the relics of St. Mark from Alexandria. This seminal act inspired the construction of the basilica of San Marco next to the Doge's Palace and marked the beginning of the Venetian state church (FIG. 9). Modeled on the sixth-century Church of the Holy Apostles in Constantinople, San Marco was intended specifically to house the saint's relics. The church would be twice rebuilt, but always on a Byzantine model. Significantly, it was constructed not as a cathedral that would have been under the direct jurisdiction of ecclesiastical authorities, but as the chapel of the doge. As such it was subject to political control, and its proximity to the halls of government laid the groundwork for a close interweaving of the sacred and the secular in Venetian life.

By the end of the twelfth century, the Venetian Republic had consolidated its trading position by establishing permanent colonies on islands throughout the Aegean. These outposts would function in turn as centers for even more rapid expansion after 1204, the year marking the unholy outcome of the Fourth Crusade, when the Venetian navy had joined forces with the French to sack Christian Constantinople. In consequence, San Marco became a display case for political spoils as well as a reliquary for spiritual treasures.

The most visible trophies came from Constantinople. In addition to the bronze *quadriga* (the famous Horses of San Marco) above the main portal on the Piazza San Marco, were a number of objects grouped around the south facade adjacent to the Doge's Palace: two exquisitely carved free-standing marble piers called the pillars of Acri (or the *pilastri acritani*); the four porphyry swordsmen, known as "the Tetrarchs," attached to the corner of the treasury; and the elegant Byzantine reliefs set into the wall above. With the addition of the Pietra del Bando, a truncated column once used for the reading of Genoese colonial decrees and brought back from the

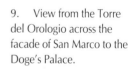

9. View from the Torre del Orologio across the facade of San Marco to the Doge's Palace.

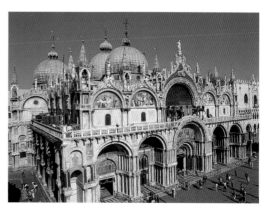

war with Genoa in 1258, the booty offered eloquent testimony to Venice's new commercial hegemony in the east.

By the beginning of the fifteenth century, Venetian galleys were familiar presences in the ports of the Adriatic, the Mediterranean, and the Aegean Seas, and were making regular trips to England, Flanders, and the Black Sea. Many of the major ports and trading cities of the Islamic world – Acre, Alexandria, Cairo, Damascus, Aleppo, Constantinople under the Ottomans – had permanent Venetian colonies or consulates during the Renaissance period.

Accessible to the cities of northern Europe by a number of Alpine passes and to the rest of Italy by the roads and rivers of the great alluvial plain of northern Italy, Venice was also ideally situated to play a significant role in land-based trade within continental Europe. Adventurous Venetian merchants also went further afield. While Marco Polo's *Travels* attested to the opening of the silk route in the thirteenth century, with profitable links established between Europe and the Mongol empire, by the end of the quattrocento we hear from other Venetian travelers who ranged through Persia, Armenia, the Caucasus, and Asia Minor. The patrician Giosafat Barbaro (1413–94) wrote in 1487 that much of this sparsely inhabited terrain, with its diversity of languages, customs, and religions, would still be unknown, "if the mercantile activities and marinership of the Venetians had not opened it up." Ca' Mastelli ("Ca" being the Venetian form of *casa*, or house), built in this period in a traditional Gothic style, was decorated on its canal facade with a bas-relief of a turbanned merchant with a camel carrying on its back a heavy load of merchandise (FIG. 10).

What made Venice different from Genoa and other great seafaring republics was not just the wide-ranging travels of her citizens, but also her central role as entrepôt or emporium to the world. In his *Cronique des Venitiens* (1267–75), Martin da Canal put it in poetic terms, "Merchandise passes through this noble city as water flows through fountains." Even Venetians who never left the confines of the lagoon were continually exposed to the widest range of goods, both exotic and mundane. From Constantinople, whether Christian or Muslim, came a variety of luxury objects; from the Aegean islands came sugar and wine; from the Far East came spices, porcelain, and pearls; from Egypt, the Levant and Asia Minor came gems, mineral dyes, peacock feathers, perfumes, ceramics, alum, and a profusion of textiles – silks, cottons, brocades, and carpets. Germany provided minerals and silver, copper, and iron; from Flanders and England came wool, woven cloth, and tin; from the nearby Dolomites and the Adriatic area came timber; from the Black Sea region came furs, grain, and, regret-

10. Ca' Mastelli, facade on the Rio de la Madonna dell'Orto.

Four statues of Levantine merchants, called *mori,* or moors, are located on the other side of the canal on the Fondamenta dei Mori.

tably, slaves. The list is by no means inclusive. Many of these goods came into Venice only to be shipped elsewhere. And to them should be added such locally made products as glass, patterned silks and other textiles, a variety of crafts and, eventually, printed books. The Venetian eye was – in consequence – practiced and discriminating as to pattern, color, quality, and material.

It was also an eye that appreciated the visual complexity of the pastiche – the collage-like assemblage of "borrowed" fragments – as witness the application of sculptural reliefs to palace facades like those at Ca' Mastelli often without any attempt to integrate them into a coherent design. San Marco itself is a case in point. The trophies displayed on the exterior wall of the treasury are carefully arranged, but in the manner of a miscellany rather than a program. Venetian craftsmen were also master counterfeiters of every sort of artifact and skilled at adapting the lucky find to contemporary use. Many fortuitous acquisitions were incorporated so artfully into the building fabric of San Marco that they look as if they were part of the original design. The elegant gray-veined marble slabs that now line the nave walls were second-hand goods, for example, stripped from the west facade of the church of Hagia Sophia in Constantinople in 1204. About half the six hundred or so columns used in San Marco were imported from Greek lands, and are so well absorbed into the overall scheme that they cannot always be distinguished from the medieval copies.

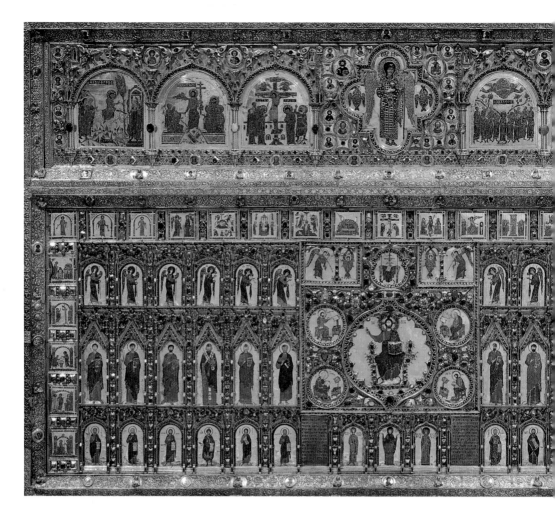

11. The Pala d'Oro, originally made in 1105 and remade in 1229 and 1345. Gold altar screen, with 255 *cloisonné* enamels and 1,927 pearls and precious stones, 10′11½″ x 6′11½ ″ (3.3 x 2.1 m). San Marco, Venice.

The stones include garnets, emeralds, sapphires, amethysts, rubies, agates, topazes, carnelians, and jasper.

Inside San Marco the renowned Pala d'Oro, a sumptuous gold altarpiece encrusted with jewel-like enamels and precious gems, was itself a pastiche (FIG. 11). Probably the single most precious object in the basilica, it was originally ordered from a Constantinopolitan workshop by a tenth-century doge. It was remade in Venice at least twice, with the Byzantine enamels and jewels reset in a new Gothic frame in 1345. The total effect is one of dazzling richness and exotic intricacy: qualities perfectly suited to an ever more refined aesthetic taste.

An even more telling example of Venetian adaptation is an intriguing object inside the treasury of San Marco, known as the "Grotto of the Virgin" (FIG. 12). Its manufacture must have begun when an unknown Venetian artisan was presented with a piece of rock-crystal, probably late-antique booty from the Fourth Crusade. Carved into the shape of a central-plan building, the

miniature edifice has walls that are articulated in the antique manner with pilasters and decorated with volutes, a sword, a shield, and a spear. Grasping its potential for adaptive re-use, the artist turned it upside down and installed a silver-gilt statuette of the Virgin in the center of what had originally been a domed vault. The figure of the Virgin was crafted in Venice in the Greek-influenced style of the late thirteenth century and may have been specially made for the purpose. The ensemble was then mounted on a base made from another piece of booty – the votive crown of the Byzantine emperor Leo the Wise (886–921). Fashioned from silver-gilt and richly decorated with *cloisonné* (enameled) medallions of the emperor, the apostles, and the evangelists that are framed with strings of large, irregular pearls, the crown was especially precious.

The resulting assemblage thus combined objects from three distinctly different cultures and stylistic traditions; and yet it is

Right
12. The "Grotto of the Virgin." Rock-crystal (c. 4th or 5th century); Crown of Leo the Wise (late 9th–early 10th century); figure of the Virgin (13th century). Rock-crystal, silver-gilt, gold *cloisonné* enamel, precious stones, pearls. Overall dimensions: 8 x 5" (20 x 13 cm). Treasury of San Marco, Venice.

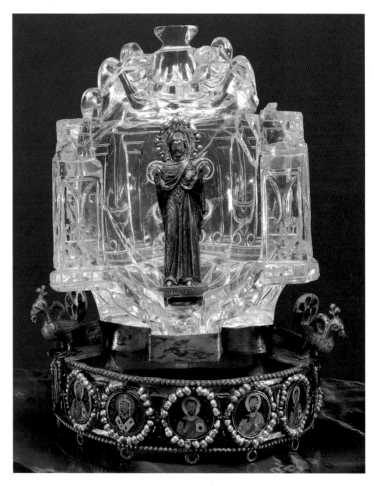

ultimately convincing. The Grotto of the Virgin is just one small instance of a larger phenomenon of which the built environment of Venice itself is the supreme expression.

Indeed, Venice was an island city that was in no way insular. A taste for the irregular and the aggregative allowed infinite incorporation of new and diverse stylistic elements into the urban fabric. By the middle of the sixteenth century, a visitor could stand in the Piazzetta and take in at a glance Venice's history. The basilica of San Marco, the consummate pastiche, preserved the republic's roots in a spiritually resonant Byzantine past. The Gothic architecture of the doge's palace documented the period of mainland expansion and the acquisition of the Terraferma. Islamic elements on both buildings – arches, patterned surfaces, stone grillwork – attested to contacts with the Levant. On the west side of the Piazzetta, the Loggetta and the new library of San Marco designed by Jacopo Sansovino (1486-1570) in a Roman Renaissance style marked Venice's universalizing pretensions as "the light and beacon of all Italy." The resulting montage was quintessentially Venetian, employing an aesthetic of diversity that is deliberately cumulative rather than naively eclectic.

In the first instance, it may have been Venice's fabled stability that allowed for the new and the exotic to be woven into the pre-existing fabric of the city. And yet, conversely, the strong sense of tradition caused assimilation of alien deposits to remain incomplete; for full absorption put at risk the beloved effect of contingency. At stake was the satisfying quality of a cosmopolitan urban pastiche that embraced the best of the known world.

The Byzantine Paradigm

How do all these factors add up in terms of *venezianità* and the formation of an aesthetic tradition? Let us return to the basilica of San Marco as a case study and look at how the Byzantine heritage remained a living presence in the Venetian visual world (FIG. 13). The vaults, domes, and upper walls of the interior of the church were covered with a shimmering golden skin of mosaic tesserae figured with three narrative themes: the lives of Christ and the Virgin; the mission of the apostles who spread the Christian message; and the life of St. Mark, including the theft of his relics from Alexandria in 828 AD by two Venetian merchants who reverently transported them to Venice. This program was augmented by a cycle of mosaics in the vaults of the atrium with scenes from the Book of Genesis. Long after the political message of the translation of Mark's relics had lost its urgency and

Opposite

13. View of the presbytery of San Marco, Venice.

The Pala d'Oro, visible behind the high altar, was usually covered by a painted panel called the Pala Feriale and was displayed only on the most important feast days.

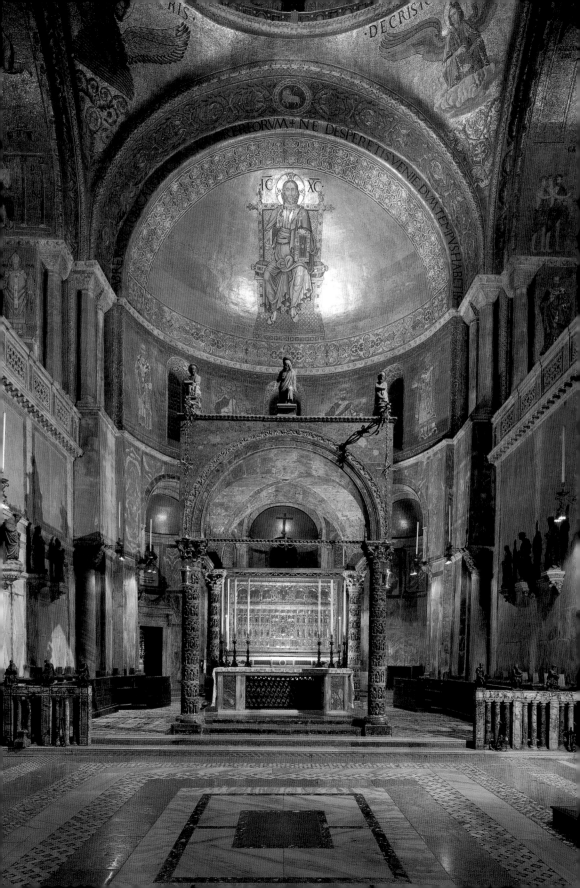

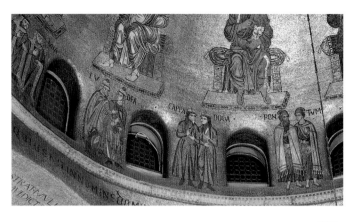

14. Pentecost dome, 12th century (detail). Mosaic. San Marco, Venice.

Sixteen pairs of figures, representing the peoples of the world to whom the Apostles would preach the Christian message, are situated between the windows at the base of the dome. Shown here are (from left to right) Iudea, Cappadocia, and Pontum.

its ideological impact, the interior of San Marco would provide a silent, powerful, and infinitely transformable model for the artists of Venice.

If we imagine ourselves for a moment in the medieval basilica, it is possible to recapture some of the sensations that would have been particularly appealing to Renaissance painters. First of all, there is an impression of goldenness – an overall surface of gold that serves as a backdrop for vivid mosaic images: both single figures and little narrative tableaux. Although the figural elements are part and parcel of the surface and do not challenge the two-dimensionality of the wall, the effect is anything but static. With the background made up of gold mosaic *tesserae* that are purposely set at different angles to catch the light, the curving surfaces of the domes and vaults remain a constantly shimmering active presence. This vitreous golden field not only provides a common unifying ground for the separate figures and narrative episodes; it also harmonizes the brilliant colors of the mosaics without absorbing them. If we look closely at one of the figures, we are reminded that the basic building unit of a mosaic composition is a *tessera*, or small piece of colored glass (FIG. 14). The face, the skin, and the clothing are composed of hundreds of such pieces, built up in an aggregative manner from bits of tesserae that are juxtaposed in rows of similar or slightly differing colors. Because these tesserae are glass, their color actually changes with the changing light. There is seldom a field of solid color; rather it is the irregularity and the subtle modulation that gives mosaic art its rich and sensuous effect. The chromatic approach to color of Giovanni Bellini, Titian, and other Venetian artists had its antecedents here. It does not really involve bright colors as such – colors were often more intense in Florentine painting – but hues that are richly orchestrated and unified by a common warm tonality.

A large part of the appeal of mosaics is their very texture. Seen from close up, they are simply separate chunks of pure color. But from a distance, it is possible to overlook this fact, and the mind blends them together in a continuous surface. One thinks of an impressionist painting, where the mind is required to fuse together dots of color, seen by the eye, into intelligible forms. And

yet, the viewer of a mosaic is always aware of the material substance of the medium and the fact that the surface is there and tangibly present. It is not just a transparent window into another world behind the surface; this sense of the built-up surface would also carry through into Venetian Renaissance painting.

The influence of the mosaics was not just visual and passive in nature, for Renaissance artists were continually involved with them in a very real physical sense as they restored or even replaced them with their own designs. Christ in Majesty in the semi-dome of the main apse, for example, was created in 1506 by a Master Pietro who sought, albeit in the middle of the High Renaissance, to replicate archaeologically the venerable Byzantine prototype of the twelfth century. And yet the same artist also made a mosaic of St. Matthew the Evangelist, just visible to the right in the southeast pendentive of the presbytery dome (see FIG. 13), in a full-blown Renaissance style. Better known artists, such as Titian, Veronese, Tintoretto, and Palma il Giovane, also eagerly contributed their own cartoons to "restore" the medieval mosaics in an up-to-date manner.

Just as the mosaics themselves were restored, replaced, and added to by artists over the centuries, so too successive generations would look into the basilica with new eyes and draw from them varying messages to meet new concerns and challenges. The stylistic evolution of the Venetian altarpiece demonstrates the power and mutability of the Byzantine example. In the trecento it

15. PAOLO DA VENEZIA
S. Chiara Polyptych,
c. 1350. Panel, 5'5¼ x 9'4"
(1.7 x 2.9 m). Gallerie
dell'Accademia, Venice.

The tiny figure of a
Franciscan nun, the
probable patroness of the
work, appears in the *Death
of St. Francis*, in the second
pinnacle from the right.
The sun and moon beneath
Mary's feet allude to John
the Evangelist's vision of the
Woman of the Apocalypse
in Revelations 12:1.

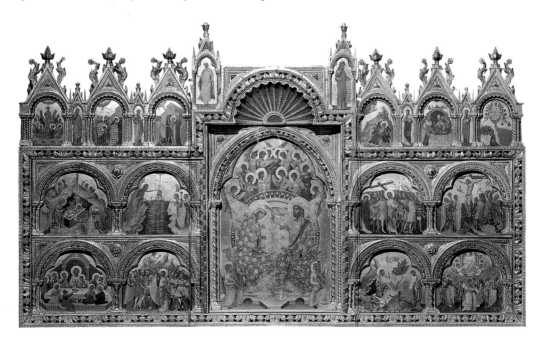

was the golden refulgence, the brilliant vitreous color, and the material preciousness of the mosaics that inspired Paolo da Venezia (c. 1290–1358/62). The earliest Venetian painter known to us as an artistic personality, he introduced the compartmented polyptych, a type that would become the norm in Venice (FIG. 15). Paolo combined Byzantine and Gothic elements in his sumptuous S. Chiara Polyptych in an idiosyncratic, but convincing, new synthesis. Painted in a miniaturist technique based upon the minute observation of tiny details that is reminiscent of the Pala d'Oro, the ensemble looks from a distance like an intricate tapestry. The large central panel features the Coronation of the Virgin, originally a French iconographical theme, with Christ and the Virgin sharing a double throne and serenaded by a choir of music-making angels. The spiritual and physical center of the ensemble, the coronation panel is framed by scenes from the lives of Christ and St. Francis. The luxury fabrics worn by the holy figures feature a range of silks embroidered with floral patterns found on Chinese silks and ceramics and offer compelling circumstantial evidence of Venice's trade with the Far East. Brilliant color, used with characteristic Venetian subtlety and restraint, is transformed in the manner of mosaics or the Pala d'Oro into a rich chromatic harmony by means of the unifying matrix of the gold background.

In the quattrocento the ornamental values of the San Marco mosaics still appealed to Venetian artists, but now they were to be reinterpreted according to new standards of naturalism. Giovanni Bellini (c. 1430–1516) was able to satisfy both demands with yet another novel synthesis in a succession of altarpieces culminating in the S. Zaccaria *pala* of 1505 (FIG. 16). Few artists still used gold leaf for the backgrounds of their altarpieces, for in an age that increasingly prized pictorial realism, the holy figures were supposed to be placed in a credible physi-

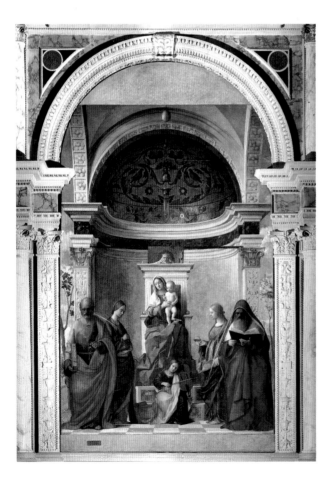

16. GIOVANNI BELLINI
S. Zaccaria Altarpiece,
1505. Canvas transferred
from wood, 16′5″ x 7′8¹/₂″
(5.0 x 2.4 m). S. Zaccaria,
Venice.

The Madonna and Child are
flanked by SS. Peter and
Catherine, Lucy and
Jerome. The connection of
Bellini's painted apse with
the marble frame would
have been more apparent
before the painting was cut
into a rectangle.

cal environment. Bellini, in all likelihood inspired by the basil-
ica, invented an individual mosaic apse as a frame for the Madonna
and restated in naturalistic terms the traditional gold-leaf back-
ground used by Paolo da Venezia.

Having mastered the Renaissance art of linear perspective,
invented in Florence by Brunelleschi (1337–1446) and codified
by Alberti, Bellini created the illusion of a three-dimensional world
on a flat, two-dimensional surface by following a geometric
formula that conceives of the picture space as a window. The holy
figures are thereby placed in a measurable relationship to one another
in an architecturally rational-looking church setting. But Bellini
does more than that. For he paints the arches supporting the groin
vault in the fictive picture space so that they appear to be exten-
sions of the real marble frame. Here he parted company with
his Byzantine models, and yet he endowed his setting with a mea-
sure of the chiaroscuro experience of San Marco. The tonality –
light slipping into shadow – appears to mold the surfaces, thereby
endowing them with a convincing three-dimensionality. It also
modulates the color, for the chromatic variations are bathed
and fused together by the golden light. Symbolically, Bellini's ref-
erence to the mosaic decoration of San Marco endowed his
altarpiece with some of the time-hallowed presence of the medieval
basilica and brought this presence into the early Renaissance
nave of S. Zaccaria. Once installed it was no longer so much a piece
of church furniture as it was a piece of architecture, visually acces-
sible and contiguous to the viewer's own physical space.

For Bellini it was not the actual rough texture of mosaics that
was of interest, but rather their precise appearance. In his oil paint-
ing technique, he thus sought to replicate the light-generating
properties inherent to glass tesserae. By first priming the canvas
or panel with a white ground and then overpainting it with
layer upon layer of thin colored glazes, he achieved the effect
of an inner glow in which the light appears to emanate from
the depth of the picture itself.

Seven decades later we find Titian (Tiziano Vecellio: c. 1488
–1576) moving from Bellini's literal translation of the mosaics
to the replication of the optical effect of light on their surface. For
the *Pietà* that was to be installed above his tomb in the Church
of the Frari after his death, he invented a unique rusticated con-
struction whose mosaic apse is now but a graceful gesture to the
mosaics of San Marco (FIG. 17). Titian, like Bellini, sometimes used
glazing to achieve transparency and luminosity, but he also followed
an alternative approach that abjured Bellini's smooth, polished
surfaces. Probably developed by Vittore Carpaccio (c. 1465–1526)

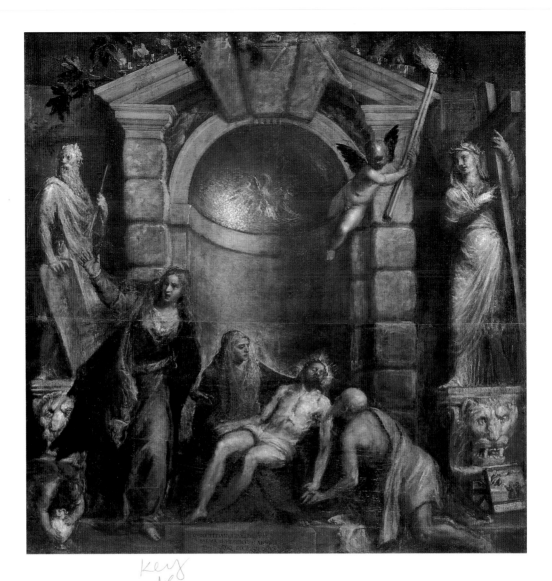

17. Titian
Pietà, c. 1570s. Oil on
canvas, 11'7½" x 11'5½"
(3.5 x 3.5 m). Gallerie
dell'Accademia, Venice.

Key Quote

and Giorgione da Castelfranco (1476/77–1510) in the early years of the sixteenth century, the rough-textured surface soon became one of the characterizing features of the Venetian school. Instead of using the traditional supports of smoothly sanded panels or fine-grained stretched linen, they favored a coarsely woven twill canvas. Oil paint was either brushed or dragged across it in thin patches to allow the texture of the canvas to show through, or else it was applied in thick impasto strokes further to emphasize the surface. The very physicality of the paint and canvas is reminiscent of the tangible nature of the mosaic medium. At the same time it affirms the presence of the artist.

Titian used this technique to paint the apse in the *Pietà* and

thereby caught the shimmering effect of a glittering tesselated surface. He also gave the apse a temporal dimension. Depicted in a darkening twilight that recalls the natural illumination of San Marco in the early evening, the images in Titian's fictive mosaics are all but ungraspable. Suspended on the shimmering golden ground, they retain only a trace of their color. The sense of transience and of time moving on was thus captured physically, as well as symbolically, in a painting that has been called Titian's last testament.

18. *Christ Entering Jerusalem*, 12th century. Mosaic. West vault of south transept, San Marco, Venice.

Artists of the Renaissance period were influenced not only by the optical qualities, color, and texture of the mosaics of San Marco; they also looked to them for authoritative models for compositions. The mosaic of *Christ Entering Jerusalem* (FIG. 18) in the vault of the south transept typifies a narrative paradigm of enduring consequence in Venetian art. Summing up the story in terms of procession and arrival, the figures are arranged in a frieze-like manner and movement is strictly confined to the front plane. While painters often used overlapping forms to suggest the illusion of three-dimensional space, in the mosaics solid forms tend to remain on the surface. Compositional unity is achieved through line and pattern, and, most specifically, through the repetitive gestures and the rhythmic clustering of the figures. This example of lateral rhythm, with the story unrolling across the front plane, remained so compelling to artists of a later day, that it would be used not just for narrative paintings, but also to organize the iconic space of the altarpiece (FIG. 19).

The mosaics of San Marco thus remained a living monument for the artists of Venice. They drew from them a subtle approach to color, attitudes about the physical craft of art, models for composition, a respect for the surface, and perhaps most important of all, a way of perceiving and of representing light as a powerful revealer – and, at the same time, dissolver – of form.

A City of Immigrants

For all the magic of the urban setting and its monuments, it is ultimately in the Venetian people themselves that the roots of *venezianità* must be sought. It is important to remember that Venice

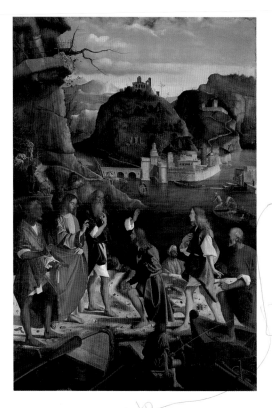

19. MARCO BASAITI
*Calling of the Sons of
Zebedee*, 1510. Panel,
12′8″ x 8′9¹/₂″ (3.9 x
2.7 m). Gallerie
dell'Accademia, Venice.

The work was originally
made for the high altar of
the church of S. Andrea
della Certosa. The
landscape includes a walled
city on the water similar to
Candia, the capital of the
Aegean island of Crete.

was a city of immigrants from its beginning. All the great families came from somewhere else, and early chronicles meticulously documented an astonishing diversity of origins from nearly every part of Italy and the Adriatic region. Ethnographic interests were already apparent in the twelfth-century mosaics of the Pentecost dome in San Marco (FIG. 20; see also FIG. 14, page 28). Although the program as a whole was based upon traditional Byzantine iconography, the pairs of figures between the windows at the base of the dome were carefully distinguished in terms of costume, facial type, and skin and hair color to indicate the different nations of the world. Such circumstantial precision, although inaccurate in this case, was characteristically Venetian.

The Serrata of 1297 had divided the population of Venice into three legally defined groups. At the top of an enviably stable social hierarchy was the ruling oligarchy of *nobili* who called themselves patricians. They constituted about five percent of the population by the end of the quattrocento. Although equal to one another in a political sense, with all adult males eligible to sit in the Great Council and to hold public office, patricians were unequal in terms of wealth and included the very rich as well as the nearly destitute. It was from their ranks that the doge was elected from a group of nominees. More figurehead than monarch, he was held to be but *primus inter pares* – first among his equals.

Beneath the nobility were the *cittadini* or citizens, a caste that comprised about five to eight percent of the population. They were the group most equivalent to the modern bourgeoisie. Like the patricians, most *cittadini* derived their livelihood from mercantile activities and some amassed great fortunes. Required to prove that neither they nor their progenitors had practiced a manual trade, they also staffed the permanent salaried bureaucracy. In this role, they provided continuity and stability in a state that was governed by "noble amateurs" who continuously rotated through the elective offices.

The rest of the population – the *popolani* – constituted the lowest estate. Embracing a wide range of occupations and conditions – from artisans and craftsmen, small shopkeepers, and wealthy

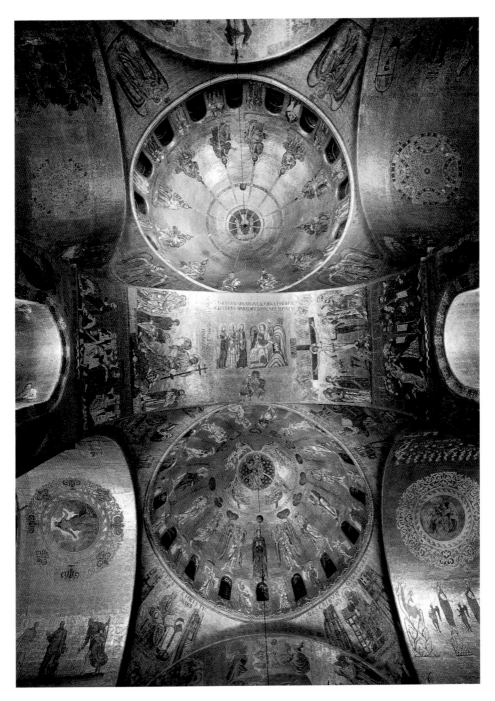

20. Ascension dome (bottom); Holy Women at the Sepulchre (west vault); and Pentecost dome (top). Mosaic, 12th century. San Marco, Venice.

The Pentecost dome symbolizes the institution of the Church and the descent of the Holy Spirit after Christ's Ascension. The twelve apostles, filled with the Holy Spirit that radiates from the dove displayed in the throne at the center of the dome, receive the gift of speaking in foreign tongues and are inspired to preach the Christian message to all the nations of the world (represented by the paired figures situated between the windows at the base of the dome; see FIG. 14, page 28).

21. Vittore Carpaccio
*Healing of the Possessed
Man*, 1494 (detail). Canvas,
whole work 11'11¾" x 12'9"
(3.7 x 3.9 m). Gallerie
dell'Accademia, Venice.

foreigners, to mariners, shipyard workers, and unskilled labor-
ers – this too was a social category and not an economic class.

By the end of the quattrocento, trading activities and immi-
gration resulting from the westward advance of the Turkish empire,
had produced one of the most heterogeneous populations in Europe.
The *calli* and *campi*, Venetian dialect for streets and public squares,
were so full of exotically clad visitors and immigrants – among
them Germans, Slavs, Albanians, Dalmatians, Turks, Mamluks,
Arabs, Africans, Persians, Greeks, and Levantine, German, and
Spanish Jews – that one visitor remarked of the city, "Most of their
people are foreigners" (FIG. 21). This motley crowd, while con-

tributing to the cosmopolitan character of Venetian culture, was not fully assimilated into it in a political sense.

And yet, for the ninety-five percent of the population who were not allowed to participate in the exercise of political power, there were important arenas of participation that helped to ensure a domestic tranquility for which Venice was acclaimed as the *Serenissima*: the most serene Republic. Most notable were the *scuole*, as Venetians called their religious confraternities. Aside from their devotional activities, the *scuole* performed a number of social functions and engaged in a panoply of charitable activities, including the financing of dowries, poor relief, and the provision of low-cost housing and medical care. They also provided the essential manpower to march in the processions that were the cornerstone of Venetian civic ritual. Virtually all the *scuole* accepted both nobles and commoners and thus formed areas of cohesion where Venetians of every condition could come together in a context of social solidarity and mutual assistance.

Social stratification in Venice had a significant impact on the patronage of art. Consensus was highly prized and personal ostentation discouraged, particularly within the patriciate and amongst the *cittadini*, so as to avoid envy and unbrotherly competition. Ornate family chapels were the rare exception, and family palaces tended to conform to pre-existing models. A sense of participation in a common enterprise was instilled in the population at every level. As a result, corporate patronage by the government and the *scuole* was more significant in Venice than in most other places. A commitment to the established order also encouraged an emphasis on tradition and continuity in art.

With all due respect to Petrarch, Venice was not just "another world." It was, in fact, several worlds that embraced the intersecting spheres of the public, the private, and the spiritual, as well as the hierarchies of rich and poor, noble and commoner, male and female. These worlds defined, and were defined by, the visual culture of the Renaissance Venetian, at once ephemeral and concrete; distinct, interwoven, and overlapping; sometimes ambiguous and often ungraspable. While the parameters had been set by the patrician-mercantile culture, the agents of aesthetic change were the artists and artisans of the city who grafted the present onto the past in an ever-changing palimpsest.

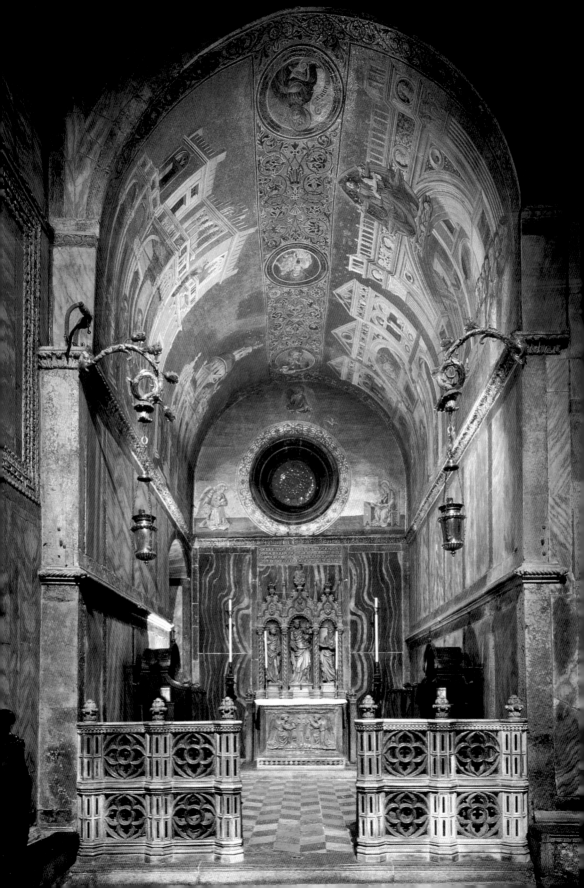

The Making of a Visual World

22. Cappella dei Mascoli, San Marco, Venice.

Marble altar: BARTOLOMEO BON, *Madonna and Child between SS. Mark and John*, erected 1430. Mosaics: *Life of the Virgin*, c. 1430s– c. 1451. Left vault: MICHELE GIAMBONO, *Birth of the Virgin* and *Presentation of the Virgin*; end wall: MICHELE GIAMBONO, *Annunciation*; right vault, ANDREA CASTAGNO, JACOPO BELLINI, and MICHELE GIAMBONO, *Visitation* and *Dormition of the Virgin*.

I n 1504 the German colony in Venice joined the ranks of foreigners who sought the spiritual and material benefits of membership in a Venetian *scuola*. To this end they established the Scuola dei Tedeschi ("of the Germans"). Dedicated to the Virgin of the Rosary, the new confraternity was granted rights to an altar in the church of S. Bartolomeo at Rialto. The location was no accident. Near at hand was the Fondaco dei Tedeschi, an exchange house where all German merchants were required to live and to transact their business in the city. A statement of cultural identity was clearly in order. Passing over a host of Venetian artists, the officers of the new *scuola* determined to commission the *pala*, or altarpiece, from a countryman: the painter Albrecht Dürer (1471–1528), already famous throughout Europe for his woodcuts and engravings.

Dürer rose to the challenge with the *Feast of the Rosegarlands*, a painting that offered a unique synthesis of German and Venetian aesthetic values (FIG. 23). Adopting the format of the single unified field altarpiece that had become common in Venice, he turned it on its side – in order to accommodate an expansive landscape and a large number of portraits, including his own. Dürer also paid homage to Giovanni Bellini. In a graceful paraphrase of Bellini's S. Zaccaria Altarpiece, unveiled only months before (see FIG. 16, page 30), he painted a music-making angel at the base of the Virgin's throne. Writing to his friend Willibald Pirckheimer in Nuremberg about his friendship with the Venetian artist, Dürer observed, "He is very old, but is still the best painter of them all."

23. ALBRECHT DÜRER
Feast of the Rosegarlands, 1506. Panel, 5'3¼" x 6'4¾" (1.6 x 1.9 m). National Gallery, Prague.

Pope Julius II and the German emperor Maximilian I kneel in the foreground, while Dürer stands in the right background holding an inscription bearing his signature. The other portraits would have depicted officers of the *scuola* and members of the German community in Venice.

With its luminous color, exquisitely detailed landscape, incisive portrayals, and semblance of movement, Dürer's *Feast of the Rosegarlands* was a dazzling *tour de force*. All Venice, including the doge and the patriarch, flocked to see it. Never one to suffer from false modesty, Dürer wrote to Pirckheimer that "there is no better image of the Virgin in the country."

And yet Dürer's situation in Venice was ambiguous. The admiration that he earned from the aristocracy was matched by resentment from the artists, not all of whom were as self-confident as Giovanni Bellini. Early in his stay, Dürer had confided to Pirckheimer, "Amongst the Italians I have many good friends who warn me not to eat and drink with their painters. Many of them are my enemies and they copy my work in the churches and whenever they can find it, and then they revile it and say that the style is not 'antique' and so not good." Several months later Dürer complained further: "The painters here, let me tell you, are very unfriendly to me. They have summoned me three times before the magistrates, and I have had to pay 4 florins to their Scuola." Dürer, for all his distinguished reputation, had run head on into the tightly regulated world of the Venetian guilds.

The World of the Guilds

While the making of art throughout Europe in this period was admittedly more a commercial business than a vehicle for self-expression, its mercantile nature was particularly notable in Venice. Like virtually every other trade practiced in the city, the arts were protected and controlled by the state. Architects and sculptors who

Right
24. *Insegna* (sign-board) of the Arte dei Tagliapietra (stonemasons), 16th century (restored 1730). Panel. Museo Civico Correr, Venice.

worked in stone were required to join the Arte dei Tagliapietra, or stonemasons guild (FIG. 24), while woodcarvers formed their own group, the Arte dei Intagliadori. But the Arte dei Depentori, whose statutes dating to 1271 make it the oldest known painters' guild in Italy, was all-inclusive. By the end of the sixteenth century, its membership was divided into eight categories, called *colonelli*. These included not only the figure painters and illuminators whom we would now define as true and proper artists, but also gilders, textile designers and embroiderers, artisans of gold-tooled leather, playing-card makers, mask makers, and sign painters.

This inclusiveness encouraged two important tendencies. In the first place it tended to level the genres, with no official hierarchy or division between crafts carried out by artisans and the "fine arts," the prerogative of the artist. In consequence, it took considerably longer in Venice than in some other centers for figure painting to be considered a liberal art: only in 1682, a good century later than their counterparts in Florence, did Venetian painters split off and form their own guild, the Collegio dei Pittori. In the second place, while individual painters might work in several of the fields recognized by the guild, with major artists from Paolo da Venezia in the 1300s to Titian in the 1500s involved in such craft-like activities as festival decoration, mosaic design, and banner making, they were strongly discouraged from crossing media boundaries into sculpture. Court records suggest that territorial disputes were common, with carvers and painters each jealously guarding (though not always successfully) the exclusive right to practice their crafts.

The guilds were involved in the lives of artisans in a number of ways. One of their functions was political, an aspect that would have been clear to each member of a guild from the moment that he was sworn in and had to pledge his allegiance to the doge. Back in 1310 the officers of the painters' guild had been presented with a unique opportunity to prove their loyalty by helping to quash one of the few rebellions in the republic's history. Led by a patrician, Baiamonte Tiepolo, it was quickly put down when the painters joined with several members of the Scuola di S. Maria della Carità to capture the fleeing rebels in a pitched battle in the Campo S. Luca. The patriotic deed was commemorated with a flagpole base, carved with the emblems of each *scuola*, that stands in the *campo* to this day.

Guilds also played a special civic role on occasions of ceremony and celebration. Twice a year, on the feast days of St. Mark and Corpus Christi, guild members displayed their corporate identities to the city at large in the spectacular processions that wound

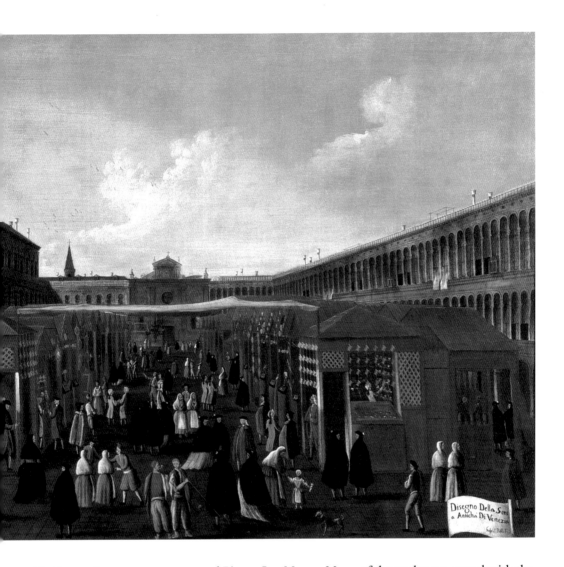

Disegno Della Sensa Antica Di Venezia

25. GABRIELE BELLA
The Ancient Feast of the Sensa, c. 1790. Oil on canvas, 38½ x 58½" (98 x 148.5 cm). Pinacoteca della Querini Stampalia, Venice.

around Piazza San Marco. Many of the trades concerned with the production and sale of luxury items – paintings, furniture, textiles, carpets, mirrors and objects of glass, gold, and silver – displayed their wares on holidays, when shops were ordered to remain closed. The most famous such event was the annual Feast of the Sensa, a fifteen-day fair that culminated in the ancient ritual of the Marriage to the Sea on Ascension Day in which the doge's – and thus Venice's – lordship of the sea was reaffirmed each year. A kaleidoscopic array of imported and locally made merchandise was displayed in a motley assortment of improvised *botteghe* (stalls) and handcarts which filled Piazza San Marco (FIG. 25). It was the only time during the year that foreign artists were allowed to sell their pictures in Venice without incurring fines such as those

26. BARTOLOMEO VIVARINI
St. Ambrose Altarpiece,
(central panel), 1477. Panel,
49¼ x 18½" (125 x 47 cm).
Gallerie dell'Accademia,
Venice.

[handwritten annotation: Scuole - extended family all had jobs lived/worked/played together]

levied on Dürer. The event attracted crowds of visitors from near and far.

Artisans also played a role in extraordinary demonstrations, such as the festivities that followed a Venetian naval victory over the Turkish fleet at Lepanto in 1571. Upon this occasion, the drapers' guild bedecked the Rialto bridge with canopies and lanterns and festooned the sides with colorful bunting. The painters' guild then further embellished the structure by using the fabrics as a backdrop to display canvases by their most illustrious members, past and present, including Giovanni Bellini, Giorgione, Pordenone, Titian, and Jacopo Bassano.

It is worth noting, however, that the Venetian guilds, unlike many of their counterparts in Florence and other cities, never wielded any real political authority. In Venice, a sense of participation and a rhetoric of inclusion provided an effective substitute for the exercise of power.

Indeed, the Venetian guilds were primarily concerned with the day-to-day practice of the trade, and their greatest impact on the lives of artisans was in the economic sphere. The guild restricted the number of apprentices allowed to enter the trade; it established norms for training, apprenticeship, and promotion to journeyman status – for sculptors, upon presentation of a *base attica* (a classical base), for painters, *un anchona a più colori* (an altarpiece in many colors); it defined days and hours of work; it set quality control standards for the various objects made by guild members; it appointed peer juries to appraise completed works; it oversaw contractual agreements. All such rules were designed to level the playing field amongst Venetian artists of an acceptable level of competence, but of vastly different levels of skill and creativity. They were also intended to give those artists – and the economy of the city – every advantage over outside competition.

The social and religious aspects of an artisan's life were centered in the *scuola* that was attached to each trade guild. As with the other *scuole*, those based upon occupational groupings functioned like miniature commonwealths. Each included a broad spectrum of members, from the most prosperous master of a busy workshop to the humblest apprentice who was still grinding pigments and sweeping the floor. The members elected officers

each year, attended regular meetings, and worshipped together. They buried the dead, dowered their daughters, and assisted each other in times of illness or economic hardship. Like many of the *scuole*, the Scuola dei Pittori operated its own small hospital.

Each *scuola* maintained an altar in a parish church or, if particularly wealthy, its own meeting house. In either case, decorative embellishment was not only fitting, it was necessary for the honor of the group. The stonemasons, who had an altar in the church of S. Aponal, commissioned a polyptych from Bartolomeo Vivarini (c. 1432–91) in 1477. According to an inscription on the work, at least two of the five holy figures depicted, Ambrose and Peter, were the name saints of the *gastaldo* and the *scrivan*, the chief officers of the *scuola* at the time. Their financial contribution to the commission, as well as those of other members, was also acknowledged by their inclusion in the group of worshippers who kneel at the feet of St. Ambrose in the central panel (FIG. 26). The image of collective piety is emblematic of confraternal ideals of solidarity and cooperation.

The Scuola dei Pittori met in the church of S. Luca, their patron saint, until 1532 when a substantial bequest left by one of their members, Vincenzo Catena, allowed them to build their own meeting house near S. Sofia. The building has long since been put to other use, but the door jambs still exhibit reliefs of St. Luke the Evangelist as emblems of the *scuola* (FIG. 27).

As Dürer learned to his annoyance, special sanctions were imposed by the guild on foreign artists who made and sold objects in Venice. Even if he had become a permanent resident of the city and thus eligible to join the painters' guild, his entrance fee would still have been double that required of a native artist, and he could normally sell his works only in his shop and not any other place.

The protectionist policies of the guild were aimed at maintaining an exclusive caste. The position of the government, as indicated by Dürer's popularity with the patrician ruling elite, was rather different. On the one hand, exports were to be encouraged and imports discouraged for the sake of the local economy. Heavy duties were accordingly levied on imported altarpieces, and standards relaxed on those made for the export market. Special dispensations were sometimes granted to further particular economic goals. The painters were thus allowed by the government to work

27. *St. Luke the Evangelist,* 1572. Istrian stone relief, 8¹/₃ x 13″ (21 x 33 cm). Capital of corner pilaster on the entrance to the former Scuola dei Pittori, Strada Nova, Cannaregio 4186–4190, Venice.

Accompanied by the bull, his traditional attribute, St. Luke is depicted in the act of painting. The *scuola* premises were located on the *piano nobile,* the floor above the retail shops on the ground floor. Early accounts describe exterior walls covered with fresco decoration and an interior filled with paintings by the group's most distinguished members. The Cannaregio is one of the largest *sestiere,* or districts, of Venice.

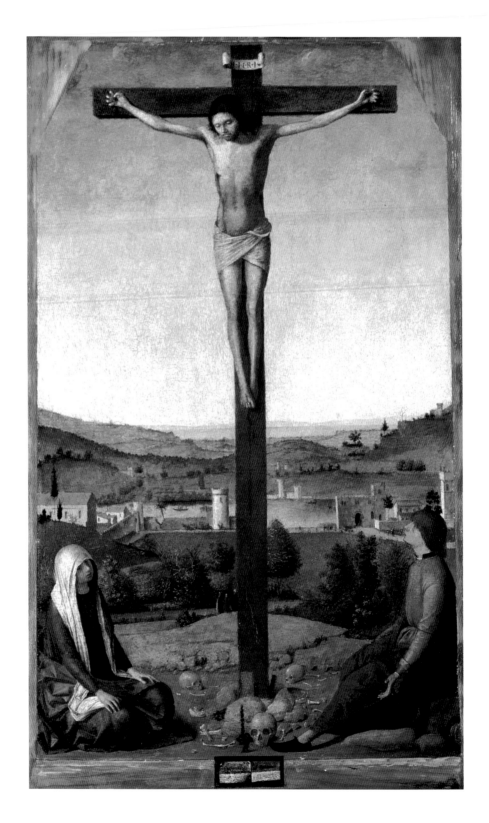

The Making of a Visual World

on statutory feast-days – about ninety otherwise unprofitable holidays each year – only if they were completing altarpieces that were to be shipped abroad. The members of the glassmakers' guilds, who possessed proprietary knowledge of one of Venice's most profitable manufactures, were held to particularly stringent standards in order to ensure Venetian preeminence in the marketplace. They were allowed neither to work outside Venice nor to sell glass made outside Venice within the city.

On the other hand, as far as the patriciate was concerned, talented foreigners were more than welcome to work in the city. Some, such as Dürer, came as visitors and carried out private commissions that provided an infusion of new ideas for Venetian artists. Antonello da Messina (c. 1430–79) a southern Italian painter who may have learned the technique of Flemish painting in Naples, was in Venice for only a year (1475-76). But during that short time he introduced spatial clarity into Venetian devotional images and demonstrated new techniques of oil painting that achieved the greatly admired luminous effects of Flemish optical realism (FIG. 28). The Florentine sculptor Donatello (c. 1385/6–1446), already influential because of his work in nearby Padua, carved a wooden statue of St. John the Baptist that still stands in polychrome splendor in the Frari upon the altar of the Scuola dei Fiorentini, the confraternity of the Florentine community. Leonardo da Vinci's (1452–1519) fleeting presence, discernible in the impressionistic canvases of Giorgione, contributed to a major stylistic revolution in Venetian art.

Foreigners also carried out prestigious state commissions in locations of the greatest civic importance. Paolo Uccello (1396/7–1475) and Castagno (1419/21–57) were involved in mosaic campaigns in San Marco, and Perugino (c. 1445/50–1523) painted for a *scuola grande* and was given a major commission (never completed) for a canvas in the Great Council Hall. The Florentine sculptor Andrea Verrocchio (c. 1435–88) designed the equestrian monument to Bartolomeo Colleoni that stands in the Piazza SS. Giovanni e Paolo.

But nowhere was the traditional Venetian "aesthetic of diversity" more operative than in the heterogeneous origins of those immigrant artists who were born on the mainland and came to stay. Virtually all the great sculptors and architects of the fifteenth and sixteenth century came from elsewhere: Pietro Solari (c. 1435 –1515), who, along with his sons Tullio (c. 1455–1532) and Antonio (c. 1485–1516), took on the surname Lombardo from his homeland in Lombardy, Mauro Codussi (c. 1440–1504) from a village near Bergamo, Jacopo Sansovino (1486–1570) from Florence by way

Opposite

28. ANTONELLO DA MESSINA *Crucifixion*, 1475. Oil on panel, 16$\frac{1}{2}$ x 10" (42 x 25.4 cm). National Gallery, London.

even though they couldn't sell + work w/o a fee to city

of Rome, Michele Sanmicheli (c. 1484–1559) from Verona, Andrea Palladio (1508–80) from Padua, and Alessandro Vittoria (1525–1608) from Trent. The roster of transplanted painters is just as impressive: Giorgione from nearby Castelfranco Veneto, Giambattista Cima (c. 1459–1517/18) from Conegliano, Paolo Caliari (c. 1528–88), better known as Veronese, whose adopted surname acknowledges his birth in Verona, and Titian from the tiny Alpine village of Pieve di Cadore.

The Problem of Authorship

Unlike Florence, where competition was a major engine for progress in the arts, the reigning ethos of artistic production in Venice throughout the quattrocento was cooperation. The contrast can be summed up in two diverse approaches to the decoration of the Great Council Hall in each city. In 1474 the Venetians commissioned Gentile Bellini (c. 1429/30–1507) to begin a campaign ostensibly to "renew," but really to replace a cycle of deteriorating frescoes in the Great Council Hall of the Doge's Palace with new paintings on canvas. Gentile's brother Giovanni soon came in to assist him and eventually took over major responsibility for supervising a team of artists. During the lifetime of the Bellini brothers, Alvise Vivarini (alive in 1457–d. 1504/5) and Carpaccio also completed works on their own for the program, but almost certainly within the characteristic style established by the lead artists.

The founders of the short-lived Florentine republic established in 1494 regarded the institution of the Great Council as one of the secrets of Venice's longevity. Accordingly, the Florentines used Venice's Great Council Hall as a model for their own in the Palazzo Vecchio. However, they handled its decoration in a different, and characteristically Florentine, manner. Leonardo da Vinci and Michelangelo (1475–1564) were each assigned a large space on the walls, under the assumption that the competition would spur them on to produce works of greater originality. That this enterprise failed is eloquent testimony to the Florentines' basic misunderstanding of the importance of consensus in ensuring the domestic tranquillity of the *Serenissima*.

The pervasive emphasis on group identity led to a distinctive approach to authorship and the meaning of an artist's signature in Venice. The curious ramifications of corporate values, leavened with a measure of *campanilismo* – civic parochialism – and a closing of artistic ranks within the guild community against newcomers, can be seen most vividly in two major artistic cam-

Florence tried to unite artists like Venice

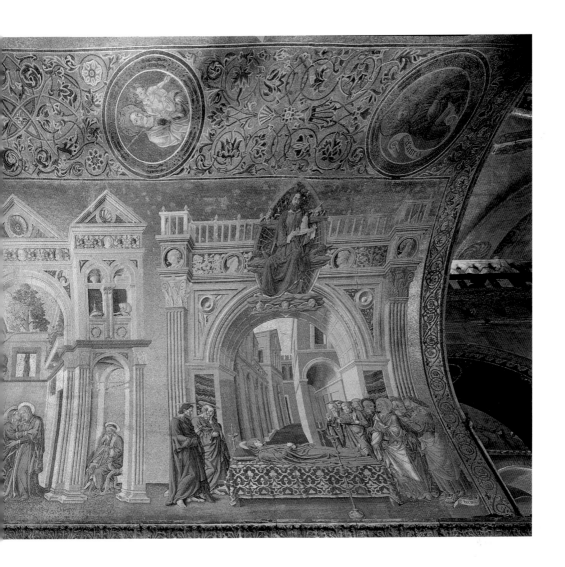

29. ANDREA CASTAGNO,
JACOPO BELLINI, AND
MICHELE GIAMBONO
Visitation and *Dormition
of the Virgin*, completed
c. 1451. Mosaic. Right
vault, Cappella dei Mascoli,
San Marco, Venice.

paigns in the quattrocento. The first example concerns the Cappella dei Mascoli (FIG. 22, page 39, and FIG. 29). Built as an addition to San Marco in 1430 by Doge Francesco Foscari, it was completed around 1451 with a mosaic decoration consisting of five scenes from the life of the Virgin. Beginning with the *Birth* and *Presentation of the Virgin* on the left side of the barrel vault, the sequence continues with the *Annunciation* in the lunette on the end wall and culminates on the right side of the vault with the *Visitation* and *Dormition of the Virgin*. As the eye follows the chronological development of the narrative, it moves from the spatial ambiguities and decorative exuberance of late Gothic palace architecture in the first two scenes to a triumphal arch, austerely classical in style and Renaissance in its rationalized perspective, in

the last. The stylistic discrepancies between the two sides of the vault are powerful testimony against authorship of both by a single artist.

And yet only one name appears in the two inscriptions that are worked into the mosaic background. A *titulus* (inscription) just beneath the *Presentation* documents the participation of the Venetian painter Michele Giambono (active 1420–d. 1462): MICHAEL ZAMBONO VENETUS FECIT. Giambono was one of Venice's foremost exponents of the International Gothic style, a courtly style that evoked a fantasy world of elegant costumes, luxurious textiles, elaborate architecture, genre elements, and engaging anecdotal detail. An art of description, it often featured a high degree of empirical realism, but only in the surfaces and details and not in the rational structuring of a measurable pictorial world. Giambono's responsibility for the scenes on the left-hand side, as well as the *Annunciation*, is completely plausible; but for those on the right it is, for the most part, incredible. Indeed, the bold perspective of the *Dormition* bespeaks a Florentine artist. Most scholars agree that the design is largely the work of Andrea Castagno, who was working on frescoes in the Venetian church of S. Zaccaria for a short time during this period. According to the most likely scenario, he would have returned to Florence leaving the cartoon still incomplete, and Giambono, with the help of a fellow Venetian, Jacopo Bellini (c. 1400–70/71), finished the job. But now this side of the vault would also seem to have called for a statement of authorship, and so Giambono added a scroll in the same Gothic script with the cryptic statement: *fecit* (he made it). While the artist's name may have been lost in a restoration, no further specifics were required. Although the *bottega* (workshop) was mixed, with at least one foreign artist among the locals, responsibility – and, ultimately, authorship – was vested in a Venetian master.

An even more blatant example of the Venetian capacity to appropriate and even to absorb foreign talent is seen in the saga of the equestrian monument to Bartolommeo Colleoni (1400–76; FIG. 30, and see page 47). The wealthy *condottiere* (mercenary captain) from Bergamo who had provided distinguished military service to the Venetian republic left a large bequest in his will for a posthumous monument

30. Andrea Verrocchio and Alessandro Leopardi *Equestrian Monument of Bartolommeo Colleoni,* 1481–88/96. Gilded bronze on a base of Carrara marble, height of statue 12'11½" (4 m). Campo SS. Giovanni e Paolo, Venice.

to be built in Piazza San Marco. Long opposed to honoring an individual in the sacred precincts of the piazza, Venetians were never hesitant to turn problematic riches to local advantage. In an act of linguistic legerdemain, they chose to interpret the designation of the site as the area in front of the Scuola Grande di San Marco in the Campo SS. Giovanni e Paolo.

A competition was held in 1479, and Verrocchio, a favorite of the Medici, submitted a life-size wax model of the horse, sent from Florence in sections. Initially he was awarded the contract for both horse and rider; but then, according to Vasari, his share of the commission was reduced to the horse alone, with the rider given to a Venetian sculptor – a breach of contract which, if true, could only be the result of guild interference. In any event, as Vasari tells it, an enraged Verrocchio smashed the legs and head of his model and decamped to Florence. Persuaded by Venetian authorities to return at double salary to carry out the original commission of both horse and rider, he had completed only a clay model of the pair by the time of his death in 1488. In his will, he asked that his pupil Lorenzo di Credi (c. 1458–1537) be allowed to cast it in bronze. But his ability to bend Venetian custom had evaporated in the grave, and the prestigious task was given to Alessandro Leopardi (active 1482–d. 1522/23), a Venetian whose main experience had been as a bronze-caster in the mint.

Casting the figures in bronze and mounting them on a marble pedestal of his own design, Leopardi signed the work with an inscription on the horse's girth, clearly visible to spectators standing below: *ALEXANDER LEOPARDVS V. F. OPVS*. He was immediately given the nickname Alessandro del Cavallo and, in effect, full credit for the work. Marin Sanudo described the unveiling of the monument in 1496: "And everyone went to see it, and it should be known that the master who made it, called Alessandro Leopardi, Venetus, in addition to the great sum of money that he was paid to complete it by the Council of Ten, was given a pension of 100 ducats a year for life." From that time forward, the artistry of the Florentine sculptor would be subsumed into the fame of the master from the Venetian mint.

Even in ordinary workshop paintings, made for individuals and not the state, original signatures were not necessarily a guarantee of authenticity. Many of Giovanni Bellini's devotional paintings were completed or reproduced by his journeyman helpers who then signed them with the master's name. Conversely, some works that were surely his alone were left unsigned. Other signatures attest to a relationship by naming the actual painter, but defining him as a disciple of the master.

Artistic Dynasties

Collective tendencies and artistic continuity were also served by the long-standing tradition of the family workshop in Venice. These often included in-laws and siblings as well as members of several generations. The usual pattern involved a paterfamilias at the head of the workshop, with his sons participating in the common endeavor. It was only upon their father's death that they would open independent shops. In the fourteenth century, Paolo da Venezia, himself the brother of a painter called Marco, had three painter sons named Luca, Giovannino, and Marco. The first two collaborated with their father on the Pala Feriale, a special painted cover made for the Pala d'Oro in San Marco, as well as on other works. Only Marco, probably the youngest, survives as an independent artistic personality with a single signed altarpiece and a number of attributed paintings. These works suggest, however, that his talents were of a considerably lesser order than his father's.

Sometimes different skills made permanent collaboration across craft lines a viable option. Andrea da Murano (active 1463–1504), a painter, operated a joint workshop over a long and presumably profitable career with his brother Girolamo, a carver of frames. But occasionally, a single family might produce a number of gifted painters, each of whom was fully capable of a successful independent career. Such was the case with the two families who dominated painting in quattrocento Venice: the Vivarini and the Bellini.

Antonio Vivarini of Murano (active c. 1440–d. 1476/84) first worked in a partnership with his brother-in-law, Giovanni d'Alemagna (d. 1450), whose name suggests a German origin. They completed a number of important altarpieces together, including a triptych for the Scuola Grande di S. Maria della Carità (FIG. 31). One of the earliest surviving Venetian paintings on canvas, it is a transitional work. In its unified pictorial field, it is forward looking. The holy figures, joined together in the grouping called a *sacra conversazione*, are set within a convincing three-dimensional space that seems to exist behind the dividers of the frame: Alberti's window to a painted world. But it is backward looking in its inconsistent figure scale and the opulent richness of the decorative apparatus. As if the elaborate architecture and

31. ANTONIO VIVARINI AND GIOVANNI D'ALEMAGNA
Madonna and Child and the Four Fathers of the Church (Jerome, Gregory, Ambrose, and Augustine), 1446. Three canvases, central 11'3½" x 80" (3.4 x 2 m); sides 11'3½" x 54" (3.4 x 1.4 m) each. Gallerie dell'Accademia, Venice.

The *hortus conclusus*, or enclosed garden, was a common metaphor for the Virgin. With the Accademia Galleries now housed in the former premises of the Scuola, the painting remains in the same room for which it was originally intended: the *albergo* (board room), where the officers held their meetings. Although the room contained an altar, the painting seems never to have been placed above it. Titian's *Presentation of the Virgin* (1534–38) was later installed in the same room and is still *in situ*.

32. JACOPO BELLINI
Campo in Front of a Church, c. 1550–55. Ink and silverpoint on re-used trecento parchment, c. 16¼ x 11½" (42.7 x 29 cm). Louvre, Paris.

The artist followed Alberti's rules for one-point linear perspective in laying out the picture space, with his construction lines still visible in the foreground. The horizon line is defined by the floorline of the arcaded building in the background, with the centric or vanishing point located just above the base of the central pier.

luxuriant textiles were not enough, in a final sumptuous flowering of the International Gothic style, the haloes, the ornament on the saints' vestments, and the liturgical implements are built up with *pastiglia* work: a thick chalk paste that is molded, carved and/or tooled with a decorative pattern and then painted and gilded. In this sense, the painting is not a window but a surface.

Upon the death of Giovanni d'Alemagna in 1450, Antonio formed another partnership, this time with his younger brother Bartolomeo (see FIG. 26, page 44). Antonio's talent lived on in his son Alvise, who was a successful painter of the later quattrocento.

The undoubted achievements of the Vivarini family were, however, eclipsed by Jacopo Bellini and his two unusually gifted sons, Gentile and Giovanni. It was Jacopo Bellini who took the first consequential steps to translate the Florentine Renaissance into Venetian dialect. The disjunction between Gothic and Renaissance artistic principles, acknowledged by Antonio Vivarini in an easy, non-problematic way, was seen by Jacopo as an aesthetic challenge. He too had been trained in the International Gothic tradition; his mentor was none less than Gentile da Fabriano (c. 1370–1427), its leading practitioner. And yet he was also exposed early on to the lure of the antique and the revolutionary notions of pictorial realism coming out of Florence and

Padua. In his later years he was further influenced by the singular contributions of his son-in-law Andrea Mantegna (c. 1431– 1506), who had married his daughter Nicolosia. At issue was not conformity to Florentine values, but the creation of a distinctly new Venetian style.

With most of his paintings now lost, including the life-like portraits for which he was renowned, Jacopo Bellini's primary artistic legacy consists of two large books containing 230 drawings (FIGS 32 and 33), a number of them extending across two folios. His wife Anna inherited both albums upon his death and bequeathed them in turn to their son Gentile. When Gentile was sent by the Venetian senate to Constantinople in 1479 to paint the portraits of Sultan Mehmed II and his court, he presented the Ottoman ruler with the album now in the Louvre. He left the other album to his brother Giovanni in his own will of 1507. Later acquired by a Venetian collector, it is now in the British Museum.

Jacopo's albums were only the tangible remains of a larger bequest. Endowed with a fertile and truly original mind, he introduced most of the defining themes of Venetian Renaissance painting: the construction of pictorial narrative, the painting of landscapes and cityscapes in an age of linear perspective, a sensuous response to the human body, the capturing of deeply felt emotion, and a romantic vision of antiquity based upon antiquarian erudition and the pastoral imagination.

The surviving work of Jacopo's two sons suggests that they divided up this aesthetic endowment according to their own very

33. JACOPO BELLINI
Pietà, c. 1460. Gray silverpoint on paper, c. 16$^1/_3$ x 13$^1/_4$" (41.5 x 33.6 cm). British Museum, London.

34. GENTILE BELLINI
Procession in Campo S. Lio, c. 1494. Ink and wash drawing on brown paper, 17$^1/_2$ x 23$^1/_3$" (44.2 x 59.1cm). Uffizi, Florence.

The sketch is a preparatory study supplied by Gentile for the *Miracle at the Bridge of S. Lio*, painted by Giovanni Mansueti. It was part of the cycle of nine narrative paintings depicting the Miracles of the True Cross that was commissioned in the 1490s by the Scuola Grande di S. Giovanni Evangelista.

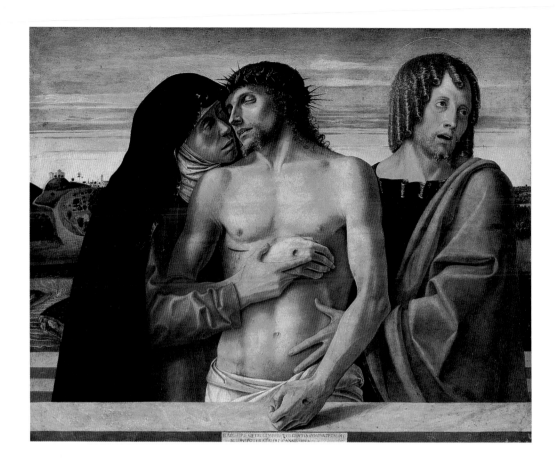

35. GIOVANNI BELLINI
Pietà, c. 1467. Tempera
on panel, 34 x 42″ (86 x
107 cm). Pinacoteca di
Brera, Milan.

Giovanni's early works
show the strong influence
of Mantegna in their
sculptural modeling and
expressive emphasis on
strong emotions.

diverse interests and artistic strengths. Gentile was the city's preeminent exponent of narrative painting in the last decades of the quattrocento. With a taste for complicated architectural constructions and a circumstantial urban scene, he was celebrated as a painter of ceremonies and public life (FIG. 34). Giovanni, by contrast, was drawn to themes of humanity and the natural world in a quest for ideal beauty. In the devotional images for which he was particularly admired, he explored the mysteries of human psychology and spirituality. He sought, as well, in works both sacred and profane, to achieve a harmony between man and nature (FIG. 35).

Family workshops, with lesser lights collaborating with a more gifted relative, or artistic dynasties, with nephews and sons continuing to practice the trade, maintained their importance in Venice throughout the Renaissance period. Jacopo Palma, called il Vecchio (c. 1480–1528), was a leading painter in the early decades of the sixteenth century. His grand-nephew, Palma il Giovane (c. 1548–1628) had a distinguished career at the end of the century

36. TITIAN
Allegory of Time Governed by Prudence, c. 1565. Oil on canvas, 30 x 27" (76.2 x 68.6 cm). National Gallery, London.

The portraits represent the Three Ages of Man. Titian reinforces the metaphor by moving from smooth brushstrokes and full illumination for the young Marco to an impressionistic application of paint for his own portrait, which seems to dissolve into the shadows. The three animal heads symbolize Prudence, a hieroglyph based upon the writings of Macrobius (5th century AD). While the wolf beneath Titian represents the past that devours memory, the lion, strong and fervent, stands for the present which acts, and the dog stands for the future which flatters. An inscription in Latin above the figures completes the allegory: "From the past, the present acts prudently, lest it destroy future action."

and was the artist responsible for completing Titian's *Pietà* (see FIG. 17, page 32). That Titian, himself a brother of a painter, thought of his successors in dynastic terms is suggested by his *Allegory of Time Governed by Prudence* (FIG. 36). In it he portrays himself, along with his son Orazio (1525–76) and young nephew, Marco (1545–1611), who were also painters. After the death of Paolo Veronese, the artist's brother Benedetto Caliari (1538–1598) and sons Carletto (1570–96) and Gabriele (1568–1631) carried on the family tradition and signed their paintings *eredi di Paolo* (heirs of Paolo).

Jacopo Robusti, called Tintoretto (1518–94), had a large family and a busy workshop. His three principal assistants were his sons Domenico (c. 1560–1635) and Marco (died c. 1637), and his daughter Marietta (c. 1556–c. 1590). In his will, Jacopo asked his son Domenico to complete those works still unfinished at the time of his death and ordered that all the drawings, plaster casts, models and other things pertaining to the workshop be kept together in the family business. His daughter Ottavia helped to perpetuate

the enterprise in another way. In her will of 1645 she wrote that she had promised her brothers that she would marry Sebastian Casser, a German employed in the workshop, "if he proved to be an able painter . . ." She further explained, "In this way, by virtue of his talent, the Tintoretto name would be maintained."

The Artist as Individual

Below and opposite above
37 and 38. ZUAN BOLDÙ *Self-Portrait* (obverse) and *Allegory of Death* (reverse), 1458. Bronze, diameter 3¹/₃″ (8.5 cm). Museo Civico Correr, Venice.

By the end of the century most Venetian artists were latinizing their names to give themselves classical roots. Vetor Scarpazza (known to us as Vittore Carpaccio) became Victor Carpathius; Giovanni Bellini signed himself Ioannes Bellinvs; and Lorenzo Lotto was now to be Lavrentivs Lotvs.

While family businesses ensured continuity, they also had the potential of stifling individual creativity. And yet, for all the emphasis on cooperative ventures, Venetian artists were not absent from the debates of the period on the nature of artistic genius. A humanist poet at the court of Ferrara thus addressed a sonnet to Jacopo Bellini in 1441: "How you may exult, Bellino, that what your lucid intellect feels, your industrious hand shapes into rich and unusual form. So that to all others you teach the true way of the divine Apelles and the noble Polycleitus; because if nature made you perfect, that is a gift from heaven and your destiny." Not averse to such notions, Jacopo did not hesitate to add an inscription to a *Madonna and Child* in 1448 that affirmed, HAS DEDIT INGENUA BELINUS MENTE FIGURAS (Bellini produced these forms with his genius).

Ten years later, the medallist Zuan Boldù (active 1454–d. before 1477) used a different medium to express a heightened sense of the artistic self (FIGS 37 and 38). He depicts himself on the obverse of his portrait medallion in a resolutely classical manner, with shoulders heroically nude and curly hair bound with an ivy-leaf wreath. On the reverse of the medal Boldù offers a personal meditation on death and immortality. Now depicting himself as a full-length figure who clutches his head in an attitude of despair, the artist participates in his own allegory. To his right, a winged putto rests on a human skull and holds a flame in his left hand. The putto and skull symbolize the inevitability of physical death, while the flame alludes to the possibility of immortality through the ineffable permanence of fame. The artist confirms not only his identity, but also his proficiency in classical languages – the mark of a good humanistic education – with the same inscription on each side of the medal, on the obverse in Greek, on the reverse in Latin, "Ioannis Boldù, Painter of Venice."

Ten years later again, Giovanni Bellini used the authority of the classics to call attention to his own gifts with a graceful paraphrase from the ancient Roman poet Propertius. Inscribing it on a *cartellino* (or little card) in the Brera *Pietà* (see FIG. 35, page 56), he alludes to the superior ability of the painter to invoke a living presence that would inspire empathy in the spectator: *HAEC FERE QVVM GEMITVS TVRGENTIA LVMINA PROMANT BELLINI POTERAT FLERE IOANNIS OPVS* (When these swelling eyes evoke groans, this very work of Giovanni Bellini could shed tears). That the *cartellino* is itself an artifice – a fictive scrap of paper seemingly pasted to the sarcophagus – suggests also that painting is superior to writing in the imitation of reality.

Bellini was making a *paragone*, a popular intellectual game that Renaissance humanists had picked up from classical texts. It involved an argument over the respective worthiness of two or more arts and most often centered on a comparison of painting with poetry, such as that made by Bellini, or of painting with sculpture.

Just as Boldù had celebrated his humanist credentials with his portrait medal, other artists employed their artistic skills to define their place in the social order. As an officer of the Scuola Grande di S. Marco, Gentile Bellini was able to paint his portrait into his *St. Mark Preaching in Alexandria* along with those of his confraternity brothers without offending the collective mentality (FIG. 39). But he did not hesitate to accouter himself with a red toga as well as the golden chain of knighthood that had been bestowed upon him in 1479 by the Ottoman sultan Mehmed II.

By the end of the century, the humanist Francesco Negro would praise the Bellini brothers: Gentile for his mastery of the theory, and Giovanni for the practice, of painting. Commending the two artists as models of right living, Negro defined painting as a genteel occupation befitting patrician youth: "the remedy for excessive study and no less an approach to virtue and an honorable relaxation of the mind and the body." Such ideas, based upon precedents in classical literature, were commonplaces in humanist writings on art.

For all the praise of the Bellini by poets and humanists, however, the painters remained essentially men of the workshop. Most of their works were made to serve specific functions – political, religious, didactic – in specific sites. With the work of Giovanni

39. GENTILE BELLINI
St. Mark Preaching in Alexandria, 1507 (detail). Oil on canvas, whole work 11′4½″ x 25′3″ (3.5 x 7.7 m).
Pinacoteca di Brera, Milan.

Evidence of a widespread fascination with Egyptian lore, the hieroglyphs on the obelisk directly above the head
of St. Mark are Renaissance inventions. Humanists saw the pictograms not only as a key to the mysteries of the
ancients, but also as a universal language that could express any idea or metaphysical concept, at least to the initiate.

Bellini's pupil Giorgione, however, we find the beginnings of a new genre of cabinet paintings, generally smaller works made solely for the enjoyment of a new category of patron: the art collector. We also find an engagement of the artist himself in literary and philosophical circles. It was Giorgione who provided the visual realization of the Arcadian world that Pietro Bembo (1470–1547) evoked in *Gli Asolani*, a collection of platonic dialogues on love that were set in the countryside near Asolo. According to Vasari, writing some fifty years after the fact, the "gentle and courteous" Giorgione was "always a very amorous man and he was extremely fond of the lute, which he played so beautifully to accompany his own singing that his services were often used at music recitals and social gatherings." Whether or not Vasari's account can be trusted in all its particulars is not the point; for it reveals to us a new romantic view of the artist who is more than just a maker of art, but has now become a personality in his own right.

Giorgione's early death cut short an already legendary career. An artist of surpassing originality, he laid out the parameters of cinquecento painting in Venice, just as Jacopo Bellini had done it for the generation that preceded him. It was, however, Giorgione's successor Titian who would achieve an unprecedented international fame and clientele that rivaled even Michelangelo.

Spanning three-quarters of a century, Titian's career was characterized by a continuous upward trajectory of achievement and success. Named a Count Palatine and Knight of the Golden Spur by the Holy Roman Emperor Charles V in 1533, who also appointed him as his official court artist, Titian was now both a painter and a gentleman. He was also one of the first artists whose reputations would be crafted by the writings of contemporary critics. As such, he came to embody Venetian painting in the great aesthetic debates of the sixteenth century.

Making direct analogies between Titian's brush and his own pen, the writer Pietro Aretino (1492–1556) fired a familiar salvo in the *paragone* debate when he praised Titian's ability to rival nature. But the imitative skill that Aretino saw as a virtue was a threat to the Tuscan conception of painting which valued the intellectual over the sensual. Vasari thus criticized Venetian artists, even Titian whom he grudgingly admired. Their shortcoming lay in their insistence on privileging the sensuous act of *colorito* (the application of colors) over the intellectual process of *buon disegno* (good design: draftsmanship from idea to drawing) as the fundamental component among the three essential constituents of painting: *invenzione, disegno, colorito* (invention, design, coloring). It was

40. Titian's *impresa*, from Battista Pittoni, *Imprese di diversi prencipi, duchi, signori, e d'altri personaggi et huomini letterati et illustri . . . Con alcune stanze del Dolce che dichiarano i motti di esse imprese*, 1568, no. XXXXIII. Private collection.

The verse below the *impresa*, written by Ludovico Dolce, states that art has competed with nature throughout the ages, but that Titian has triumphed over art, genius, and nature.

disegno, Vasari held, that offered the means to elevate art above the order of nature. Measurable, rational, and concrete, *disegno* was also the father of all the arts: painting, architecture, and sculpture.

Taking the Venetian side in what has come to be called the *disegno-colorito* controversy, Ludovico Dolce (1508–68) praised Titian for those very transgressions that had so perturbed Vasari. It was probably Dolce or Aretino who had thought up a personal *impresa* (a heraldic device and motto) for the artist (FIG. 40). It consists of an image of a she-bear licking her cub into shape and the motto: NATURA POTENTIOR ARS (Art more powerful than nature). Referring to a simile applied by classical writers to the poetry of Virgil, the device implied that the bear's offspring were born without form and had to be shaped in this way by their mother. The analogy to the artist, as well as to the poet, was obvious. He too gave form to raw material and, licking it into shape, improved on nature.

A member of the Arte dei Depentori to the end of his life, Titian was still very much a man of business, providing his patrons with products of unassailable quality. His talent, intelligence, and self-confidence gave him more latitude than most of his peers, but it cannot be argued that he engaged in "art for art's sake." In a final self-portrait painted near the end of his life, he summed up the delicate balance of art and craft that had allowed him to transcend the boundaries of caste in an ever more rigid society (FIG. 41). The heavy gold chain of honor bestowed upon him by the emperor is just visible as a subtle statement of rank, but in his hand he holds a brush, the tool of the painter's trade.

Titian's dazzling preeminence should not blind us to the sheer quantity of artistic talent in Venice during the Renaissance period. The making of a visual world is the product of a broad collaboration, knowing and unknowing, between artists of every level of skill, patrons across the economic and social spectrum, and viewers of every quality and condition.

41. Titian
Self-Portrait, c. 1570. Oil on canvas, 34 x 27¼"
(86 x 69 cm). Museo del Prado, Madrid.

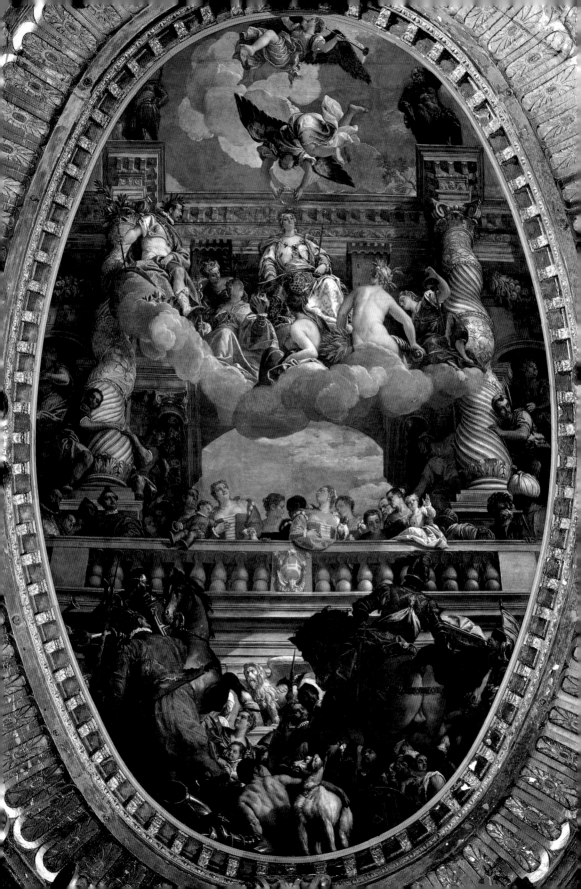

The Art of Public Life

42. PAOLO VERONESE
Triumph of Venice, 1583.
Oil on canvas, 29′8″ x 19′
(9.0 x 5.8 m). Ceiling of the
Great Council Hall, Doge's
Palace, Venice.

One of the most influential
paintings in the Doge's
Palace, the work inspired
numerous copies and
drawings by Baroque artists.
The personification of
Honor is shown with the
features of the French king,
Henry III, in accordance
with the Francophile policies
of Doge Nicolò da Ponte.

The Doge's Palace was a visible expression of the idea of
Venice itself (FIG. 43). In marked contrast to the fortress-
like Palazzo Vecchio in Florence, the Venetian center of
government was designed to be as open and inviting as possi-
ble: the very image of "the city walled by the sea, with open gates
unafraid." Built in the fourteenth century in a Gothic style, the
building featured Islamic and classical elements as well. It thus sit-
uated the republic in deep-rooted historical time and in the expan-
sive geographical space of a great trading nation. The two lower
storeys are defined by graceful arcades: large pointed arches
with sturdy columns on the ground floor and lighter ogival arches
carved with delicate tracery and a quicker rhythm on the tier above.
Appearing to rest lightly atop the two-tiered arcade, the upper
storey – double in height to accommodate the great halls of
state – is pierced with huge windows to let in light and air. The
facade has a Moorish flavor; its masonry of white Istrian limestone
and pink Verona marble is laid in a lozenge pattern, creating a
shimmering effect that seems to dematerialize its substance.

More Perfect than Rome

As befitting the center of a world empire, the Doge's Palace
was lavishly decorated with paintings and sumptuous compart-
mented ceilings. The politically most resonant room was the Great
Council Hall, where all male members of the hereditary patri-
cian order, numbering some 2,500 by the end of the sixteenth cen-

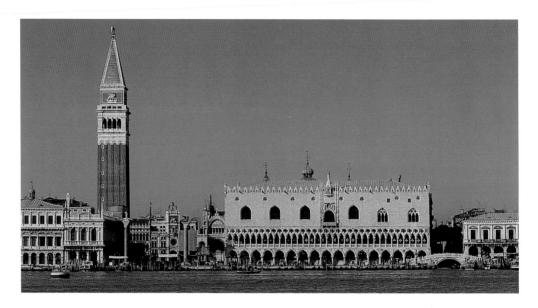

43. View of the Library of St. Mark, the Campanile, the Piazzetta and the Doge's Palace, Venice.

tury, were entitled to attend weekly meetings every Sunday afternoon (FIG. 44). The room extended across the front of the building, and by the mid-sixteenth century its walls were lined with portraits of the doges above a cycle of history paintings by Gentile and Giovanni Bellini, Carpaccio, Titian, and other artists. It was completely gutted by a devastating fire in 1577, but with tragedy came opportunity. Rebuilt on its original plan after the fire, the room was completely redecorated with paintings in an up-to-date style to suit the triumphalist rhetoric of the times.

The newly refurbished room was dominated by Jacopo Tintoretto's *Paradise*, a huge canvas that covered the entire east wall behind the tribunal where the doge sat with his councilors. Veronese had been awarded the commission in a competition, but died in 1588 before beginning the work, and Tintoretto obtained the job by default. The painting was intended to replace a badly burned fresco of the Coronation of the Virgin painted in the fourteenth century by the Paduan artist, Guariento da Arpo (c. 1310 –68/70). In the best tradition of Venetian conservatism, wherein artists were often admonished to "restore" and not to replace works of art, Tintoretto paid his respects to his predecessor. He too included a full panoply of saints and alluded to Venice's holy origins by framing the scene with the Virgin Annunciate and the Archangel Gabriel at the upper corners. But he offered a revision of the earlier work as well. Drawing heavily on Michelangelo's *Last Judgement* in the Sistine Chapel, he abjured the massive throne depicted by Guariento and packed all the hosts of heaven into a great cloudy space that is without measure and depth. He

thus cut them loose from earthly referents and, essentially, brought the kingdom of heaven into the Great Council Hall. At the very top of the angelic hierarchy in the center of the scene, the Virgin – a metaphor of Venice itself – kneels before Christ, illuminated by the radiant glow of his resplendent halo. The holy pair are attended by the Archangel Gabriel, who extends a spray of lilies in a further reference to the Annunciation, and the Archangel Michael, who holds the scales of Justice. Directly below them are the four evangelists – Mark, Luke, Matthew, and John – with saints and prophets filling the rest of the field. The message was clear. In a supreme statement of the grandeur, power, and piety of one of the longest lasting republics in history, all the important decisions of state would be made under the auspices of Christ and the Virgin and with the inspiration of the heavenly hosts.

[handwritten margin note: Religious Idea]

Venetians pointed to their political system as a major source of the longevity and peacefulness which had earned for Venice the name of *Serenissima*. While the Senate conducted the most important matters of state, such as finance, taxation, and foreign affairs, nearly all elections to public office were held in the Great Council (FIG. 45). By the end of the fifteenth century, the diarist Marin Sanudo recorded 831 different posts that were filled by such votes. With many terms of office less than one year, frequent elections offered the opportunity to reward friends and to punish enemies. Indeed, whether or not election to office was considered an honor or a burden often depended upon the personal circumstances of the individual in question. The doge, as the highest officer of state, was elected by the members of the Great Council in a procedure specially designed – with varying degrees of success – to eliminate corruption. By a sequence of alternating lotteries and votes, an electoral college of forty-one men drawn from "the most experienced, worthy and important of the city" was chosen to elect the doge: one of the few positions in government that carried lifetime tenure.

[handwritten margin note: Include in Synthesis Classical Idea like Athens]

The wisdom of such momentous deliberations was further ensured by a program of secular decoration that augmented the *Paradise*. Most costly and most characteristically Venetian was the compartmented ceiling that featured oil paintings enclosed in an armature of elaborate gilded frames of various shapes and sizes. A humanist advisor had worked out an elaborate scheme comprising large allegorical canvases along the central axis and smaller narrative scenes of Venetian deeds at the sides. Veronese's great oval painting of the *Triumph of Venice*, placed directly above the tribunal in front of the *Paradise* was the culminating image of the entire ensemble (FIG. 42, page 65). Following the written

Overleaf
44. JACOPO TINTORETTO *Paradise*, 1588–92. Oil on canvas, 23' x 72'2" (7 x 22 m). Great Council Hall, Doge's Palace, Venice.

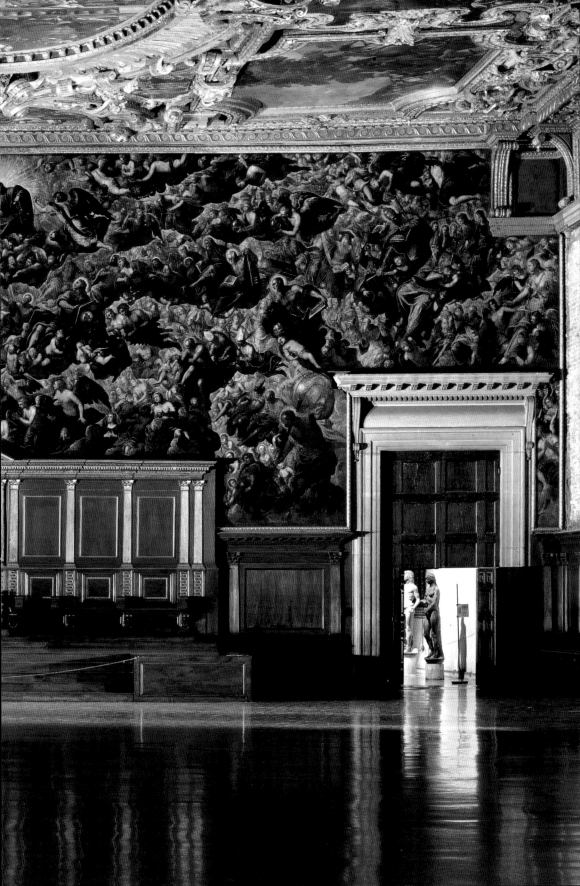

45. JAN GREVEMBROCH
(1731–1807)
*The Voting System in the
Great Council,* from *Varie
Venete Curiosita Sacre e
Profane,* 1755. Watercolor.
Museo Civico Corregr,
Venice.

An elaborate process was
contrived to guard against
broglio, or election
corruption. With the seating
arranged for maximum
visibility from the podium,
nominating committees
were drawn by lot. On the
left, a *ballottino* fills an urn
with as many balls as there
are patricians present: sixty
gilded and the remainder
silver. If the patrician on the
right draws a gold ball, he
proceeds to the next stage
when only thirty-six gold
balls will be drawn. The
resulting pool is separated
into four committees, each
of whom nominate one
candidate for each office to
be voted upon by the Great
Council.

Influence of Humanism and Rome

script quite closely, Veronese depicted the queenly figure of Vene-
tia "residing above towers and cities in imitation of Roma, who
presided over the globe on antique coins." A winged victory prof-
fers a crown, and seven virtues surround her, all clothed in antique
dress. Fame hovers above Victory, while Honor, Peace, Security,
Felicity, Abundance, and Liberty form her court on the cloud below.
Beneath them are "multitudes of celebrating peoples": refugees
of every age and condition who had sought the protection of the
republic and whose homelands were now part of the Venetian empire.

By now a master of illusionistic painting that featured a *dal
sotto in sù* (literally, from below upwards) perspective, Veronese
transcended the sonorous platitudes of the written program to cre-
ate a vision in progress. As the members of the Great Council

looked up at the ceiling from their benches on the pavement below, they could see Venetia and her entourage descending on a cloud directly into the room. With the apparition providing a transition from ideology to political action, art became a powerful mediating device that linked the world of ideas to the world of men.

Veronese also invented a noble setting that demonstrated his preeminent skills in architectural invention. Venetians already knew that their city was superior to Rome. Not only had Venice maintained its liberty for more than a thousand years; it also had no pagan past and had been founded – so they claimed – on the Day of the Annunciation. Their Christianity, therefore, was pure, legitimate, and undefiled. To make the point, Veronese fashioned his architectural fantasy after the big twisted columns in Old St. Peter's in Rome, precious relics that were thought to have come from the Temple of Solomon. In the metaphorical language of Renaissance art, Venice had become not only a more perfect Rome, but the new Jerusalem as well.

[handwritten margin note: Showing Venice is better then Rome]

Emblematic Occasions

The walls of the Great Council Hall provided a commentary on Venice's historical past. Here the republic defined itself in terms of its sovereignty and military strength, and scenes of battles and diplomatic triumphs were prominent (FIG. 46). Before the fire of 1577, the entire space had been devoted to the Peace of Venice, a momentous chain of events in which the Doge Sebastiano Ziani had been host to the Holy Roman Emperor Frederick Barbarossa and Pope Alexander III in 1177 for the signing of a peace treaty. By the fifteenth century, the story – based on a real event – had grown considerably in the telling. In exchange for Venetian protection and military support, the pope had purportedly granted the doge a number of symbolic gifts called *trionfi* (triumphs). These included a white candle as a sign of faith; a sword as a sign of sovereignty and justice; one of a trio of umbrellas, establishing Venetian equivalence to the papacy and the empire; a gold ring as a sign of Venice's marriage to the sea; and a *sedia* or ceremonial throne, silver trumpets, and banners as signs of regal dignity. The *trionfi* became the official ducal insignia and accompanied the doge whenever he went outside the Doge's Palace in processions throughout the year.

After the fire, an abridged version of the cycle was painted on the north wall of the room, while scenes from the Fourth Crusade (1204) and the War of Chioggia (1378-81) were painted on the remaining walls. Little visual evidence survives from the earlier program that had perished in the conflagration. However,

46. JACOPO PALMA IL GIOVANE
Siege of Constantinople, c. 1587. Oil on canvas, 18'10½"
x 20'6" (5.8 x 6.3 m). Great Council Hall, Doge's Palace,
Venice.

The painting celebrates Venice's role in the Fourth Crusade in
1204. Leading the Venetian forces to a profitable victory over
the Christian capital of Byzantium, Doge Enrico Dandolo,
eighty years old and nearly blind, urges on his troops from the
galley in the center of the scene. Although criticized by other
European powers for their role in the dubious enterprise,
Venetians continued to celebrate it as an emblematic event
that marked the republic's rise to empire.

Titian's *Battle of Spoleto*, a skirmish between the papal and the imperial armies, is partly known to us from his own preparatory drawings and several copies by other artists (FIG. 47). Attesting to Titian's achievements as a history painter of great dramatic power, these chance survivals offer a more complete vision of an artist whose greatest surviving works are primarily religious subjects, portraits, and mythologies. Set against the backdrop of a mountainous landscape studded with burning buildings, the action develops with a counter-clockwise movement around a stone bridge spanning the river in the foreground. The emperor's troops, mounted on horseback and wearing contemporary armor, gallop in from the right. Crossing the bridge, they savagely put to rout the papal army, clad in *all'antica* (antique style) armor, who try to hold their ground on the opposite side.

Titian was aware of artistic developments in central Italy and almost certainly gained ideas from the frescoes planned for the Palazzo Vecchio of Florence at the beginning of the century. Michelangelo's cartoon for the *Battle of Cascina* had never been executed, but Titian's rendering of the human body in contorted poses and violent action is good evidence that a copy of it had reached Venice by the 1530s. Likewise, the rearing horses on the bridge suggest an awareness of Leonardo's *Fight for the Standard*. The only part of his *Battle of Anghiari* to be completed, it would have been visible until it was painted over by Vasari in the 1560s.

47. TITIAN
Battle of Spoleto, c. 1537. Black chalk with white highlights and traces of brown wash on blue squared paper, 15 x 17½" (38.3 x 44.6 cm). Louvre, Paris.

The work has also been identified as the *Battle of Cadore.* The early cycle was begun by Gentile and Giovanni Bellini in 1474 as a replacement for a fresco program begun by Guariento in the middle of the fourteenth century.

The Art of Public Life 73

The new abbreviated version of the cycle that was installed in the Great Council Hall in the 1580s after the fire is emblematic of long cherished Venetian attitudes about civic art. In the first place, the twelve paintings that comprise it exhibit a striking stylistic unity, considering the involvement of twelve artists of varying degrees of talent and skill. The traditional Venetian emphasis on consensus and cooperation was clearly operative in the collective workshop. Secondly, in accordance with the documentary status accorded history paintings in Venice – they were often cited as forms of visual proof – the new works almost certainly replicated in a general way the compositions that they replaced. Titian's battle was not one of the subjects that was repeated, but Francesco Bassano's (c. 1540–92) *Consignment of the Sword* (FIG. 48) restored a subject painted by Gentile Bellini in the late fifteenth century. Bassano's composition is strikingly close to Vasari's account of the earlier version of the work. Describing an episode where Doge Sebastiano Ziani is about to lead the Venetian army into battle with the emperor on behalf of the pope, Vasari wrote: "One sees the Pope, standing in pontifical dress, giving the benediction to the Doge, who armed and with many soldiers behind him, prepares to go to the enterprise. Behind this Doge one sees infinite

48. FRANCESCO BASSANO
*Consignment of the Sword
by the Pope to the Doge,*
1584–87. Oil on canvas,
18'4½" x 18'4½" (5.6 x
5.6 m). Great Council Hall,
Doge's Palace, Venice.

gentlemen in a long procession, and in the same part, the Palace and San Marco, drawn in perspective."

Vasari had seen the larger picture, but he may have missed the point. To Venetian eyes, the granting of the sword, an emblem of sovereignty and just rule, would have been the conceptual heart of the scene. Bassano, on his part, embeds the episode within the bustle and circumstance of a festive occasion on the *molo* (waterfront) of the Piazzetta: men in fine dress mingle with artisans and laborers, boatmen maneuver their crafts, a man and a dog are pulled from the water. To the Venetian viewer such details satisfied a taste for the accidental and the trivial. They made the painted scene that much more credible because the ceremony of consignment was, presumably, simply "caught" by the artist in the confusion of life as it happens.

Many paintings in the Doge's Palace represented historical events in purely allegorical terms. Jacopo Palma il Giovane painted the *Allegory of the League of Cambrai* in the Senate Hall to commemorate one of the most perilous moments in Venetian history, when, moved by fear and resentment of Venice's imperialism and ambition, the major European powers had formed an alliance in 1508 to take over her subject cities in the Terraferma

49. JACOPO PALMA IL GIOVANE
Allegory of the League of Cambrai, 1590–95. Oil on canvas, 12'10¾" x 15'2" (3.9 x 4.6 m). Senate Hall, Doge's Palace, Venice.

(FIG. 49). After several humiliating military defeats, the worst of which was the Battle of Agnadello in the following year, Venice lost almost all her mainland possessions. Although Venetian armies regained the captured territories by 1517, the precariousness of the moment – with the very survival of the republic at risk – remained fresh in Venetian memories.

Palma visualizes the story in terms of a direct but elegantly choreographed confrontation. On the left Venetia, flanked by the civic virtues of Peace and Abundance and a combative Lion of St. Mark, brandishes a sword. Doge Leonardo Loredan is a still presence behind them, his arms extended in a gesture of supplication. Europa, astride a bull, attacks from the left, her shield bearing the arms of members of the League: the Emperor Maximilian, the pope, the King of France and the Duke of Milan. As the first city to return to the Venetian fold, Padua is visible in the background, thus signifying the positive outcome of the conflict.

Venice's eventual triumph is made clear by the winged victories who descend from the heavens holding palm fronds and a laurel wreath. It is important to note that they intend to crown the lion and not Doge Loredan. Although the living symbol of the state – and, as such, an intermediary with the divine – a Venetian doge was long on charisma and short on real power.

Primus inter pares

Indeed, it is important to distinguish between the office and the man. The dogeship was a quasi-sacral office, and doges represented something more than themselves as men. In the minds of the patriciate, their elected doge – for all the symbolic importance of his office – was but *primus inter pares* as a man: the first among equals, with the emphasis on the latter word. Accordingly, unlike many absolute monarchs of the time, the doge was hemmed in by a set of rules and obligations. These were set out in the ducal *promissione*, a document specially drawn up at the time of his election. Copies were made for the doge, the ducal chancery and the procurators. To ensure that the doge remained aware of his duties and of the limitations of his prerogatives, the law required that the text be read aloud to him every two months.

Official documents were often decorated with illuminations of considerable originality. A page in the *promissione* of Doge Antonio Grimani, who took office at the age of eighty-seven, shows the doge kneeling before St. Mark to be blessed as he receives from him the *vexillum* or standard of office (FIG. 50). The subject matter would have been familiar to any Venetian, for it had

been a standard image on coins since the Middle Ages. But here the illuminator has inserted it into a context of intriguing spatial ambiguity with a clever play between nature and artifice. A fanciful construction of acanthus scrolls, athletic *putti*, and zoomorphic structural elements creates a stage for the benediction ceremony and frames an aperture through which a convincing Terraferma landscape is visible. Clad in his ducal robes with an ermine cape, the doge wears a linen cap, the *camauro*, on his head and has not yet been crowned with the red velvet *corno* held by the small boy behind him. The doge was given the courtesy title of *il Principe*, and the *corno* was equivalent to a royal crown. Such distinctions were symbolic dignities, but essential for the honor of the republic in the world at large. They asserted the doge's superiority to neighboring heads of state – and his equivalence to the pope, the emperor and other crowned heads of Europe. Grimani, who died less than two years after his coronation, called his sons to his deathbed and asked them to preserve his copy of the *promissione* "for the honor of our house."

Giovanni Bellini captured the hallowed majesty of the dogeship in a portrait of Leonardo Loredan painted shortly after he

50. *Promissione* of Doge Antonio Grimani, 6 July 1521. Illumination on vellum, 12 x 8¼" (30.5 x 22 cm). British Library, London.

51. GIOVANNI BELLINI
Doge Leonardo Loredan,
c. 1501. Oil on panel, 24½
x 17¾" (61.6 x 45.1 cm).
National Gallery, London.

Emphasis on
Self - Humanism

took office (FIG. 51). Using a familiar Venetian formula of the bust-length figure behind a ledge against a clear blue sky, he achieved an exquisite rendering of the exterior man and his dress. A sharp shadow models the thin aristocratic face, and now the *camauro* is covered with a white brocade *corno* that matches the doge's mantle. The sumptuous fabric is woven with a white-on-white pattern worked out in golden thread. The row of large buttons, called *campanoni d'oro* or golden bells, was also part of the ducal costume. Loredan was known for his fastidious dress, and Bellini gives him a dignified presence and even a certain warmth. And yet, for all his meticulous attention to detail, the artist nonetheless disjoins the doge from time and space. The man has become the office, and could as well be the reliquary bust of a saint sitting on a shelf with all the aura of a holy figure.

The doge's role as an intermediary between the Venetian people and the supernatural forces of heaven was given visual definition in the sequence of votive paintings in the Doge's Palace. Each doge was allowed to commission one upon his election. Sometimes these works came dangerously close to extolling the man more than the office, and the patriciate exercised constant vigilance to prevent the former from upstaging the latter. A surviving *modello* or sketch for Veronese's *Votive Painting of Doge Sebastiano Venier*, when compared to the finished work, shows a modification that may have been made in response to such concerns (FIGS 52 and 53). Elected in 1577/78, Venier ordered the painting to commemorate his heroic role as captain general of the Venetian navy in the Battle of Lepanto of 1571. The sea battle, visible in the background of the painting, was an emblematic event of the period and was much celebrated in public art and state propaganda.

After losing Cyprus to the Turks and seeing her maritime empire slipping away, Venice had joined with the pope and the King

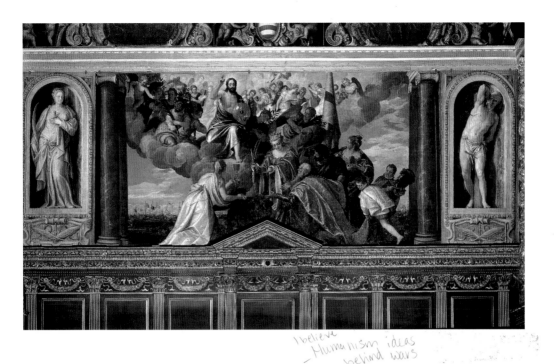

I believe — Humanism ideas behind wars

of Spain in a Holy League to mount a new crusade. In a time of shifting alliances, it was not unusual for former enemies to become allies. The combined Christian forces numbered some forty to fifty thousand men manning 208 galleys, just over half of them commanded by Venetians. The Turkish fleet was of equal strength. When the two forces met in the Gulf of Patras near Lepanto, the Christians raised a crucifix on every galley and fought with crusading zeal. In an extremely bloody fight that was decided in hand-to-hand combat across the decks of all the galleys jammed

52. PAOLO VERONESE *Votive Painting of Doge Sebastiano Venier*, c. 1578. Oil on canvas, 9'3" x 18'8½" (2.8 x 5.7 m). Hall of the Collegio, Doge's Palace, Venice.

The Collegio was the steering committee of the Senate, the major locus of political power in Venice, and set the agenda for that body. The painting is installed directly above the tribunal where the doge sat with his councilors, a group called the Signoria.

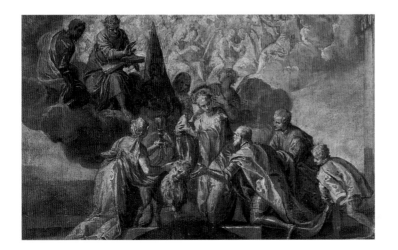

53. PAOLO VERONESE *Modello* for the *Votive Painting of Doge Sebastiano Venier*, c. 1578. Oil sketch in chiaroscuro on prepared red paper, 11¾ x 18½" (29.7 x 47 cm). British Museum, London.

The Art of Public Life 79

together, the Christians lost nine thousand men and the Turks more than three times that number. In the end the victory was really only a symbolic one, for Venice never did regain Cyprus, her last important possession in the Aegean. But symbols are important, for if the Turks had won or the Christians had withdrawn without a fight, no Venetian ship could have sailed the Mediterranean for years to come without being at the mercy of the Turkish fleet.

In Veronese's preparatory drawing for Venier's painting, Venetia is the central focus of the scene. Crowned with a garland of roses, she displays the *corno* to the kneeling doge. His ducal mantle – identifiable as such by the *campanoni d'oro* on the shoulder – is swept back to reveal his battle armor, suggesting that his exploits at Lepanto had earned him the dogeship. To the left, the personification of Christian Faith raises a chalice, bringing it close to the ducal *corno*. St. Mark, accompanied by two figures, sits above her in the clouds and confers his benediction on the group below.

In the finished painting, Venetia, still holding the *corno*, is relegated to a less prominent position behind the doge. Taking her place front and center is a regal St. Giustina, on whose feast-day the battle had been won. Crowned with pearls, she is armed with a sword and the palm of victory. Christ is now brought in to dominate the scene, and St. Mark is transferred from the cloud to a supporting role behind Venier, where he takes his place next to another military hero.

While the drawing had privileged the mortal over the eternal, mystical doge, Veronese's changes give the painting a more universalizing character. By displacing Venetia and St. Mark, he made it less specific to the election of a particular doge. The Lion of St. Mark, however, maintained his pride of place in a central position in both versions. He was a more fluid sign, at once a heraldic animal and a symbol of the abstract concept of the state.

Symbols of State

Venice could be personified in human guise as Venetia, the Virgin, or even as Venus or other female figures, but the Lion of St. Mark – popularly called "our San Marco" – was the oldest and most universal symbol of the republic. Greeting visitors to the city from atop his column on the Piazzetta, he was also its ambassador abroad. In cities throughout the Terraferma and the *stato da mar*, he stood guard on top of columns and graced the city gates and facades of public palaces as a permanent reminder of Venetian dominion. He was also visible at close hand, and on a daily

Influence of humanism Christ w/ human war heros, Venitia herself

Symbols of Humanism

basis, on coins, banners, ducal seals, and official documents and proclamations, both inside and outside Venice.

It is important to remember that the Lion of St. Mark was a multi-valent image and more than just a sign of the republic and its presence. He was also a symbol of its divine destiny and ongoing protection. Carpaccio's *Lion of St. Mark* summed up the larger message (FIG. 54). Equipped with wings and a halo, the lion alludes to St. Mark's continuing protection of the city with one paw on an open book bearing an inscription: *PAX TIBI MARCE EVANGELISTA MEVS* (Peace unto you, Mark my evangelist).

I think so – disagree here
St. Mark depicted as animal/nature ⇒ Humanism?

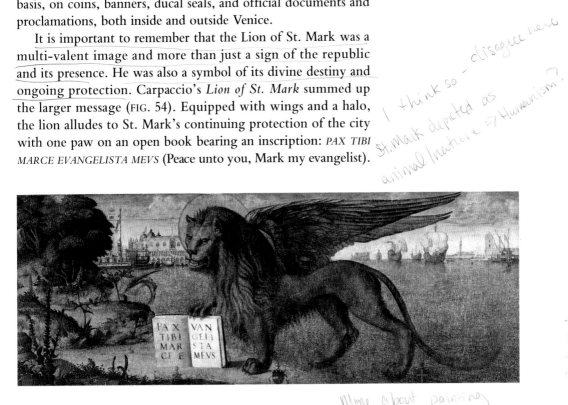

More about painting

According to a legend that dates back to the thirteenth century, these were the very words spoken by an angel to St. Mark himself in an episode called the *praedestinatio*. On this occasion, it was claimed, Mark had received a prophecy that his body would find its final resting place in Venice on the spot where the church of San Marco was to be built. Not only did the story justify Venice's pious theft and possession of the saint's relics, but it also served as proof of the city's holy predestination.

The lion's stance gives visual form to the fulfillment of that promise. With his front paws on the land and rear paws in the water, he symbolizes Venice's dominion over both land and sea. The political and religious center of the city and the source of its justice, piety, and tranquillity – the Doge's Palace, the Campanile, the domes of San Marco, the Torre dell'Orologio – is visible behind him along with the *bucintoro*, the ceremonial barge of the doge. To the right are the great galleys, the source of Venice's wealth and abundance, and the fortress of San Nicolò that guarded the sea entrance to the lagoon.

Justice, as the highest civic virtue, was another symbol of the republic, second in importance only to the Lion of St. Mark.

54. VITTORE CARPACCIO
Lion of St. Mark, 1516. Canvas, 4'6¾" x 12'1" (1.4 x 3.7 m). Doge's Apartments (Sala delle Volte), Doge's Palace, Venice.

Painted in 1516 for the Magistracy of the Treasury, whose offices were located in the Palazzo dei Camerlenghi near the Rialto bridge, the work documents its own provenance, with the coats-of-arms of the five noble officials who commissioned it painted along the lower edge. Commissions of public art by office-holders were acceptable modes of self-aggrandizement in a patriciate of equals.

55. *Venecia-Justice*, mid-14th century. Stone relief. Piazzetta (west) facade of the Doge's Palace, Venice.

It made its first explicit appearance as an emblem of state in a sculpted roundel on the Piazzetta facade of the Doge's Palace above the seventh great column from the southwest corner (FIG. 55). Probably dating from the middle of the fourteenth century, the relief depicts a matron seated on a Solomonic throne of double lions. She holds a sword in her right hand and a scroll in the left bearing an inscription: *FORTIS / IUSTA / TRONO / FURIAS / MARE / SUB PEDE / PONO* (Just and strong, I am enthroned, I vanquish by sea the furies). The furies lying at her feet may be seen as the vices of Pride and Ire and – through an extension of the analogy – as the evils of civil discord and military threat. The female figure could be mistaken for a personification of Justice (and perhaps Fortitude) alone were it not for the inscription above her head – *VENECIA* – and the fact that she holds no scales.

In the early fifteenth century, two full-round sculptures of Justice were installed in even more prominent positions on the building: a standing figure that rises above the roofline and forms the pinnacle of the great balcony of the south facade facing the lagoon; and a seated figure atop the Porta della Carta, the main entrance to the palace complex. The association of the Doge's Palace with the virtues of justice and wisdom was underscored by a sculptural group of the *Judgement of Solomon* on the corner of the building erected to the right of the Porta della Carta in the 1420–30s to house offices involved in the administration of justice.

An even denser multi-layered elaboration of the theme was achieved in the decoration of three bronze flagpole bases cast by the sculptor Alessandro Leopardi and installed in front of the basilica of San Marco in 1505 (FIG. 56). Pietro Contarini, writing around 1541, described the central pedestal:

> The one in the middle shows three ships coming from the high seas. On the stern of the first ship one sees the golden Virgin of the Pole, who having been exiled by the wicked world, has fixed her abode in Venetian waters. In her right hand she has the honored sword, but in the left she holds the head of a convicted traitor. A merman guides her golden vessel; the prow bears the balanced scales.

56. ALESSANDRO LEOPARDI *Astraea-Justice*, 1504. Bronze pedestal in front of the basilica of San Marco on Piazza San Marco.

The Virgin of the Pole is to be identified as Astraea, the goddess of justice, introduced in Virgil's *Aeneid* as the harbinger of a new Golden Age. Two other vessels are included in the cortege that moves around the pedestal. They carry Ceres, "the Mother of the Granaries," who holds a sheaf of wheat and a horn of fruit and represents Abundance, and "happy Victory in a white dress," who holds a palm branch in her right hand and spoils of the enemy in the left.

Astraea, holding a sword and vanquishing a figure of discord, is a graceful metamorphosis of the trecento relief of Venecia as Justice in the roundel on the west wall of the Palazzo Ducale into a conflation of Venetia-Justice-Astraea. But Francesco Sansovino, writing in 1581, made an even more expansive reading, suggesting that all three figures on the pedestal added up to a metaphor for the abstract idea of Venice as the sum of the civic virtues of Justice, Abundance, and Peace.

A City Joyous and Triumphant

Exclaiming on a diplomatic visit in 1495 that Venice "is the most triumphant city that I have ever seen," the French ambassador Philippe de Commynes was particularly impressed by Venetian ceremonial. While every society had its recurring feasts, as well as ceremonies for special occasions, civic ritual in Venice was notable for its exceptional splendor. Spectacle, the most ephemeral of the visual arts, offered a unique opportunity to respond to the needs of a given moment while giving structure to the myth of Venice.

Overleaf
57. GENTILE BELLINI *Procession in the Piazza San Marco*, 1496 (detail). Canvas, whole work 12' x 24' 5¼" (3.7 x 7.5 m). Gallerie dell'Accademia, Venice.

Gentile Bellini's *Procession in the Piazza San Marco* records an event held each year on 25 April, the feast-day of St. Mark (FIG. 57). Commissioned by the Scuola Grande di S. Giovanni Evangelista as part of a cycle of paintings that honored their miracle-working relic of the True Cross, the painting depicts members of the confraternity marching through the Piazza San Marco – the main ceremonial space of the city. Preceded by a choir and an honor guard of marchers holding huge candlesticks called *doppieri*, the relic is carried on a richly decorated platform under a canopy. The painting commemorates the miraculous healing of a child whose father, wearing a red toga, drops to his knees in supplication. He is just visible through a break in the procession to the right of the cross. The manner in which his personal act of devotion is embedded within the context of Venetian ceremonial life is characteristic of the eyewitness style of painting, of which Gentile was a leading exponent in the later years of the fifteenth century.

Significant in itself as a work of art, the painting also gives testimony to civic values. Although pride of place is given to the Scuola Grande di S. Giovanni Evangelista, the canopy is decorated with the coats-of-arms of all the *scuole grandi* of the city. The message is clear: all are included and consensus prevails. The bystanders scattered through the piazza, as well as the spectators who line the procession and fill the windows of palaces on the right-hand side, include young and old, religious and secular, male and female, foreign and local, rich and poor. In short, they mirror the diverse character of the Venetian polity.

The doge is visible at the far right, preceded by groups of standard-bearers and trumpeters and followed by patrician magistrates, with the highest-ranking officials marching closest to the doge. With the order of the procession determined by caste, office, and seniority, the procession gives visible definition to the Venetian constitution. Recurring and well orchestrated, such processions conveyed a reassuring message of order and stability. Indeed the special power of ritual lies in its repetition.

The coronation of a new doge was a ceremonial of a different sort. A happening outside the annual ritual agenda, it was surely inevitable, given the certain mortality of the doge, but it was not predictable. Although here, too, the ceremony was carefully planned according to rigid protocols, it belongs in the category of liminal moments: a time of transformation from one state of being to another.

When a law was passed in 1485 making the coronation of the doge a public event, construction was begun on a great ceremonial staircase in the courtyard of the Doge's Palace (FIG. 58).

58. View of the Scala dei Giganti framed by the Arco Foscari. Doge's Palace, Venice.

Initiated by the architect Antonio Rizzo (active 1465; d. 1499/1500) during the term of Doge Marco Barbarigo, it was essentially completed around eight years later, during the dogeship of Barbarigo's brother Agostino. It came to be called the Scala dei Giganti after Jacopo Sansovino's colossal statues of Mars and Neptune were installed on the top landing in the mid-sixteenth century. The *scala* served as a monumental plinth for the doge, designed to frame and display him in spectacles of state. As Francesco Sansovino later put it: "From the Porta della Carta the staircase looks truly royal, [built] of the whitest marble [and] worked with trophies; standing at the base of the campanile one sees it from top to bottom . . ."

In the ducal coronation ceremony, the staircase was the culminating point of a lengthy ritual. The first phase began when the doge was presented to the citizenry from the porphyry pulpit in San Marco. He then moved to the high altar, where he was invested with the *vexillum* of St. Mark – the mystical source of ducal authority – in a reenactment of the ritual depicted in Antonio Grimani's *promissione* (see FIG. 50, page 77). The second phase took place in Piazza San Marco, where the doge was carried on a platform by sailors from the Arsenal and made a symbolic display of ducal largess by tossing coins into the crowd.

Influence of Classics & Humanism) opposite of Christian Painting in meeting Hall

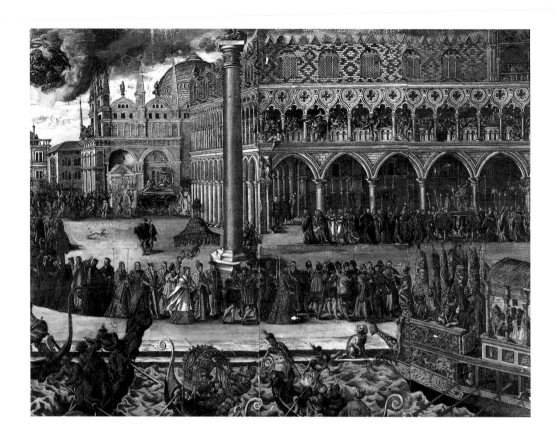

59. JOST AMMAN
The Feast of the Sensa,
c. 1560 (detail). Woodcut
with watercolor, whole
work 21¹/₄″ x 8′5³/₄″ (54 cm
x 2.6 m). Graphische
Sammlung der Staatsgalerie,
Stuttgart.

Finally, he was carried through the Porta della Carta into a shaded passageway toward the shining staircase. After ascending it on foot between a double row of his electors, he reached the top landing and took the oath of office. Swearing to abide by the provisions of the ducal *promissione*, he was crowned with the *camauro* and a costly jeweled *corno*, called the *zoia* – the symbol of supreme political authority. While the ritual clearly posited the source of ducal prerogatives in the patriciate through its electors, once the power was handed over to the doge during his coronation, the top landing of the staircase was transformed from a place of ritual to a place of rule.

Pageantry and civic ritual refreshed the force of political symbols through repeated exposure in public space. The *trionfi*, as the insignia purportedly granted the doge by Pope Alexander III in 1177, were essential components of the ducal procession. They accompanied the doge on those dignified excursions into civic space referred to by the phrase *andar in trionfo* (to go in triumph).

The Feast of the Sensa was depicted in a woodcut by the Flemish artist Jost Amman, probably after a lost original by Titian

(FIG. 59). Held every spring on Ascension Day, the celebration had both religious and secular connotations and was one of the most festive occasions of the ritual calendar. A richly symbolic ritual which reenacted Venice's marriage to the sea, the ceremony had an elaborate script. A gold ring, a ceremonial replica of one of the *trionfi* bestowed upon the Venetian doge by the pope in the Peace of Venice of 1177, played an emblematic role in the event. After attending mass in San Marco, the doge with an entourage of high magistrates and foreign ambassadors processed *in trionfo* to the water's edge in front of the Doge's Palace and boarded the *bucintoro* (the doge's ceremonial barge). Joined by a barge carrying the patriarch, along with other galleys and thousands of private boats, all colorfully festooned, the *bucintoro* was rowed out into the lagoon. When they drew near the church of S. Nicolò di Lido where the lagoon opens into the Adriatic, the patriarch blessed the waters in an ancient ritual of propitiation and emptied a vessel of holy water into the brine. The doge then dropped the gold ring into the sea, reciting a vow, "We espouse thee, O sea, as a sign of true and perpetual dominion."

In Amman's print the doge, clearly visible under the ceremonial umbrella and accompanied by other *trionfi*, makes his stately progress to the water's edge. Preceded by an altar-boy carrying two white candles (according to the legend and the established protocol there should be only one) and two men-at-arms bearing aloft the *sedia*, he is followed by the sword-bearer and a long line of splendidly clad gentlemen. The standard-bearers are already on board as the trumpeters approach the barge. Affixed to the prow is a gilded wood figure of Justice. Religious processions, with *tableaux vivants* carried on platforms, take place in the background while spectators fill the loggia of the Doge's Palace. On the Piazzetta to the left, it is just another day, with shops open for business.

While such spectacles displayed and reinforced the social and political hierarchy, they also provided a means for cohesion through participation in a group activity that transcended distinctions of caste, class, and condition. Pageantry thus gave meaning to the mundane and reaffirmed the sacred bond between the city and her holy protectors.

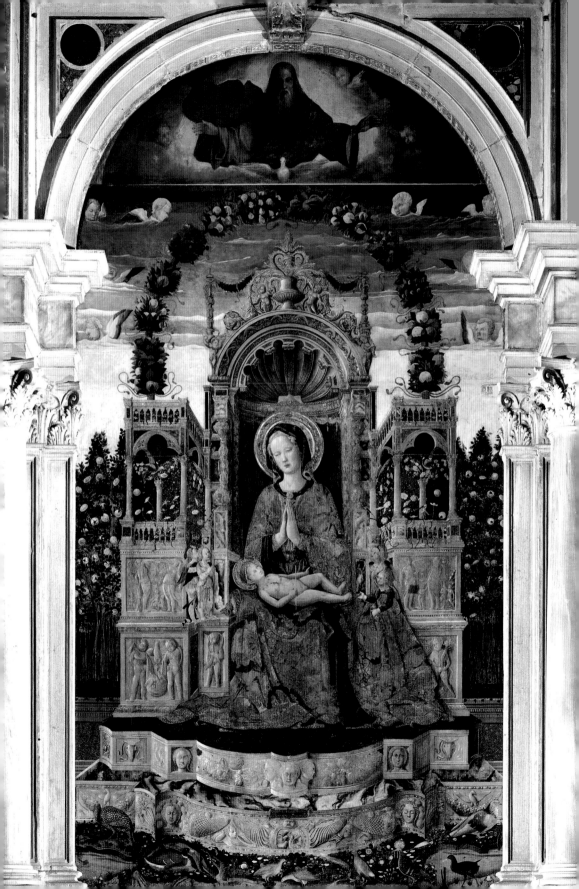

FOUR

A Pious People

T o Venetians, their city was imbued with holiness; they called it *sancta città* (the holy city). God had shown his special grace by allowing a city to be founded and to survive in such an unlikely place. The embarkation point for pilgrimages to the Holy Land, it was described by citizen and stranger alike in terms of its churches and the relics that they held. As the coronation ritual and the decoration of the Doge's Palace attest, the sacred and the profane were inextricably interwoven in every aspect of political life.

Holy Protectors

The painter Bonifazio de' Pitati (c. 1487–1553) summed up the matter with his *God the Father above the Piazza San Marco* (FIG. 61), the central canvas of a triptych that originally included separate canvases of the Angel Gabriel and the Virgin Annunciate at the sides. God the Father and the Dove of the Holy Spirit soar in the heavens above the major monuments of civic government and the state church spread out below, with the great columns of the Piazzetta silhouetted against the lagoon in the background. Significantly, it is not a day of holy feast or political celebration. With shops open and people going about their business in the piazza, it is an ordinary day: life as it should be in a city that enjoys ongoing divine care and attention. Bonifazio had moved to Venice from Verona, but his commissions from government bodies called for him to express a Venetian sense of the past. When still intact with its side panels, his triptych would have presented an even fuller message that referred to Venice's hallowed origins on the day of the Annunciation.

60. FRA ANTONIO FALIER DA NEGROPONTE
Madonna and Child,
1465–67. Tempera on panel, 9'10" x 7'8¹/₂"
(3 x 2.4 m). S. Francesco della Vigna, Venice.

61. BONIFAZIO DE' PITATI (BONIFAZIO VERONESE) *God the Father above the Piazza San Marco*, central panel of a triptych of the *Annunciation*, after 1540. Oil on canvas, 6'2" x 4'4" (1.9 x 1.3 m). Gallerie dell'Accademia, Venice.

The work originally hung in the Palazzo dei Camerlenghi in the offices of the Magistrato degli Imprestidi, the state loan office. During the period 1529–45, Bonifazio made many works for the departments of the state treasury that were located in the building.

My opinion
so did the Humanism

The sacred element in public life was not confined to the ceremonial center of Piazza San Marco. Indeed, it spread throughout the labyrinthine streets of the city in the form of images of the Virgin Mary, the saints, and Christ affixed to the exterior walls of houses, churches, and bridges. Encased in tabernacles, niches, or frames called *capitelli* in Venetian dialect, these could be sculpted figures or reliefs, paintings of modest quality, or even cheap popular prints. Many such images remain today in residential neighborhoods and are a standard feature at docks for *traghetti* – gondolas providing public transport across the Grand Canal. Offering spiritual sustenance to boatmen since the sixteenth century, a handsome (if now eroded) stone relief called *The Madonna of the Gondoliers* is affixed to the Ponte della Paglia, in front of the southeast corner of the Doge's Palace (FIG. 62). The shrine features a tympanum with a figure of God the Father, side pilasters decorated with candelabra, and two gondolas carved in low relief beneath a deeply sculpted tableau of the Madonna and Child. The

62. *The Madonna of the Gondoliers*, 1583. Istrian stone relief, 59 x 31½" (150 x 80 cm). Ponte della Paglia, in front of the southeast corner of the Doge's Palace, Venice.

inscription of dedication states that it was made in 1583 under the auspices of the "Fraglia del Tragheto" – the consortium of gondoliers who operated a ferry service at that location.

The origins of the *capitelli* are unclear. The earliest document to make note of them cites a new law of 1128 declaring that oil lamps that burn through the night should be placed in front of icons at the foot of bridges, in covered passageways, and on street corners that were particularly dark and narrow. Whether the lamps or the images came first is unstated. The German priest Felix Faber offered a pragmatic view of the matter on a visit to Venice in 1483. He wrote:

> It is the custom that on the corners where the narrow streets of the city turn, lamps are hung that remain lit all night; and so that it would not seem that they burn for nothing, they affix in the walls, behind the lamps, some images of the Blessed Virgin, so that (the lamps) would appear to be lit in honor of the Madonna more than for the convenience of the pedestrians.

Whatever their beginnings, the *capitelli* contributed to the common good. Some were held to work miracles, others protected from the plague, yet others warded off the dangers of night. Most were attended to by nearby residents or by a confraternity, who filled the lamps with oil and often honored them with flowers. Thought to inspire reverence and to discourage anti-social behavior, as well as to protect and to comfort, the *capitelli* were officially sanctioned by the state. A law was passed in 1450 providing for additional ones to be installed in each neighborhood where a local patrician would be given the duty of watching over them. Moreover, taxes were to be levied from the citizens of all classes to pay for the oil. Whether they were initially contrived for piety or for utility, these icons created small precincts of the holy, scattered through the public spaces of a city built "more by divine than human will."

Sanctity could reside, as well, in Venice's citizens. Lorenzo Giustiniani (1381–1456), the first patriarch of Venice, was venerated for his asceticism and piety. Gentile Bellini painted his portrait just nine years after his death (FIG. 63). The earliest dated work by the artist and one of the oldest Venetian paintings on canvas to survive, it probably served originally as a processional banner. Now badly damaged by moisture that has effaced much of the background and bled out the color, the work remains, nonetheless, a powerful evocation of a figure who was already considered a saint during his lifetime.

Giustiniani belonged to one of the oldest and most powerful families in Venice. At twenty-one he had turned away from the political career expected of patrician men. After experiencing a vision of the Wisdom of God who appeared to him as "a virgin more splendid than the sun," he joined a congregation of secular canons who lived on an isolated island in the lagoon in the monastery of S. Giorgio in Alga. Spiritual retreat and a life of prayer and study, however, did not mean disengagement from the larger world. In accordance with the strong sense of duty so central to the Venetian aristocratic ethos, Giustiniani sought not only his own spiritual improvement, but also the purification of society. Although he had spurned "the goods of fortune, nobility, magistracies, honors, a wife and children, wealth and pleasures of every other kind," for a life of fasting, vigils, "and every attrition of the flesh," he embraced high ecclesiastical office as a duty and an opportunity. He appeared frequently in front of civil magistrates, spoke out against luxurious feminine attire, and gave counsel – largely accepted as prophetic – on affairs political, moral, and mercantile.

63. GENTILE BELLINI
S. Lorenzo Giustiniani,
1465. Canvas, 7'3" x 5'1"
(2.2 x 1.6 m). Gallerie
del'Accademia, Venice.

The work was recorded
inside the church of
Madonna dell'Orto,
hanging above the main
portal, at the end of the
sixteenth century. When
Venetians were forbidden
to display the Lion of St.
Mark in public places after
the fall of the republic in
1797, they adopted the
effigy of S. Lorenzo
Giustiniani as a civic
emblem.

Depicting Giustiniani in the strict profile that was the stan-
dard format for bust-length portraits of the time, Gentile Bellini
demonstrates the uncompromising realism that earned him a
reputation as the leading portrait painter in the city. But he
goes beyond portraiture and transforms man into icon by por-
traying him full length and flanking him with the figures of
two worshippers. Two angels stand behind him, one holding
the cross and the other the tiara and a maniple – a liturgical
vestment – as insignia of his office. Giustiniani, his right hand raised
in a gesture of blessing, thus becomes a vivid memory image of
unimpeachable spiritual authority.

The painting is faithful to a written description of Giustini-
ani's appearance made by his nephew Bernardo, a historian of note

and an early prime mover in Lorenzo's eventual elevation to saint-hood: a little taller than average, frail, emaciated, with erect posture, and with eyes expressing devotion and sanctity. Although Lorenzo was beatified only in 1524 and would not be recognized as a saint by the church until 1690, Gentile depicts him here with an aura or radiance – indeed, the suggestion of a halo – surrounding his head. He was already to be included in the pantheon of saints who ensured special protection for the city and her inhabitants.

Corporate Spirituality

For many Venetians, spiritual improvement was to be sought not in a life of ascetic renunciation but in the convivial atmosphere of the *scuole*. By the end of the fifteenth century, these confraternities of laypersons numbered in the hundreds and took several forms. The largest category included the *scuole comuni*, devotional groups that typically included both men and women and featured a broadly based membership in terms of occupation, and social and economic class. A significant variant of this type catered to specific national groups. They gave immigrants, a potentially alienated segment of the population, a sense of belonging, a new Venetian identity, and a stake in the fortunes of the city. There were also *scuole* linked to the trade guilds, each accommodating a specific occupation.

Finally there were the wealthy and powerful *scuole grandi*. The first such groups were founded in the thirteenth century when the flagellant movement swept through Italy. Much of the population was caught up in a penitential fervor amidst dire predictions that the end of the world was near at hand. Large bands of people marched from town to town whipping themselves to atone for their sins. When the world did not end, the penitential groups settled down to more practical pursuits and formed permanent organizations that provided devotional, economic, and social support to their members (FIG. 64).

Each of the *scuole* had its rules written out in a bound manuscript called a *mariegola*. An early example, commissioned in the mid-fourteenth century by the Scuola Grande di S. Giovanni Evangelista, has an illuminated frontispiece that reads as a diagram of human salvation (FIG. 65). The imposing figure of

64. Insignia of the Scuola Grande di S. Giovanni Evangelista. Istrian stone, approx. 19³/₄ x 27¹/₂" (50 x 70 cm). Calle de l'Ogio o del Cafetier (San Polo 2474), Venice.

Set into the wall of a house on the street that leads from Campo S. Stin to the meeting house of the *scuola*, the relief marks the confraternity's ownership of the building. The house would probably have been rented to a needy member, *per amor dei*. Many such buildings were left to the *scuole grandi* as testamentary bequests by affluent members or those who died without heirs.

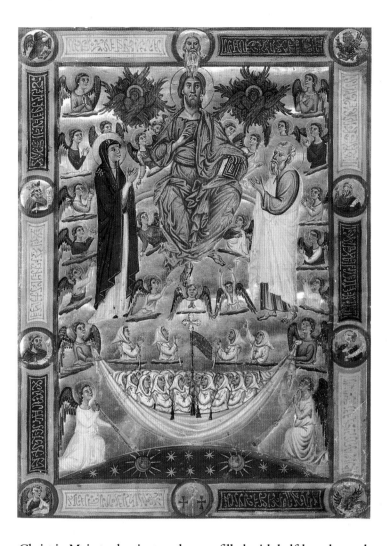

65. *Last Judgement,* frontispiece of the *Mariegola* of the Scuola Grande di S. Giovanni Evangelista, 14th century. Tempera and gold leaf on parchment, 10³/₄ x 7³/₄" (27.3 x 20 cm). The Cleveland Museum of Art.

The Kufic script that decorates the borders of the page is a decorative element that was also used in church decoration in Constantinople.

Christ in Majesty dominates a heaven filled with half-length angels who float as spirit-beings on clouds. With God the Father and the dove of the Holy Spirit directly above his head, Christ is also one element of the Trinity. Flanking him are the Virgin and St. John the Evangelist, the patron saint of the group, who serve as intercessors for the confraternity members below. They wear their hooded processional robes embroidered with a pastoral staff and crosses as insignia of their corporate identity. Two angels in the lower corners kneel on the celestial sphere and blow trumpets to announce the end of time. The *confratelli,* all looking up in supplication, are pulled up into heaven in a great net. The message is transparent: the piety of the group is more powerful than the piety of a single individual. But even within the group there is hierarchy, with the four officers elevated above the rest. Each holds

66. Facade of the Scuola Grande di San Marco, Venice. Begun c. 1487 by Pietro Lombardo and Giovanni Buora; completed 1490–95 by Mauro Codussi.

The photograph was taken by Carlo Naya (1816–82), who ran one of the most famous architectural photography studios in Venice.

a scourge, used in the flagellation ritual, while one points toward Christ and the way to spiritual redemption.

By the end of the fifteenth century, five *scuole grandi* were an important presence in Venetian religious life. The members marched together on feast days, wearing robes and hoods, and performed the ever more symbolic ritual of flagellation to atone for the sins of the entire community. With their large all-male memberships of five to six hundred *confratelli*, and their considerable financial resources, they were – aside from the government itself – probably the most important patrons of art and architecture in the city.

The Scuola Grande di San Marco rebuilt its meeting house at the end of the fifteenth century after an earlier building had been destroyed by fire (FIG. 66). The facade, begun by Pietro Lombardo and Giovanni Buora (before 1450–1513) represents a unique marriage between illusionistic scenography and real architecture. Each of the two doors is flanked by a set of sculpted reliefs: a pair of lions guarding the main portal and scenes from the life of St. Mark at the sides of the entrance to the *albergo* – a board room where the officers met. Employing a perspective construction designed to fool the eye, the reliefs create the *trompe l'oeil* semblance of three-dimensional space. Radically new in concept, they explore a range of spatial relationships and ambiguities.

Mauro Codussi, brought in as head architect when the project was only half-finished, was responsible for the upper zone. Giving the facade a more classical flavor with the pedimented windows of the *piano nobile* (the main storey above the ground floor), he completed the roofline with a row of lunettes, his trademark motif, and – in this case – surely a deliberate echo of the basilica of San Marco. Embellished with intricately carved reliefs, freestanding sculpture, and colored marble inlays, the facade – unapologetically asymmetrical – is more pictorial than architectonic. Indeed, although the facade has a distant ancestor in the Roman triumphal arch, the overall effect is distinctively Venetian. Its closest parallels are to be found in the huge canvases, filled with color and circumstantial detail, that Gentile Bellini, Carpaccio, and other artists painted for the interior spaces of the *scuole*. Its greatest contrasts

can be seen in Alberti's church facades of the later quattrocento: S. Andrea and S. Sebastiano in Mantua, S. Francesco in Rimini and even the richly encrusted marble facade of Santa Maria Novella in Florence. All are conceived in large units with a concern for symmetry, centrality, clear geometry, and rational proportions – the hallmarks of a classical style – and thus achieve a monumentality that is absent in the Scuola.

The Scuola Grande di S. Giovanni Evangelista redecorated its meeting house in the 1490s with a cycle of narrative paintings dedicated to the miracles of the True Cross, a much-venerated relic fragment that the confraternity had owned for just over one hundred years. Vittore Carpaccio, the *scuola* painter par excellence, was responsible for one of the canvases (FIG. 67). It documents the healing of a possessed man in the palace of the Patriarch of Grado

67. VITTORE CARPACCIO *The Healing of the Possessed Man*, 1494. Canvas, 11'11¾" x 12'9" (3.7 x 3.9 m). Gallerie dell'Accademia, Venice.

near the Rialto bridge. The area is bustling with activity, with the sidewalks crowded with merchants and the Grand Canal filled with gondolas. The casual viewer might miss the miraculous event entirely, for it takes place in an upper portico on the left side of the scene. That Carpaccio pushed it to one side, while lavishing his attention on a panoramic view of the Rialto area, is no accident, for he exceeded even Gentile Bellini in his sensitive mastery of the eyewitness style. The scene is intended to look uncontrived, for that is the way that miracles really happened. Had Carpaccio privileged the miracle, positioning it front and center, it might have lost some of its credibility for the practiced eye of the Venetian viewer.

The counterbalanced composition, with the architectural mass on the left offset by the canal scene on the right, required a deft hand. A palette dominated by earth-tone colors is punctuated by bright patches of color, some in the background, that unify a scene full of contingency and circumstantial detail. By making the holy event just one more activity that takes place in the well-known center of Venetian commerce, Carpaccio gives civic space a resonance of the sacred.

While such charismatic objects as the True Cross were often focal points of popular devotion, painted images could also be accorded miraculous powers of healing and protection. *Christ Carrying the Cross*, probably painted by the young Titian, was recorded by the diarist Marin Sanudo on an altar of the church next to the Scuola Grande di S. Rocco in 1520 (FIG. 68): "it has made and makes many miracles, so that every day many people go there; there are many alms with which the Scuola is made most beautiful." Like St. Roch, the titular saint of the *scuola*, the image was associated with protection against the plague.

Among such miracle-working images, the painting is an anomaly. Icons of the Madonna were by far the most common type. Also atypical is Titian's equal attention within the scene to Christ and his tormentor, who are pushed together into direct confrontation by the two bystanders who flank them. But only Christ engages the viewer. Herein lies the image's power; his gaze, a mixture of pathos, resignation, and compassion, evokes empathy and offers strength.

68. TITIAN
Christ Carrying the Cross,
c. 1510. Canvas, 27¹/₂ x 39¹/₂" (70 x 100 cm). Scuola Grande di S. Rocco, Venice.

Once used as a processional banner as well as an altarpiece, the painting is badly abraded. Although some scholars attribute the work to Giorgione, the incisive rendering of the faces, the cropping of the figures, and the absence of an atmospheric quality all point to Titian.

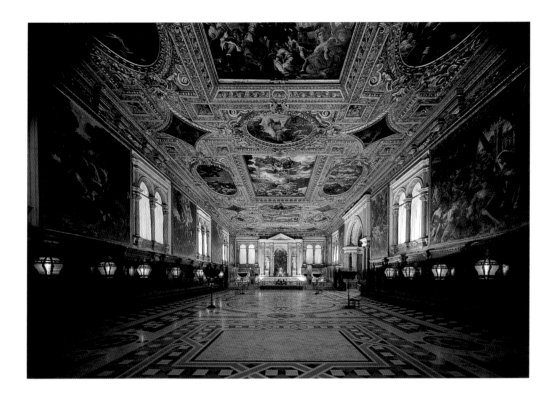

The Splendor of Holiness

Six decades later, in 1581, Francesco Sansovino saw the painting as the basis of the Scuola Grande di S. Rocco's prosperity:

69. View of the Sala Grande of the Scuola Grande di S. Rocco, Venice.

> They made, therefore, the facade of their fraternity all incrusted with the most noble marbles and rich with ornaments, at incredible expense. In which enterprise [they were] helped greatly by an image of Christ painted many years ago by Titian; making diverse miracles, it was patronized with the most ample alms and gifts, not just from all of Venice, but also the surrounding cities. Then having grown through calamitous times of plague (which has often brought trouble to these parts) by means of alms, bequests, and other profits and benefits, [San Rocco] finally became the richest confraternity of all.

By Sansovino's time, Jacopo Tintoretto had completed the sumptuous decoration of the *piano nobile* of the Scuola Grande di S. Rocco with scenes from the Old and New Testaments. They lined the walls and were inserted in heavy gilded compartments on the ceilings (FIG. 69). After painting the first canvas free of charge, Tintoretto joined the *scuola* and promised to devote the rest of his

life to the pictorial embellishment of its meeting house. Delivering three paintings a year on the feast day of St. Roch, he went on to decorate the walls of the ground floor in a campaign that eventually included sixty canvases. The building as a whole can be considered one of the greatest decorative achievements of the entire Renaissance period.

The values implied in Sansovino's statement sit uneasily with the pious and charitable concerns of the *scuole grandi*. Citing the *scuole grandi* as "the best things that Venice has," the Milanese ambassador had written in 1497:

> their revenues are spent in part on decorating the scuole, all of which have elaborate and gilded ceilings, and are now becoming more imposing than ever: their buildings are being embellished with facades of marble and stone of great value. Some of the revenues are spent on the many religious services that they perform continuously, where they dispense innumerable candles; and the balance is spent on helping members of each scuola . . . There are always many infirm among them, who are cared for, fed and clothed, along with their families, until they get well or die.

At issue was the proper way to honor the holy. The impulse to build was sanctioned by the long-standing view that architectural splendor, costly decorations, and elaborate ceremony were considered just as essential for the proper expression of religious devotion as charity and the care of the poor.

Ecclesiastical splendor also had a political dimension. Magnificent churches and lavish meeting houses for the *scuole* were important for the honor – and protection – of the state. The church of S. Maria dei Miracoli is an exquisite example of civic holiness (FIG. 70). Built as a votive chapel to house a particular miracle-working image of the Madonna that was once framed in a *capitello* on a street corner, it was completely financed by public donations. Pietro Lombardo, its architect, was literally given *carte blanche*. Ordered to seek out the finest Greek, Carrara and Veronese marbles, *verde antico* (polished green serpentine or marble) and porphyry, he covered all the wall surfaces, both inside and out. The interior of the raised choir, crowned by a dome, features sumptuous and innovative *all'antica* carving of marble sea creatures by Pietro's son, Tullio Lombardo, and creates a special stage for the miracle-working image on the high altar. The barrel vault above the nave with its elaborate gilded compartments, each containing the bust-length painting of an Old Testament prophet,

was constructed *alla veneziana* – in the Venetian manner. The building has often been justifiably likened to a precious jewel box or reliquary chest – a most appropriate container for the venerated icon that it was built to honor and to protect.

70. View of the nave of S. Maria dei Miracoli, Venice.

71. Paolo Veronese
Marriage Feast at Cana,
1562–63. Oil on canvas,
21'11½" x 32'5¼" (6.7
x 9.9 m). Louvre, Paris.

Among the hundred or so
guests is a group of
Venetian painters posing as
musicians in the central
foreground. Identifiable
from other portraits are
Veronese, dressed in white,
and Tintoretto behind him
to the right, both playing
the *viola da braccio*. Titian,
dressed in red, sits on the
right side of the table,
playing the *viola da gamba*.
Between them the figure
playing the flute has been
associated with Jacopo
Bassano, but the younger
man playing an early
version of the violin is
unidentified.

Simple stories could also be set by painters in splendid settings. The Benedictine monastery of S. Giorgio Maggiore was one of the richest in Venice when Paolo Veronese was commissioned to decorate the end wall of its refectory. The monks of S. Giorgio would have been aware of the artist's huge pageant-like scenes of historical, allegorical, and biblical subjects and were thus opting for a splendid display. Indeed, although refectories, as monastic dining rooms, typically featured paintings of the Last Supper, Veronese and his patrons responded to the Venetian taste for spectacle and chose the altogether more festive theme of the *Marriage Feast at Cana* (FIG. 71). Like many of Veronese's works, the painting has a theatrical quality. The architecture is of a noble classical style, with a Doric order in the foreground and a Corinthian order behind. But although the composition seems to promise a view into deep space, it is effectively closed off by the balustrade that cuts across the canvas and defines a stage in the foreground that is packed with wedding guests. In a densely articulated narrative mode, analogous to the eyewitness style of about fifty years earlier, here too the main event is embedded in a profusion of seemingly trivial detail. In fact, nineteenth (and even twentieth) century critics called the *Marriage Feast at Cana* indecorous, complaining that it had too many figures and too many distractions. Indeed, they argued, the religious message simply got swallowed up in all that opulence and splendor.

But this kind of criticism misses the point. Although the bride and groom are relegated to an inconspicuous location on the far left, Christ, whose miraculous transformation of water into wine is being celebrated in the painting, is placed in the center, just like in Leonardo's *Last Supper*. Here again, he is both the quiet observer and the effective agent of the miracle.

Directly in front of Christ on a table surrounded by a group of musicians is an hourglass. It symbolizes music as measured time and suggests that the hour has come. On the balcony behind Christ, butchers are cutting up meat with cleavers. Taken together, the two contrasting activities define the central axis and probably allude to Christ's coming sacrifice.

One of the notable features of this work is the great mixture of costumes: Turkish, contemporary Venetian, antique. Expanders of time and of space, they broaden the geographical and chronological context of the event and help to draw the scene right into the present. So opulence has a purpose here. To Venetian eyes it would not have trivialized a religious mystery. Rather it ennobled it and imbued it with a meaning that was both timeless and also specific to the times.

The Face of Poverty

During the Counter-Reformation period, the debate on splendor versus charity had heightened, and many of the *scuole* were sharply criticized for their luxurious tastes. Aside from the growing gap between rich and poor with ever greater disparities of wealth, class lines had become more firmly drawn. Emphasizing assistance to the deserving poor and punishment of the able-bodied who chose to "practice the trades of the beggar and the cheat," the Venetian Senate passed a comprehensive poor law in 1529:

> Charity is, without any doubt, to be considered the most important form of good work, and it must always be practiced towards our neighbors. As is everyone's duty, we must look to the interests of the poor and the health of the sick and offer food to the hungry; and never should we fail to extend our aid and favour to those who can earn their bread by the sweat of their brow.

The debate is reflected in the visual arts, but not always in a straightforward manner. In many of his New Testament scenes for the

72. Tintoretto
Annunciation, 1583–87.
Oil on canvas, 13'10" x 17'10½" (4.2 x 5.5 m).
Scuola Grande di S. Rocco, Venice.

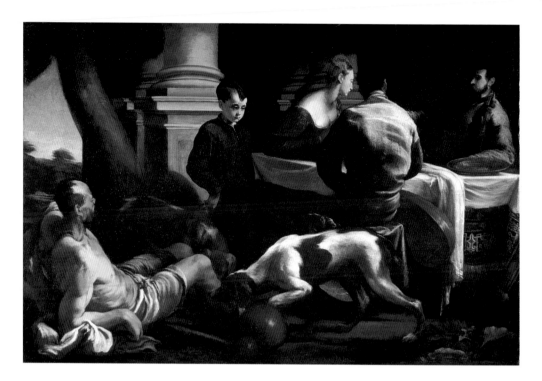

73. Jacopo Bassano
Lazarus and the Rich Man,
c. 1554. Oil on canvas,
4'9"½ x 7'4" (1.46 x 2.23 m).
The Cleveland Museum of Art.

Scuola Grande di S. Rocco, Tintoretto displayed a pronounced ambivalence. In the *Annunciation*, Mary sits in a room furnished with an elegant canopied bed and a gilded compartmented ceiling (FIG. 72). Its wall is dilapidated, nonetheless, with brick masonry that is awkwardly patched with mortar augmenting part of a classical column base. Inside the room, a fraying straw-bottomed chair shows unmistakable signs of age. At once splendid and humble, the setting recalls Christ's modest origins, suggests the passage of time, and documents the end of classical civilization.

A disjunction of a different sort is seen in Jacopo Bassano's (c. 1515–92) *Lazarus and the Rich Man* (FIG. 73). Here the artist depicts a parable from the Gospel of St. Luke (16:19–31), often cited by preachers to make the point that the poor will receive their reward in heaven, while the rich will pay dearly for their wealth. Dives, the rich man, dressed in fine clothes and feasted magnificently every day, while a poor leper named Lazarus lay starving – and ignored – at his gate. Dogs would come and lick the man's sores. When he died, angels carried him directly into Abraham's embrace in heaven. Dives, by contrast, was consigned to the eternal torments of Hades.

In Bassano's painting, the scene is set in an elegant loggia constructed with heavy classical columns. Dives sits at a table covered with an oriental carpet and a fine linen cloth and holds a golden

plate in his hand. He is joined by a musician and a beautiful woman – probably a courtesan – who is dressed in a low-cut gown of red velvet that reveals a generous expanse of snowy white skin. Lazarus, clad in rags, lies on the ground hoping for crumbs. Literally unseen by the convivial group at the table and ignored even by a young servant boy in the foreground, he is acknowledged only by the dogs.

What was the purpose of works such as this? They were surely commissioned by the rich to hang in their homes as a permanent reminder of their obligations to the poor. But there is a tension here between the moralizing message and the manner in which it is depicted. The luxurious lifestyle is presented in an unambiguously attractive manner. The poor beggar is simply one more trapping of that lifestyle, emphasizing it by contrast, but in an unthreatening way. Most significantly, any reference to Dives's unfortunate destiny is excluded altogether. Such a painting offers a means to avoid dealing directly with a social problem by "aestheticizing" it and incorporating it unproblematically within a world of leisure and privilege. Art could thus serve once more as a mediating factor, helping to bridge the gap between religious values and secular aspirations.

The Lure of the Antique

By subsuming artifacts and reminiscences of the pagan world into Christian imagery, art also reflected changing attitudes toward the ancient past. Venetian painters of the fifteenth century participated in the revival of antiquity with responses that ranged from the romantic to the archaeological. A painter from one of Venice's Aegean possessions, Fra Antonio Falier da Negroponte (active 1450–60s), encountered the classicizing inventions of Jacopo Bellini, Mantegna, and Donatello with a particularly receptive eye and open mind. He worked for a time in Venice, where he produced only one work that can be attributed to him with any certainty: an altarpiece notable for its uncritical embrace of the imagery of the ancient world (FIG. 60, page 91).

Fra Antonio, though a Franciscan friar, had a fine eye for fashion, clothing the Madonna in a cloak of costly Venetian brocade trimmed with pearls. She is seated on an elaborate throne in a paradise garden, abundant with fruit trees, small birds, and flowering shrubs. While the environment of flora and fauna can be associated with the traditional International-style iconography of Gentile da Fabriano and Pisanello (c. 1395–1445/6), the scene is enriched with new citations of a fanciful antiquarian character.

The throne, though Gothic in conception, is decorated with exuberantly classicizing, but patently unclassical, reliefs of portrait busts, cornucopiae, *bucrania* (ox skulls), playful *putti,* and Hellenistic looking figures wearing filmy garments *all'antica* (in the antique style). The central lobe of the throne base is adorned with the *tricipitium* – a grouping of three heads that appeared in a number of architectural settings in Venice as a late antique symbol of prudence (see also FIG. 36, page 57). Presumably untroubled by the theological implications of his wholesale appropriation of pagan imagery for Christian purposes, Fra Antonio may well have been influenced by the architectural fantasies of Jacopo Bellini. He too did not hesitate to apply a classical decorative vocabulary to Gothic buildings. It is also important to remember that although Renaissance humanism was concerned with pagan accomplishments, it was not anti-religious. The aim was to augment, and not to replace, Christian teachings with the inspired wisdom of the ancient world – a syncretic approach that extended into art as well.

74. CIMA DA CONEGLIANO *Madonna and Child with SS. Michael and Andrew,* c. 1496–98. Panel, 6′4¹/₂″ x 4′4¹/₄″ (1.9 x 1.3 m). Galleria Nazionale, Parma.

Cima da Conegliano, a painter from a Veneto town north of Venice that was part of the Venetian Terraferma and cultural milieu, represented the next generation of gifted immigrants. He approached the classical world with a greater sense of decorum. In an altarpiece in Parma, he places the Madonna on the crumbling doorstep of a ruinous classical building (FIG. 74). Once splendidly adorned with pilasters carved with *grotteschi*, a marble revetment, and monumental columns, it is counterbalanced by the view of a hill town, identifiable as the *castello* of Conegliano. The landscape was thus relevant to the artist and not to its original placement in the Franciscan Observant church of SS. Annunziata in Parma. Saints Michael and Andrew, however, would have been specific to the patron as intercessors both spiritual and visual between the worshipper and the Virgin and Child.

The asymmetrical scheme, later to become a distinctively Venetian format for altarpieces, was still a novelty at the time. Her lower body positioned toward the left and her torso twisted and tilted to the right, the Virgin is the focus and facilitator of the composition – the link between the architecture in the foreground and the deep landscape vista behind. Unlike Fra Antonio's ingenuous pastiche, Cima's painting preaches a moralizing sermon. The pagan ruins mark the end of the old order; the Madonna and Child, with the saints and the hill town, signal the advent of the new. The crystalline atmosphere, meticulous detail, and fine finish make the work a culminating statement of quattrocento empiricism.

With Sebastiano del Piombo's (c. 1485–1547) *Judgement of Solomon*, the Venetian viewer was brought into a living classical world (FIG. 75). Unlike Fra Antonio or even Cima, Sebastiano reveals a new archaeological exactitude and a sense of historical consistency. Appropriately, the setting for the scene of judgement is a basilica, the ancient site of Roman justice. The double-aisled, arcaded interior, with a golden half-dome above the throne, is constructed with the Corinthian order of architecture in a late antique style. Sebastiano turns the centralized composition of the *sacra conversazione* – the holy figure flanked by saints – to narrative purposes and achieves Albertian rationalism, dynamism, and a rigorous clarity. But although the perspectival system was care-

75. SEBASTIANO DEL PIOMBO *Judgement of Solomon*, begun c. 1508–09. Canvas, 6'10" x 10'4" (2.1 x 3.2 m). The National Trust, Kingston Lacy, Dorset.

Infra-red photographs reveal two earlier versions of the composition, one with a horseman. Venetian painters in this period frequently worked out their compositions on the canvas itself, in contrast to Florentine practice which called for a well-formulated preparatory design.

fully planned, with the receding and lateral lines of the pavement incised in the gesso (white gypsum) ground, the work was never completed: the babies are missing, the executioner lacks his sword, and passages throughout the work still reveal their underpainting. And yet the story is told through the gestures. Even though something is clearly missing, the viewer has no problem in imagining the as yet unpainted children. The raised arm of the executioner, about to deliver a sword blow, implies the body of a living child beneath it. The true mother, standing behind him, holds her hand to her heart in artless sincerity. With her head tilted to one side and a facial expression bespeaking tenderness and a lack of guile, she represents a new canon of female beauty that appeared in Venetian art in this period: ample curves, soft skin, and a gentle sensuality. The false mother, by contrast, bends forward in an awkward pose that has the forced, insistent quality of one who does not have the reassurance of truth on her side. With her back to the viewer and her shadowed face visible only in partial profile, she appears to be less than candid as she points to the spot where her dead baby would have been painted.

The protagonists are not wholly of the ancient world, for the two mothers and the youth on the right are all clothed in modern Venetian dress. And yet, such is the structural coherence of the scene that one is not aware of the temporal disjunction. Sebastiano moved permanently to Rome in 1511 – probably the reason for the unfinished state of the painting – but already his work has a quality of *romanitas*, with an underlying geometry, weighty figures and a grand rhetorical style.

76. GIOVANNI BELLINI *Madonna of the Little Trees*, 1487. Panel, 29 x 22³/₄″ (74 x 58 cm). Gallerie dell'Accademia, Venice.

Nature and Transcendence

The natural world, particularly the verdant landscapes that were so poignantly absent from lagoon life, was another special concern of Venetian painters. Already in the thirteenth century, Franciscan teachings were making people aware of the spiritual qualities of nature. Such views were brought to artistic fruition in the paintings of Giovanni Bellini. Even in his small devotional paintings, such as the *Madonna of the Little Trees*, the landscape background is more than just a set-

ting (FIG. 76). The two small trees that flank the Virgin are prominent enough to suggest a symbolic meaning – perhaps standing for the Old and New Testaments. Behind them the peaks of the lower Alps dissolve in the haze of the afternoon sun. The same light falls on the Virgin and Christ, placing them in the world of the beholder. And yet, Bellini creates for them a privileged space within that world through the use of a favorite formula: the parapet that links and separates that space from our own; and the cloth of honor that demarcates it from the background. But there are countertendencies that provide a delicate balance between distance and approach. For example, the cloth hanging, of green moiré bordered in red, creates a chromatic bridge between the Madonna's gown and

77. LORENZO LOTTO
St. Jerome in the Wilderness, 1506. Oil on panel, 19 x 15¼" (48 x 40 cm). Louvre, Paris.

the fields that stretch out behind her. Furthermore, while the mother's attention is focused on her child, he looks out at the viewer from the protective embrace of her hands. By bringing the holy figures down to earth, Bellini imbues the natural surroundings with an aura of the sacred.

Bellini's landscape remains essentially a separate realm; while the viewer is involved in it visually, the painted figures are not really part of it physically. Inevitably, Bellini sought ways to create a rational painted landscape into which the human figure is convincingly integrated. His painting of St. Francis in the Frick Collection in New York was a forerunner of a long line of pastoral paintings of religious themes, such as Lorenzo Lotto's *St. Jerome in the Wilderness* (FIG. 77). Here, the saint is an important presence in the scene, but his participation is of a quiet, retiring sort. Surrounded by huge boulders and wooded crags, he is embraced by a wilderness that is no longer simply a backdrop. Rather, it has an independent reality of its own. As Jerome averts his gaze from the beholder and withdraws into that reality, his left arm – indeed, his body – forms a diagonal that almost parallels the rock formation behind him, and his drapery plays against the edge of the outcropping on which he rests.

78. TINTORETTO
St. Mary of Egypt in Meditation, 1583–87.
Oil on canvas, 13'11¹/₃"
x 6'11" (4.3 x 2.1 m).
Pianterreno, Scuola di S. Rocco, Venice.

The painting is located at the end of the right-hand wall of the hall, opposite a pendant painting of Mary Magdalene. Also a reformed prostitute and a model of the penitent sinner, Mary of Egypt experienced a sudden conversion on a visit to Jerusalem. She retired to the desert beyond the River Jordan with three loaves of bread and lived there alone for many years in penitence and prayer.

The image of the penitent St. Jerome in a wilderness set-
ting had a long pedigree, with the earliest paintings of the theme
appearing around the beginning of the fifteenth century. These
were seen as metaphors of atonement, of the triumph of the spirit
over the flesh, and of the virtue of separation from the world
and worldly concerns. Jerome had written of his meditations on
the passion of Christ, "Whenever I found a deep valley or rough
mountainside or rocky precipice, I made it my place of prayer and
of torture for my unhappy flesh." The image was particularly pop-
ular in Veneto painting as an aid to private devotion. The settings
ranged from arid desert landscapes to rocky habitats abutting ver-
dant fields and walled towns to inhospitable forests like that in
Lotto's panel.

The untamed quality of Lotto's landscape suggests the influ-
ence of northern – particularly German – art, but the use of
light and color as major unifying agents shows the mark of Bellini.
All the colors of the foreground are picked up in the twilight
sky in the distance: the rosy hues of Jerome's drapery, the glow of
sunlight on rock faces, the chiaroscuro effects of shadowy recesses
and silhouetted branches. In works such as this, Venetian artists
were beginning to capture the flux and flow of nature – a concern
that had first been explored in a consequential way by Leonardo
da Vinci.

And yet, can the artist truly realize the ungraspable, tran-
sient quality of a Venetian sunset: neither daytime nor night-time,
but something of both? And can he charge a landscape with a spir-
itualized sense of religious ecstasy? Tintoretto attempted to do
so in his *St. Mary of Egypt in Meditation* (FIG. 78), painted for
the Scuola di S. Rocco nearly seventy-five years after Lotto finished
his *St. Jerome*. It is a new spiritual world in which the Catholic
Church has withstood the challenge of the Protestant Reforma-
tion by emphasizing a more intense emotional relationship with
God. Applying white oil paint on a dark ground in thick impasto,
Tintoretto creates a magical environment, illuminated by sil-
very moonlight, that is not quite of this world, with shimmer-
ing trees, sparkling water, and luminous reflections. In so doing,
he seeks not so much to embed the figure in a natural environment
as to create a landscape of transcendence through the pulsating
and kinetic effect of light. He thereby sanctifies nature itself and
elevates it to a new, poetic level of spirituality.

FIVE

Private Worlds

T he public domains of church and state were surrounded
by a multitude of private worlds. Indeed, the Venetian
family defined itself and its place in the city by its palace,
whether situated on the prestigious Grand Canal, on a *campo* in
front of a parish church, or on one of the small waterways that
wove the urban mass together into an integral whole. Perhaps it
was the strong commitment to consensus amongst the patrici-
ate, along with a cherished fiction of equality, that discouraged
the use of the word *palazzo* to describe these homes in the early
period. For Venetians abbreviated the word *casa* to *ca'* and called
them simply "houses."

With Venice's wealth coming from her trading activities,
the great fortunes were built by merchants who ran their busi-
nesses out of their homes. Many Venetian palaces thus served two
essential roles – home and office – which blurred the distinction
between the public and the private. This dual function, reinforced
by the conservative tendencies of a mercantile society, meant that
the basic structure of the Venetian *casa-fondaco* stayed much the
same from the twelfth century on.

It is in the window shapes of the *piano nobile* that the stylis-
tic evolution from Veneto-Byzantine to Roman Renaissance can
be documented: round-topped but narrow openings in the twelfth
and thirteenth centuries; pointed – sometimes trefoil – and often
with an ogival reverse curve profile, in the Gothic period of the
fourteenth and fifteenth centuries; and a revival of Roman clas-
sical forms in the later fifteenth and early sixteenth centuries, with
a return to round-topped apertures, but now with a wider radius,
and the introduction of pedimented window frames.

Because the palaces had to be built on deep pilings, they were
essentially columnar structures. In consequence, they could have
many openings, and the generous number of windows and open

79. VITTORE CARPACCIO
Dream of St. Ursula, 1495.
Canvas, 9' x 8'9" (2.7 x
2.7 m). Gallerie
dell'Accademia, Venice.

Elegant beds like St.
Ursula's, made of iron with
a cloth canopy and a base
of painted chests used for
storage, were frequently
cited in estate inventories.

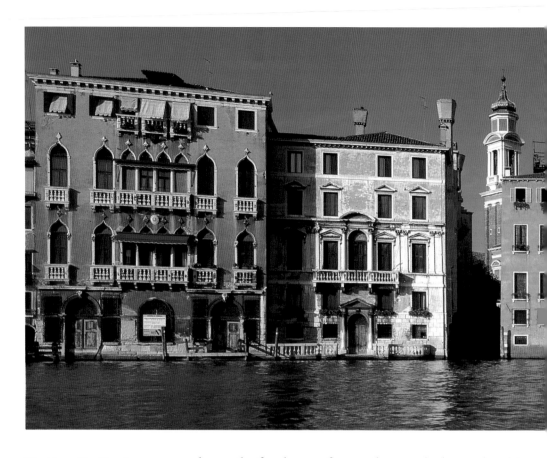

80. View of the Grand Canal from the Pescheria. The palaces, from left to right, are: Palazzo Michiel del Brusà (16th century; rebuilt 1774 after a fire); Palazzo Mangilli-Valmarana (18th century); Casa Zago (17th–18th century); Ca' da Mosto (11th–13th century); and the Ca' Dolfin (14th–15th century), Palazzetto Dolfin (15th century); and Palazzo Bollani Erizzo (16th century).

arcades on the facades was frequently remarked upon by visitors. Surrounded by water and a water-laden atmosphere that refracts and reflects the light in manifold ways, a row of Venetian facades provides an eclectic, but harmonious, sequence of period stage-sets for an ever-changing urban spectacle (FIG. 80).

A Noble Facade

Utilitarian purposes did not thwart the Venetian propensity for the figurative and the colorful, and facades were enhanced by sculpture and painted decoration which produced a picturesque chromatic effect. Analogues to the spoils of conquest set into the walls of San Marco, Veneto-Byzantine sculpted reliefs were a favored element of facade decoration on the thirteenth-century palace. These plaques took two basic forms: a tondo or circular shape and a tall round-headed rectangle, that were called, respectively, *patere* and *formelle*. Ca' da Mosto features a typical arrangement, with reliefs set into the spandrels between and above the windows of the *piano nobile* on the facade (FIG. 81). The plaques depicted subjects

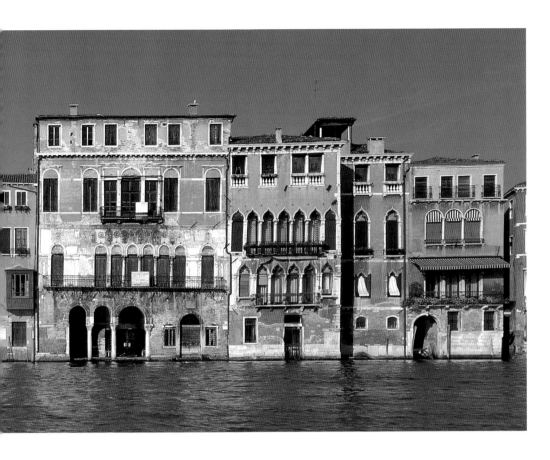

81. JOHN RUSKIN
Ca' da Mosto, 1852. Pencil and watercolor, 13¹/₂ x 19"
(34 x 48.2 cm).
Birmingham City Museum and Art Gallery.

Ruskin wrote *The Stones of Venice* (1851–53) in praise of Venetian Gothic architecture. Deploring the neglect and ruinous condition of the earlier buildings, he made numerous sketches and wash drawings to record them for posterity. He annotated this drawing: "Two beautiful birds and an animal eating another, Broken and stained plaster."

ranging from the purely ornamental – plant motifs, birds, animals – to the quasi-magical. The latter category included positive symbols such as Hercules and icons of Christ, as well as metaphors of virtue triumphing over evil – for example, an eagle killing a hare or a snake. But there were also negative signs: demons, fighting animals, centaurs, and sirens. Such images probably had an apotropaic function: if symbols of evil, they could ward off enemies and prevent misfortune from entering the house; if symbols of good, they could protect the family within. No longer in fashion in the sixteenth century, *patere* and *formelle* still formed part of the palimpsest of the urban fabric. Some remaining in place and others migrating to walls of churches or interior courtyards, they retained their symbolic power, with new readings given in response to current circumstance. In 1509, Doge Leonardo Loredan thus interpreted three such plaques as political metaphors and cited

82. GENTILE BELLINI
The Miracle of the Cross at the Bridge of S. Lorenzo, 1500 (detail). Canvas, whole work 10'7¼" x 14'1¼" (3.2 x 4.3 m). Gallerie dell'Accademia, Venice.

The painting documents an episode in which the reliquary of the True Cross owned by the Scuola Grande di S. Giovanni Evangelista fell from the bridge and hovered miraculously above the water until Andrea Vendramin, the Guardian Grande, retrieved it. Frescoed facades are visible at the left.

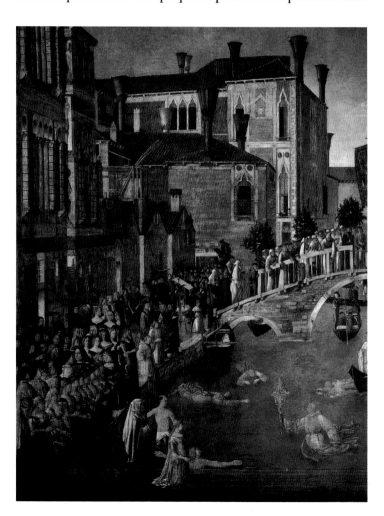

a carving of a weeping woman, "who is interpreted by many as Venice" as a warning against going to war with the emperor.

Frescoes would eventually replace the small sculpted reliefs as the facade adornment of choice. In 1495 on a trip along the Grand Canal, the French ambassador Philippe de Commynes observed: "The palaces are very large and tall, and of good stone, and the old ones are all painted." Indeed, by his time, Venice was becoming an *urbs picta* – a painted city (FIG. 82). The earliest such decoration highlighted parts of buildings with feigned masonry or festoons, tapestries and carpets, but figurative motifs and grotesques of an antique character – vegetal, animal and human – became increasingly popular over time. Unlike facade paintings in Florence and Rome which tended to be in monochrome grisaille, the Venetian frescoes were typically painted with a many-hued palette of colors. Sixty-eight painted facades are recorded in early written sources. Seven of them attributable to Giorgione, they were decorated with such mythological figures as Bacchus, Venus, Mars, and Mercury, as well as poets, musicians, and female nudes. However, as Vasari later observed, the frescoes began to deteriorate in the damp Venetian climate as soon as they were painted. Today, only faded fragments remain of Venice's early multicolored face.

Domestic Space

Behind those resplendent facades lay the more private world of domestic space. The main entrance to a palace faced the waterway and served both the *fondaco* or commercial business on the *pianterreno* (ground floor) and the *piano nobile* and upper floors where the wealthy family lived. The basic floor plan, a tripartite scheme that originally derived from Byzantine models, was already well-established in the thirteenth century and survived with variants until the end of the republic (FIG. 83). Its most prominent feature is a large central hall called a *portego* that runs from front to back. Sometimes taking an *L* or a *T* shape when combined with an open gallery or loggia running across the front, this was the heart of the house and served as the main living and entertaining area. In patrician homes, it typically held a display of family trophies and weapons called a *lanziera di arme*, which could include animal skulls from the hunt and such spoils of battle as banners, armor, spears, swords, and scimitars. Significantly, all these signs of high birth and aristocratic distinction were located above ground-floor storerooms filled with merchandise from the family business – sacks of sugar, bales of wool, or maybe boxes of spices.

83. Variations of the traditional Venetian *casa-fondaco*.
a) Byzantine tripartite plan;
b) *U*-shaped plan;
c) *L*-shaped plan;
d) *C*-shaped plan.

The portego was flanked by smaller rooms at the sides where the kitchen and the bedrooms were located. The tripartite plan was efficient in terms of making use of every bit of available space, but it often provided little light into the interior rooms and adaptations were called for. The primary innovation was the incorporation of a walled courtyard to give more light and air to the central block (FIG. 84). This open space could be moved around, depending on the site, and produced plans with *L*, *C* or *U* shapes. Although most ground-plans were quite irregular in shape because of the watery origins of Venetian building sites, the symmetrical Byzantine facades characteristic of many of the earliest buildings remained popular throughout the fifteenth century, standing alongside such Gothic palaces as the Ca' d'Oro whose facades were organized with a carefully calculated asymmetry.

Moving inside the Venetian palace, the significant decorative role played by light becomes apparent: not only the natural sun-

84. Palazzo Pisani-Moretta. Front elevation and plan of the lower *piano nobile*. Constructed in the mid-15th century, the palace features an evolved version of the traditional tripartite plan and was probably intended to house two families. It incorporates two courtyards at the sides, making a double *C* plan, as well as a larger courtyard in the rear, a feature of an *L* plan.

light and moonlight that streamed in through the great screen of windows on the facades, both front and rear, but also the artificial light from lamps and candles, as well as reflections of every kind on glass, mirrors, bronzes, and shining terrazzo floors (FIG. 85). The terrazzo floor is a glassy-smooth surface, made of colored cement with chips of stone embedded in it. And just as the exteriors of the palaces are like stage sets, the interiors function in the same way as box seats in a theater, for the windows are made for looking out of as well as for drawing in the light. This makes for a very different relationship between public and private

85. The Salone del Guarana, on the piano nobile of the Palazzo Pisani-Moretta.

The room is named after its ceiling fresco by Jacopo Guarana (1720–1808).

space than can be found in most other cities of the period, where houses were like fortresses, and windows were small and often fitted with oiled paper or cloth rather than with translucent glass.

The domestic interior, by virtue of its private character and the portability of furnishings, is more difficult to reconstruct than the halls of church and state. Much has perished, much has been redecorated, much has been sold off. In order to recapture an image of such rooms as they would have appeared in the Renaissance, it is first necessary to imagine them without the decorative accretions of later periods. Then with the help of inventories, early descriptions, and the handful of Venetian paintings that depict interiors, one may get a sense of the decorating conventions of the time. Finally, the reconstituted spaces must be restocked mentally with numerous objects – furniture and wall decoration, paintings, bronze and marble sculptures, glassware, ceramics, and the like – that have long been detached from their original settings.

The Art of Living

In 1494, Fra Pietro Casola, a Milanese priest of noble background, toured Venice in the company of the Milanese ambassador. Although their itinerary focused on churches and other public buildings, they also visited a private palace to pay their respects to a patrician lady in childbed, the wife of a member of the noble Dolfin family. The visit had been specially arranged, Casola suspected, "to show the splendor and great magnificence of the Venetian gentlemen." The comment is revealing. Although the home was to a large degree the extent of a woman's world – aside from the parish church – it still defined the husband's status. As Sabba da Castiglione (1485–1554) would later write in his *Ricordi*, a book of moral reflections published in Venice in 1546, "great gentlemen, rich, ingenious and magnificent . . . delight very much in adorning and furnishing their palaces, their houses, and especially the chambers and the studies with various and diverse ornaments, according to the variety and diversity of their ingenuity and fantasy . . ."

When asked his opinion about what he saw, Casola wrote: "I could only reply with a shrug of the shoulders, for it was estimated that the ornamentation of the room . . . had cost 2,000 ducats and more." The room that Casola saw is gone forever, but Giovanni Mansueti's painting of an interior in the palace of a certain Ser Nicolò Benvegnudo who lived in the *sestiere* of S. Polo (one of the six administrative units of the city) is remarkably close to his description (FIG. 86):

The fireplace was all of Carrara marble, shining like gold, and carved so subtly with figures and foliage that Praxitiles and Phidias could do no better. The ceiling was so richly decorated with gold and ultramarine and the walls so well adorned, that my pen is not equal to describing them. The bedstead alone was valued at five hundred ducats, and it was fixed in the room in the Venetian fashion. There were so many beautiful and natural figures and so much gold everywhere that I do not know whether in the time of Solomon . . . in which silver was reputed more common than stones, there was such abundance as was displayed there.

Ser Nicolò's room, with its carved fireplace, an abundance of gold, and a coffered ceiling painted with gilt and ultramarine, measures up well to Casola's observations. Though sparsely furnished, it has

86. GIOVANNI MANSUETI *Miraculous Healing of the Daughter of Ser Nicolò Benvegnudo of S. Polo,* c. 1502–06 (detail). Canvas, whole work 11'9¼" x 9'8½" (3.6 x 3 m). Gallerie dell'Accademia, Venice.

The work belonged to the cycle of the Miracles of the True Cross painted for the Scuola Grande di San Giovanni Evangelista.

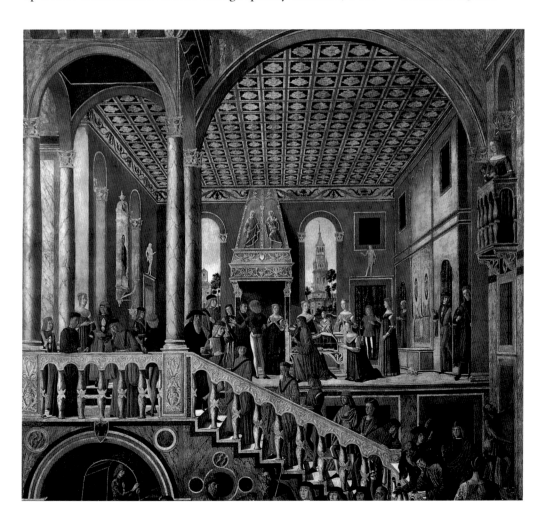

87. Velvet cloth of gold, woven in Venice at the end of the 15th century. Fragment, 32³/₄ x 21¹/₂" (83 x 54.5 cm). Museo Civico Correr, Venice.

The background is yellow silk taffeta woven with a gold brocade weft forming loops that catch the light and create a sparkling effect (*allucciolatura*). The pattern, defined by velvet pile of red silk cut in two heights, includes a mandorla and pomegranate flowers surrounded by vegetal motifs of acanthus leaves and palmettes.

patterned curtains in the doorways, an elaborate gilded child's crib instead of a built-in bed, and a *lettuccio* on the right-hand wall. This was a wooden bench with an upholstered backrest made of a luxury fabric, probably silk, with the coats of arms of husband and wife embroidered or woven into the design. These insignia of family identity were used on many domestic objects. In fact, another is carved in relief on the mantlepiece.

Ser Nicolò's *lettuccio* offers but a tantalizing glimpse of the textiles that made Venetian cloth manufacturing famous throughout Europe (FIG. 87). A sumptuary law passed in 1476 allowed

the use of taffeta for wall hangings and other furnishings in Venetian homes, but forbade more luxurious stuffs: cloth of gold or silver, velvet, brocade, and satin. Politically motivated to ensure the equality of the patriciate and to pacify religious reformers, such laws were generally ignored by wealthy gentlemen, who were more than willing to pay a fine to furnish their houses with the richest materials.

The art of silk-making in Venice had reached a high level of technical perfection in the fourteenth century with the immigration of exiles from Lucca who were highly skilled in spinning and weaving. The quality was carefully controlled. With raw silk imported from Syria, Turkey, and Persia, two thousand looms were in operation by the end of the fifteenth century, producing velvets, brocades, and silk damask both for domestic use and for export.

Seemingly, few objects in a prosperous Renaissance home escaped embellishment. Architectural elements such as banisters, pilasters, and ceiling beams were decorated with intaglio inlays or with painted designs, as in Ser Nicolò's chamber, and fabrics were worked with embroidery or trimmed with lace. Many fabrics were embroidered in professional workshops, but embroidery – both a craft and a cultivated pursuit – was also considered a suitable activity for high-born women. One of the earliest printed books of embroidery designs was published in Venice in 1527 by Giovanni Antonio Tagliente. A similar handbook announced that it aimed "to teach delightful young ladies how to embroider." Lacemaking was also women's work. Although Venetian women were skilled at needlepoint lace, Venice was particularly renowned for its bobbin lace (FIGS 88 and 89).

88. Bobbin lace-making pillow. Venice, 16th–17th century. Wood and stuffed hemp. Musei Civici, Centro Studi di Storia del Tessuto e del Costume, Venice.

According to a long-standing, and probably erroneous, tradition, the bobbin lace technique had developed from the making of fishing nets. Using linen thread wound around a bobbin, the pattern is worked out around an arrangement of pins stuck in a "pillow."

89. *Merletti* (bobbin lace) border, second half of the 16th century. Linen, 5½" x 7'6" (14 cm x 2.3 m). Museo Civico Correr, Venice.

The term *merletti* – "little battlements," – refers to the "points" of the border that resemble crenellations running along the roofline of a building. The border contains figural elements framed by hexagons.

Carpaccio decorated the bedchamber of St. Ursula in a more subdued manner than that of Ser Nicolò's, with less gold and no fireplace visible (FIG. 79, page 117), but the room is dominated by a canopied bed suitable for a princess, with coats of arms – those sure signs of aristocratic status – on its headboard and on the lintel of the doorway to the rear. The framed painting of the Madonna and Child illuminated by a votive lamp on the left-hand wall, featured in the same position in Ser Nicolò's room, was an element drawn from life. Inventories indicate that ninety percent of artisan homes contained at least one painting; the upper classes would have had more. While there were many paintings of saints, the Madonna, called *Nostra Donna*, was by far the most popular subject; she was the protectress of the house. Many such paintings were Byzantine icons, images which were thought to be endowed with a particular holiness. Described in inventories as *alla greca*, hundreds of icons were imported into Venice from Crete to be sold there in the city and elsewhere in the west. The demand was so great that replicas were also made in Venice by a cadre of local artists of modest artistic talent, who were

90. TITIAN
Gypsy Madonna, c. 1512.
Oil on panel, 26 x 33″ (65.8 x 83.5 cm).
Kunsthistorisches Museum, Vienna.

called *madonneri*. Venetian artists also produced numerous works that were painted without gold-leaf backgrounds in a more naturalistic Renaissance style. Giovanni Bellini's workshop was particularly active in this regard, providing small devotional paintings of the Madonna and Child, often set within the Terraferma landscape so beloved to Venetian patrons (see FIG. 76; page 112). Titian continued the tradition with his *Gypsy Madonna* (FIG. 90). Featuring a red and green color scheme, it also would have harmonized with the interior decoration, for the inventories reveal that these were the most popular colors in the middle-class home.

A Woman's World

The red and green color scheme reappears in yet another painting by Carpaccio, whose *Birth of the Virgin* broadens our vision of the domestic environment to embrace the home of the prosperous artisan, complete with kitchen (FIG. 91). As in Ursula's bedchamber, a rich green fabric, now bordered with a delicate tracery of gold embroidery, hangs on the wall as a decorative form of insulation in a damp, and often icy climate. St. Anne reclines in a built-in bed, probably the type that Casola had referred to as

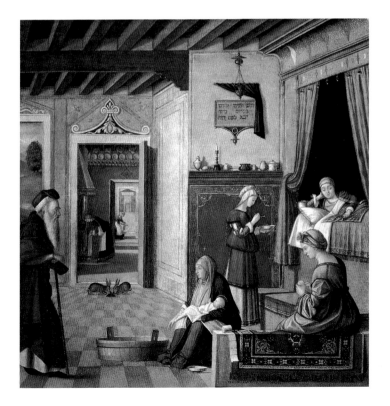

91. VITTORE CARPACCIO *Birth of the Virgin*, 1504–08. Oil on canvas, 49½ x 50¾" (1.3 x 1.3 m). Accademia Carrara, Bergamo.

The work was part of a cycle of five paintings of the Life of the Virgin painted for the Scuola di S. Maria degli Albanesi.

"fixed in the Venetian fashion." The beamed ceiling, far less costly than coffering – unadorned wood in St. Ursula's room and gilded and painted in Ser Nicolò's – was probably more typical of most Venetian homes.

Oriental carpets were frequently cited in inventories. They might be placed on the cold tile floor, as in Ursula's bedchamber, or used as table covers. In St. Anne's room, a carpet with a red and green pattern is draped over a low partition to create a bench for sitting. Signs of taste and wealth, such carpets were not local products, but were imported from the east. During Carpaccio's time, most of them came from Egypt and, less often, from Persia. They were to be had in various shapes and sizes: rectangular, round, and square, both with and without fringes. They featured both geometrical and figured patterns, and could be simple or quite elaborate. They were always colorful. On festive occasions they were draped over windowsills, emblems of a comfortable lifestyle spilling into the public sphere.

The bare walls are given architectural definition with a delicate linear design painted in reddish fresco. Aside from a plaque with a Hebrew inscription that placed the scene in biblical time, there are several other new elements in Carpaccio's painting: a row of small objects – jars, vases, and a candlestick holder – on the high ledge next to St. Anne's bed and a full set of dishes in the kitchen to the rear. We know from inventories that these were essential components of every well-furnished house. With the exception of textiles and carpets, which are particularly vulnerable to deterioration, many such objects survive today.

Had St. Anne been a young bride living in late fifteenth-century Venice, the ledge near her bed might have held a betrothal goblet (FIG. 92). A fine example in emerald-green glass features granular gilding and is decorated with two portrait medallions draped with garlands and flanked by cupids executed in enamels of various colors. The fashionably coiffed lady holding a bouquet is matched by a gentleman on the other side of the goblet who holds a scroll bearing the motto AMOR.VOL.FEE. (love requires faith). A token of love and marriage, the goblet is a very personal object. Its message would have been intended for an intimate audience: the lover and the beloved.

Different genres of art often shared the same images and motifs. The betrothal cup is a case in point, for the lovers depicted on the sides are clearly part of the same social world as Carpaccio's *Two Venetian Ladies on a Terrace*. Now in the Correr Museum in Venice, the painting is the lower half of a dismembered panel that was recently re-united, if only in a photo-montage, with a

92. Betrothal goblet, late 15th century. Enameled glass, height 8³/₄″ (22.4 cm), diameter 4″ (10.4 cm). British Museum, London.

Similar cups were made in milk glass called *lattimo*, using a technique that Venetian glassmakers developed in the mid-15th century in imitation of white porcelain imported from China.

93. VITTORE CARPACCIO
Hunting in the Lagoon, c. 1495.
Oil on panel, 30 x 25" (75.4 x
63.8 cm). J. Paul Getty Museum,
Los Angeles, California.

The reverse of the Correr panel
(below) has been planed down, but
the reverse of the Getty panel is
painted with a *trompe l'oeil* image
of letters and notes stuck behind a
fictive ribbon tacked onto a board.
Both panels bear the marks of
hinges, suggesting the piece was
originally a door to a piece of
furniture or perhaps a shutter, and
that it was intended to be seen on
both sides.

94. VITTORE CARPACCIO
Two Venetian Ladies on a Terrace,
c. 1495. Oil on panel, 37 x 25¼"
(94 x 64 cm). Museo Civico Correr,
Venice.

Many elements in the scene are given
a dual symbolism in 16th-century
emblem books. The doves, though
companions of Venus, were symbols
of marital fidelity, as they were
thought to mate for life. The peahen,
sacred to Juno, was an emblem of
conjugal concord and fecundity. The
parrot, associated with amorous
activities, was also admired for his
ability to salute the Virgin with his
characteristic cry of *Ave*. As to the
orange, or *malus aureus,* its
associations include not only Venus
and the nuptial celebration of Juno
and Jove, but also the Virgin.

painting in the Getty Museum in California, known as *Hunting in the Lagoon* (FIGS 93 and 94). Technical analysis proves conclusively that the two paintings were originally a single panel (that probably extended further to the left), with the maiolica vase in the lower panel holding the lily that protrudes into the upper. With the two panels juxtaposed, Carpaccio's original intentions begin to emerge: to join the confined domestic recreation space of women to the more public recreation space of their male counterparts. The young boy, probably a page, provides a link – both visual and conceptual – between the two domains.

While some scholars have argued that the women are not respectable ladies at all, but Venetian courtesans waiting for customers, this view is surely a misreading of the work. Indeed, it is far more likely to be a celebration of marriage. The pair are dressed in the latest fashions worn by women of honor and sit decorously on an *altana* – the private rooftop terrace of their family palace. Even the most respectable patrician ladies in Venice – and Casola observed this with some relish – painted their faces and exposed their shoulders and a good amount of bosom. The dress and demeanor of Carpaccio's ladies represent the Venetian marital ideal of voluptuousness controlled by chastity or fidelity. The lady in the rear, the younger of the two, wears a pearl necklace, prohibited to prostitutes, and allowable in Venice only to noble brides. Her linen handkerchief is an emblem of her chastity. She is flanked by two vases, one holding lilies, long associated with purity, and the other myrtle, a symbol of marriage. The hound suggests vigilance, the lapdog fidelity.

Elegantly painted with the coat of arms of the ancient Preli family, the maiolica vase on the left end of the parapet would seem to offer a key to the identity of the sitters. However, with the patrician branch of the family having died out already in the twelfth century, it may be suggested that the blason pertains to a wealthy *cittadino* family, whose daughter is about to make a noble marriage. In any event, the vase introduces another element into our exploration of the Venetian home. Probably imported from one of the Umbrian hill towns that specialized in making tin-glazed earthenware, the depicted piece features a fish-scale pattern used on pottery made in Deruta. In Venice, the traditional ceramic of choice was incised slipware, involving a Byzantine technique in which earthenware is covered with a liquid white slip (or dilute clay) into which the decoration is scratched through to the darker clay before glazing.

95. WORKSHOP OF MATTEO D'ALVISE DA FAENZA(?) *Bella donna*, 1499. Maiolica jug (*boccole*), height 11¾" (30 cm). Museo Civico, Bologna.

The maiolica technique was introduced to Venice at the end of the fifteenth century by craftsmen from Faenza. Early pieces made in Venice tended toward large, simple designs adapted from the slipware technique, such as a jug featuring the profile of a woman (FIG. 95). An example of a genre of pottery decoration called the *bella donna*, she embodies a type of female beauty that was particularly admired in that period: swept-back hair with a few provocative tendrils escaping; large protruding eyes; a plump face and a full bosom amplified by the swell of the vase. With an arrow piercing her milky white skin, the theme of the work was made clear by the *cartellino* bearing the word *Amore*. The date 1499 on the opposite side of the jug suggests that the piece was a gift relating to a specific event, such as a marriage or engagement. It was probably the product of a collaborative effort, with a potter from Faenza responsible for making the ceramic and a Venetian painter for adding its painted decoration. Although all clay had to be imported, Venice's policy of offering financial incentives to skilled artisans who relocated to the city helped the industry to develop quickly, and it was not long before Venetian maiolica-ware was considered equal to that of Faenza. In 1545 a decree was passed banning the importation of all foreign tin-glazed pottery except the distinctive Hispano-Moresque wares from Spain.

Relatively inexpensive, portable, and open to unlimited pictorial invention, ceramic painting was an ideal medium for making personal statements. In addition to objects of occasion, such as the betrothal cups and the vase painted with the family coat of arms, pieces decorated with classical motifs offered the opportunity to display the patron's humanistic learning and refined taste. A large plate in the Victoria and Albert Museum is a sophisticated example of a distinctive style of Venetian maiolica that emerged in the early years of the sixteenth century (FIG. 96). Painted with deep blue and white colors on a grayish-blue (*berettino*) glaze, it employs an *all'antica* triumphal decorative vocabulary that had enjoyed great popularity in a wide range of media in Venice since the late quattrocento. Here the allegorical figure of Abundance, attended by a cupid or winged putto, holds a cornucopia and reclines in the midst of a densely packed field of trophies. These include the spoils of war and the benefits of peace: armor, shields, and weapons; grotesque masks and musical instruments; horses

96. WORKSHOP OF DOMENICO DA VENEZIA(?) *Abundance Surrounded by Trophies*, c. 1540–50. Maiolica dish, diameter 18$\frac{1}{3}$" (46.5 cm). Victoria and Albert Museum, London.

Scattered among the trophies are several white placards, one inscribed with the name of the painter – J. Francesco Tertiarius – and another with *Venezia*. Venetian furnaces were the first to produce dishes of such generous dimensions.

and a slumbering dog. The border of the dish features four classicizing medallions, two containing male profile busts and two with reclining female nudes.

An Antique Ambience

Antiquity – that defining theme of the Renaissance – was itself an object to be collected. Sabba da Castiglione wrote of gentlemen who liked to "decorate their houses with antiques, such as heads, torsos, busts, ancient marble or bronze statues. But since good ancient works, being scarce, can not be obtained without the greatest difficulty and expense, they decorate it with the works of Donatello . . . or with the works of Michelangelo . . . [or other modern artists]." Sabba could have found no better example of a gentleman who adopted a cultivated lifestyle and fashioned his self-image through the acquisition of *anticaglie* and works of art than Andrea Odoni. A wealthy merchant, Odoni commissioned Lorenzo Lotto to portray him amidst his possessions (FIG. 97). The work was seen in Odoni's palace in 1532 by the writer Marcantonio Michiel who described it as a "portrait of Messer Andrea himself, in oil, half-length, contemplating some antique marble fragments."

Odoni lived in the *sestiere* of S. Croce on the Fondamenta (a street next to a canal) del Gaffaro, in a palace with a facade frescoed with mythological figures. Some of the pieces depicted in the portrait may well have been genuine ancient marbles as Michiel claimed, but others were surely copies. The sculpture in the left background, for example, is a reproduction of an over-life-size statue of *Hercules and Antaeus*, also in a fragmentary state, that was then in the Belvedere courtyard of the Vatican. In the background to the right are three nude statuettes that have not been linked to known antiques: another Hercules, identifiable from his lionskin and club; a kneeling female, probably a Venus or a Diana Bathing; and a putto or Cupid. The marble head at the lower right was probably a stucco cast of a bust of Hadrian listed in an inventory made in 1555 after Odoni's death. Propped against it is a female torso, possibly a Venus.

While several of these objects might well be Lotto's own inventions, Michiel also described numerous pieces of sculpture, both ancient and modern, as well as paintings, vases, and other works of art distributed throughout the house. Among these signs of taste and refinement were two illuminated books of hours; one of which may be the tiny leather-bound volume with ribbon ties that rests on the table with a handful of medals or coins in the painting.

Odoni, richly dressed in a voluminous charcoal-gray coat of a heavy material lined with wolf fur, wanted more than simply an accurate portrayal of his outward appearance. Engaging the viewer with a direct gaze, he proffers a statuette of Diana of Ephesus, a symbol of Nature or the Earth, contrasting her to the transience of human things as symbolized by the antique fragments. Extending his left hand in front of his heart in a gesture of sincerity, Odoni thus appears to profess his trust in Nature over the works of man.

More typically, the antique was brought into Venetian homes in a less ostentatious way. The chambers of St. Ursula and Ser Nicolò (see FIGS 79 and 86, pages 116 and 125) both reveal a comfortable assimilation of classical elements into the prevailing Gothic style. In Ser Nicolò's palace, pilasters, balustrades, and wainscoting are carved with foliate forms that include the lamps and sphinxes that were common elements in a generalized *all'antica* aesthetic. But, more tellingly, both rooms feature small nude

97. LORENZO LOTTO
Portrait of Andrea Odoni, 1527. Oil on canvas, 39¾ x 45″ (1 x 1.1 m). Royal Collection, Hampton Court Palace.

98. *Venus*, North Italian, end of the 15th century. Bronze, height 9″ (23.1 cm). Kunsthistorisches Museum, Vienna.

The statuette has long been attributed to Tullio Lombardo, but has no analogues within his oeuvre.

figurines, probably cast of bronze and gilded, that stand on the doorway lintels. By the last decade of the fifteenth century, an industry specializing in the production of antique-looking bronzes had developed in Padua and Venice.

A standing *Venus* crafted with truncated arms is an engaging example of one of these surrogate antiquities (FIG. 98). Cast of solid bronze, she was once painted with a blackish-brown lacquer but was probably never gilded. The worn-smooth surface, with the bare metal showing through in places, suggests that she did not spend all her time above a doorway. She was surely passed around between her owner and his guests, to be observed closely, handled, and, indeed, caressed. With elongated proportions and a hairstyle more contemporary than classical, she might be considered an antique "paraphrase" – albeit a conscious emulation – rather than a "forged antique." In any event, such anachronisms do not detract from an overall impression of balance and grace nor from her evocative power as a paradigm of classical beauty.

An Aesthetic of Escape

The world of classical myth also offered an avenue of escape from an ever more complex and challenging present. Humanists had learned this lesson well, making forays into the ancient past through its literature. The establishment of the printing industry in Venice in 1469 made such texts available to a far wider audience. During the next five years, over 130 editions would be printed in the city, a tally that would rise to around 3,500 by the end of the century. Early editions of classical texts were still informed by the manuscript tradition and were often decorated with illuminated frontispieces of stunning originality. They were particularly notable for their *trompe l'oeil* illusionism, a cognitive taste with roots in Paduan art, particularly in the circle of the young Mantegna.

Typically, they employed an architectural monument as a gateway to the text. A frontispiece to the life of Theseus in a copy of Plutarch's *Parallel Lives*, printed in Venice in 1478, thus features a large purplish-gray monument cut out like a picture frame to contain the first page of the text (FIG. 99). The surface of the monument is seemingly decorated with fictive grisaille carving in low relief: primarily floral arabesques on the left and top borders, trophies on the right, and a frieze of nymphs and satyrs on the base. Over this structure an elaborate apparatus of jeweled ornaments – encrusted with pearls, gems, and cameos in elaborate gold settings fashioned from classical motifs – appears to be suspended from tiny cords. At the top, two gold wreaths encircle tiny

99. Girolamo da Cremona (attrib.)
Frontispiece to Plutarch, *Parallel Lives*, printed in Venice by Nicolaus Jenson, 2 January 1478. Parchment, 15³/₄ x 10¹/₂″ (40.2 x 27 cm). Bibliothèque Nationale, Paris.

The volume carries the coat of arms of the Agostini, a Venetian merchant-banking family.

100. Titian(?)
Pastoral Symphony,
c. 1510. Oil on canvas,
43 x 54" (1.1 x 1.4 m).
Musée du Louvre, Paris.

scenes from Ovid: on the left, a group of sea creatures and on the right, Vulcan fashioning the wings of Cupid.

The monument sits in the unspoiled countryside of Arcadia, populated with satyrs and wild animals of forest and field: a lion and lioness and two pairs of deer who dwell together in a state of primeval harmony. With a lake with swans just visible at the right-hand side, this peaceful country is accessible to the reader only through the text.

By the first decade of the sixteenth century, Venetian artists would create a larger vision of Arcadia by bringing it into easel painting. The *Pastoral Symphony* is one of the masterpieces of the genre (FIG. 100). Its authorship is uncertain, with the majority of scholars attributing it to Giorgione or Titian or even to both artists. The subject of the work has also eluded a sure interpretation. Two young men, one elegantly dressed and the other clothed in the rough garments of a shepherd, are seated in the countryside. Flanking them are two voluptuous nude females, but the men look only at each other.

According to one proposal, the painting represents an attempt to offer a visual equivalent to the *Eclogues* of Virgil – a genre of pastoral poetry that enjoyed great popularity in the period and was imitated by Italian poets. The central idea was the excursion of the "highly cultivated young man" into the idyllic countryside of Arcadia where mortals mingled with gods. Not a place so much as it was a state of mind, Arcadia was neither only the real world nor only the pastoral one. It was a superimposition of both worlds.

As such it was distant enough to provide escape and close enough to be always accessible. Indeed, there are buildings in the distance, which remind us that the city is somewhere nearby. One of the major contributions of Venetian artists of this period was to transform this literary scenario into visual form.

In the *Pastoral Symphony*, the young men are making beautiful music, and the nymphs come out to listen. Thus the men *create* Arcadia – they bring it to life. The nymphs are not invisible. Rather, by being visible they encourage us to join in. And yet a melancholy tone pervades the work; there is a tacit acknowledgement that the peaceful arcadian world of Virgil is really unattainable.

The artist stresses the fictive quality of this world by his technique of painting. Loading his brush with thick oil paint, he applies it to a coarse canvas that has been primed with a dark ground. In some areas the globs of oil paint are deliberately left visible. All the figures are in harmony with the natural world, but while they are clearly distinguishable and are not totally absorbed into it, they are grounded in the paint itself. The artist becomes a poet with these paintings, and he wants us to see his hand.

Pastoral scenes were much favored by printmakers, and the genre soon expanded beyond Arcadia with scenes of rural life that brought it more completely into the present day. It is as if Venetian artists and patrons put down their copies of Virgil's *Eclogues* and opened up the *Georgics* – a poem dedicated to agriculture, with work now privileged over leisure. The shift from shady groves to expansive agrarian vistas can be discerned in the *Landscape with a Milkmaid*, a woodcut after a drawing by Titian (FIG. 101). The

101. TITIAN
Landscape with a Milkmaid,
c. 1520–25. Woodcut from
original sketch, 14³/₄ x 17″
(37.6 x 43.3 cm).
National Gallery of Art,
Washington, D.C.

scene includes not only a shepherd boy feeding his flock of sheep and goats, but also cattle and a woman milking a cow. Although the figures and barnyard animals are clustered in the foreground, the countryside of broad meadows and rocky outcroppings is an equal player in the composition. Like the *Pastoral Symphony*, it does not appear to be informed by a specific literary text, indeed, it comes close to a pure landscape; and yet the galloping horse in the middle ground and the eagle perched on a stump in the front plane – both missing from the original drawing – hint at a possible allegorical message. The poetic effect is grounded in Titian's essential naturalism, with a medley of textures and shapes bound together in an organic unity by means of a sensitive play of light, shadow, and texture.

The growing prominence of the rustic in Venetian art was paralleled by new initiatives in land reclamation in the Veneto. Already in the quattrocento, Venetians had sought refuge from a densely populated urban environment by purchasing farms on the mainland. In the century that followed, many families built or expanded villas, and participated in a distinctive culture of villa life, called *villegiatura*, with seasonal relocations from city to country living. Originally inspired by such classical writers as Pliny and Vitruvius, who extolled the benefits of a healthy country life, Venetians who developed their villas as working farms were given official support by the Venetian government, which sought to safeguard the food supply of the lagoon.

The rural aesthetic culminated in the paintings of Jacopo Bassano, an artist from the market town of Bassano, nestled in the foothills of the Dolomites northwest of Venice. He was particularly famous for his nocturnal scenes and paintings in which biblical events were set in the midst of country life. With his *Pastoral Landscape*, he is probably the first artist to translate the rustic environment of Titian's woodcut into paint (FIG. 102). The work has been called the earliest true landscape in sixteenth-century Italian painting. The hour is sunset; the mood is tranquil; the figures are absorbed in their own activities: preparing a simple meal, watering the sheep, sowing the last seeds before the sun goes down. The chromatic harmony of the work is based upon a tenebrous palette of earth colors. One can imagine no better escape from the material opulence of the Venetian palace and from the man-made character of its urban setting.

That such a work as Bassano's would find its place in a sumptuous domestic setting of kaleidoscopic color and intricate patterns is not surprising. Venetians throughout their history demonstrated a striking ability to incorporate the alien, and to make it their

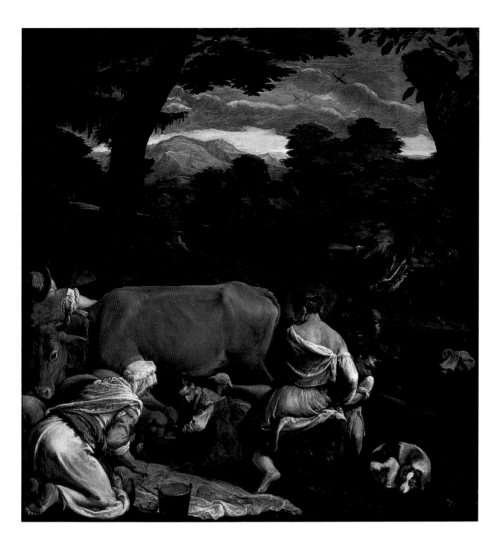

own without losing a sense of the exotic and the unfamiliar. Even the homes of artisans might contain objects of diverse provenance – German, Flemish, French, Chinese, Islamic, Byzantine, antique – all brought together in a new all-encompassing synthesis.

As Francesco Sansovino put it later in the sixteenth century, "There is no person so miserable with a house open [to visitors] that he would not have chests and bedsteads of nutwood, green draperies, carpets, pewter, copper, chains of gold, forks and rings of silver; such is the civility of this city."

Indeed, the Venetian palace was filled with a wealth of other objects too varied and numerous to describe here: boxes of ivory and papier maché; an array of furniture types; musical instruments; and, most notably, portraits, a genre which enables us today to put a human face on the Venetian past.

102. JACOPO BASSANO
Pastoral Landscape,
c. 1554. Oil on canvas,
55 x 51" (1.4 x 1.3 m).
Fundación Colección
Thyssen-Bornemisza, Madrid.

The painting has also been interpreted as an illustration of the Parable of the Sower in the New Testament (Matthew 13): "the seed sown in rich soil is someone who hears the word and understands it . . ."

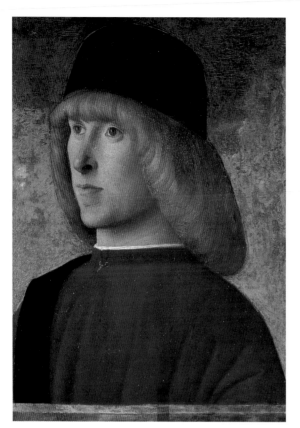

The Aristocratic Ideal

A commissioned portrait was a mark of distinction in Sanudo's Venice, and Giovanni Bellini was, according to Vasari, the city's first major portrait painter:

> having devoted himself to doing portraits from life, he started in Venice the custom by which anyone of a certain rank should have a portrait done either by him or by some other painter. So there are many portraits in all the houses of Venice, and in many gentlemen's homes one may see their fathers and grandfathers back to the fourth generation, and in some of the more noble houses back further still.

104. GIOVANNI BELLINI *Portrait of a Young Senator,* 1485–90. Panel, 13¾ x 10½" (35 x 26.4 cm). Museo Civico, Padua.

Portraiture involves a complex social transaction between the artist, the sitter – the term is used in a broad sense, since people rarely "sat" for portraits in the Renaissance – and the spectator. For the artist, it is a question of finding the proper balance between truth and flattery: to render a credible likeness while satisfying the patron's expectations of a pleasing appearance. The sitter's concern is the presentation of self – a delicate matter in Venice, where individuals were not encouraged to express their individuality at the expense of the patrician consensus. For the spectator, the challenge is to assess the artist's share in relation to the visual reality of the sitter.

The *Portrait of a Young Senator* is characteristic of Bellini's personal response to the artist's brief. The sitter is portrayed in three-quarter view, his figure truncated by a parapet and silhouetted against a neutral blue sky. Avoiding eye contact with the viewer, he gazes into space with calm equanimity. The artist remains true to his formula – later demonstrated, as well, in his portrait of Doge Leonardo Loredan (see FIG. 51, page 78) – but the naturalism praised by Vasari is also evident. Though idealized, with smooth skin that seemingly never felt the bite of a razor and luxuriant blond hair that needed no comb, the sitter has a long nose, thin

sensitive mouth, and pointed chin: features that are distinctive enough to suggest a specific, recognizable individual. His toga, broadly painted in *scarlatto*, is fastened at the neck with a meticulously rendered gold clasp. The calculated balance between abstraction and particularity comes close to a classical statement of the aristocratic ideal of the late quattrocento. Indeed, the sitter, with his self-confident demeanor and impassive gaze, is more an icon than a protagonist in a social transaction. As much a type as an individual, he represents his caste – the hereditary patriciate – as well as himself.

During the first half of the sixteenth century, Venetian sitters became more animated, if no less guarded. A more complex psychological dimension is already evident in the portraiture of Lorenzo Lotto. His *Young Man with a Lantern* (FIG. 105) engages the viewer in a manner that the self-possessed *Young Senator*, painted a generation earlier, might well have considered indecorous. His lips parted, as if he is about to speak, he gazes directly

105. LORENZO LOTTO
*Portrait of a Young Man
with a Lantern*, 1506–08.
Oil on panel, 16½ x 21″
(42.3 x 53.3 cm).
Kunsthistorisches Museum,
Vienna.

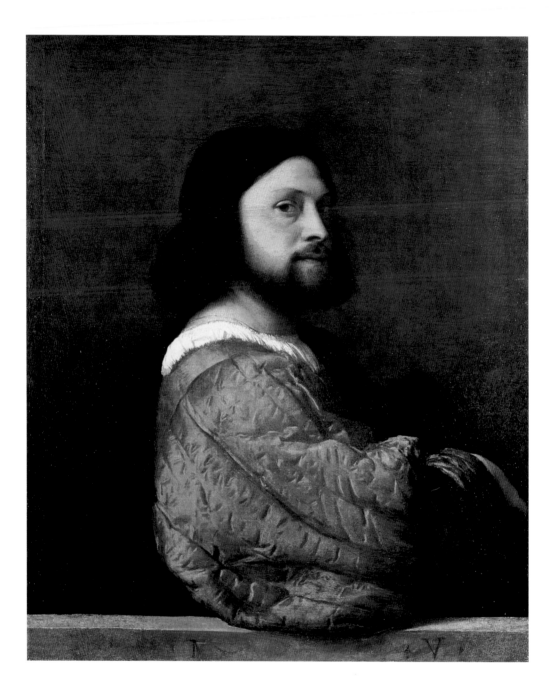

106. TITIAN
Portrait of a Man in Blue,
c. 1512. Oil on canvas,
32 x 26″ (81.2 x 66.3 cm).
National Gallery, London.

at the onlooker and seems to demand a response. The portrayal expresses an inner life of tension and suggests that aristocratic demeanor comes at a price. Rendered with an attention to surface detail that is characteristic of Northern European art, the painting betrays a debt to Dürer and was probably made immediately after the German artist's visit to Venice in 1506. Lotto retains the

146 *Caste, Class, and Gender*

bust-length format employed by Bellini, but he rejects the neu-tral blue sky in favor of a delicate white damask curtain edged with a green hem. The fabric is more than a backdrop, for it plays an expressive role in the painting, with three vertical diagonals – the faint crease on the left, the deep pleat in the center, the right edge that plays against the nervous, rippling hem – both anchoring the figure and allowing it to move in space. The formal tension created between the sitter and his setting reinforces the ambiguity of his expression. Not content with a psychological por-trayal alone, Lotto added an intellectual component with the burn-ing oil-lamp that hangs from the wall in the upper right-hand cor-ner. A traditional symbol of transience, it too bespeaks uncertainty and an unquiet spirit.

Portraits took on ever-larger dimensions. Lotto's *Young Man* was twice the size of Bellini's *Young Senator*. Titian's *Portrait of a Man in Blue*, painted just a few years later, would double the pic-torial field once again (FIG. 106). Not surprisingly, the artist fol-lows Bellini's lead in placing a bust-length figure behind a para-pet, a feature that persisted because of its formal utility: it provides a base for the figure, it defines the front plane, and it separates the sitter from the beholder while providing a transition between the fictive and the real worlds. But benefiting from Leonardo's innovations to include the sitter's upper torso and drawing upon Giorgione's example to envelop the figure in an atmosphere, Titian transcends his models. The *trompe-l'oeil* effect of the sump-tuous quilted sleeve of blue satin moves the sitter into the viewer's space, for it extends in front of the ledge and effectively breaks the barrier that separates the painted world from our own. Fur-thermore, in an even more compelling acknowledgement of our presence, the sitter tilts back his head and gives us a sidelong – but disarmingly penetrating – glance. In so doing, he projects his personality with an air of challenging assurance. There is the sure sense of a particular individual captured at a particular point in time.

The spectator is moved to ask: who *is* this individual? While the initials *T.V.* fictively incised on the parapet may simply be the artist's signature, standing for Tiziano Vecellio, it has been sug-gested that this is a self-portrait of the young artist himself. The idea is plausible, given the similarity of features with Titian's later self-portraits, but we will probably never know for sure. The inscribed letters had a classical pedigree. Renaissance antiquari-ans had long been copying inscriptions from Roman monuments, and Titian's epigraphy was clearly inspired by the practice. He was also making a subtle claim for the superiority of painting over

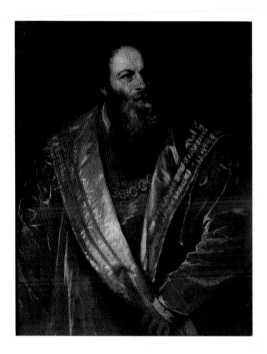

107. TITIAN
Portrait of Pietro Aretino,
c. 1545. Oil on canvas, 38½
x 30¾" (98 x 78 cm). Pitti,
Florence.

sculpture – a popular subject of debate in artistic circles of the time – by "carving" his initials into stone: normally the prerogative of the sculptor.

As the sixteenth century unfolded, aristocratic deportment received increased attention in public and private life. With hereditary courts replacing civic oligarchies and the consolidation of real political power in ever-fewer hands, standards of decorum became more rigid and manners more refined. In republican Venice, a statute was passed in 1506 requiring the registry of all noble births to ensure the purity of patrician bloodlines; in 1526, marriages between noble and commoner – no matter how wealthy the latter – were forbidden by law. The greater differentiation and heightened individuality already visible in the portraits of Giovanni Bellini's successors seem to reflect such changes. Noble sitters, and those who aspired to a noble manner, affected *sprezzatura*, an attitude of nonchalant self-confidence, even as they became more expensively dressed.

Titian's *Portrait of Pietro Aretino* is a case in point (FIG. 107). The son of a shoemaker, Aretino arrived in Venice in 1527 and became a close friend of the artist. Despite his humble background, he moved easily in patrician circles, his intellectual brilliance and wit achieving for him a considerable reputation in most of the courts of Europe. He was a prolific writer and produced plays, poetry, satires, and religious narratives, as well as pornography and a large correspondence. Wielding a sharp, biting pen and exhibiting little false modesty, he called himself the "Scourge of Princes" and took great pleasure in flattering and insulting the noblest heads of his time.

Titian portrayed Aretino with the insight that came from close association. The artist had long since discarded the parapet formula and moved toward a more inclusive view of the figure in which the hands generally established the lower boundaries of the image. Aretino's imposing form is defined by the grand sweep of his cloak, held together, as others have observed, like an ancient orator grasping his toga. The V-shape of his collar contains and frames his head and bearded face, so that all that bulk of fabric does not distract the eye from what would have been – to him – the main area of interest. That he does not look at us directly

is part of his power. He is a presence, more than a participant, in a social transaction. Of course, one aspect of being a great gentleman is being ostentatiously modest, and just visible under Aretino's cloak is a golden chain of honor bestowed on him by Francis I, the King of France.

After Titian completed the portrait, Aretino sent it off as a gift to Cosimo I de' Medici, the Grand Duke of Tuscany, along with a letter in which he praised its naturalism: "It breathes, its pulse beats, and its spirit moves just as I do in real life." Although the poet also complained to Cosimo that Titian had not given sufficient attention to replicating the rich fabric of his gown, he allowed that the portrayal was still "a miracle." As Aretino put it in a letter to another friend, the portrait was "such an awesome marvel."

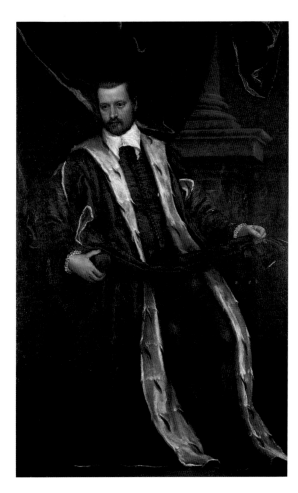

108. PAOLO VERONESE
Portrait of a Member of the Soranzo Family, 1570s.
Oil on canvas, 72½ x 44½"
(1.8 x 1.1 m). The Earl of Harewood, Leeds.

While the rise in class-conscious portraiture reflected real changes in a society that was becoming ever more hierarchical, there is another aspect to the problem. Earlier on, in the time of Giovanni Bellini, the very existence of a portrait was in itself a sign of high status, for only the upper classes had their portraits painted. By the middle of the sixteenth century, however, even tradesmen and artisans regularly ordered portraits of themselves. This phenomenon did not escape Aretino's acid pen. Overlooking his own modest origins, he wrote, "It is the disgrace of our age that it tolerates the painted portraits even of tailors and butchers." Indeed, the inventories support his contention, listing a good number of portraits even in artisans' homes. Despite the extraordinary achievements of artists at the most exalted end of the market, portraits themselves had, on the whole, become more democratized.

The Social Hierarchy

When portraits had become commonplace, artists inevitably found ways to distinguish upper-class patrons from the lower orders. Generous dimensions were themselves signifiers of affluence, a fac-

tor undoubtedly contributing to the trend toward ever larger canvases. By way of example, the painted surface of Veronese's *Portrait of a Member of the Soranzo Family* (FIG. 108) is nearly three times that of Titian's *Pietro Aretino*, painted about thirty years earlier. Just as significant, however, is Veronese's portrayal of Soranzo as a full-length figure seated in a throne-like chair. The composition is one that originated in royal and papal portraiture, and Titian had already represented the Emperor Charles V and Pope Paul III in such a manner. In an era in which royalty remained seated and at their ease while subjects stood or bowed before them, the formula establishes an immediate hierarchy between the sitter and the spectator. That Veronese adopted it for a private individual, albeit a member of the Venetian patriciate, is a powerful statement of the sitter's social status. The massive column base and drapery behind him are also attributes of a signorial domestic setting.

The noble Soranzo's dress, moreover, may be somber in color, but it is costly in its substance. As the faint white line around the hem attests, the opulent *zimara* – a floor-length tunic worn at home – is fully lined with luxuriant ermine, complete with tiny tails. The fur lining was an index of rank, and the discriminating eye would immediately have grasped Soranzo's status as both noble and rich. Ermine stood at the top of a hierarchy of furs, to be followed by marten (sable), vair (miniver), and lynx. While the middle classes wore squirrel, wolf, and sheared black lamb, the lower classes lined their clothing with rabbit and even cat and dog pelts. Holding his black stole, normally worn over one shoulder in public life, across the arms of his chair, Soranzo adopts an informal pose that bespeaks his nonchalant ease with the trappings of conspicuous consumption.

By contrast, the three magistrates in Jacopo and Domenico Tintoretto's *S. Giustina and the Treasurers* are depicted in their official roles (FIG. 109). Their robes are made of rich red velvet lined with lynx, a spotted fur that was less costly than ermine, but also favored by patricians. The composition provides an eloquent illustration of the relationship between the patrician and the *cittadino* castes. The three noble treasurers, who served together for terms of sixteen months, stand in the front plane under the protective cloak of S. Giustina, Venice's protectress at the Battle of Lepanto in 1571. Their coats of arms with initials in the lower right corner identify them as Marco Giustiniani (Zustinian), Angelo Morosini, and Alessandro Badoer, all of whom held office in 1580, the date inscribed on the painting. Behind the magistrates stand their *cittadino* secretaries, dressed in sober black. Although they are

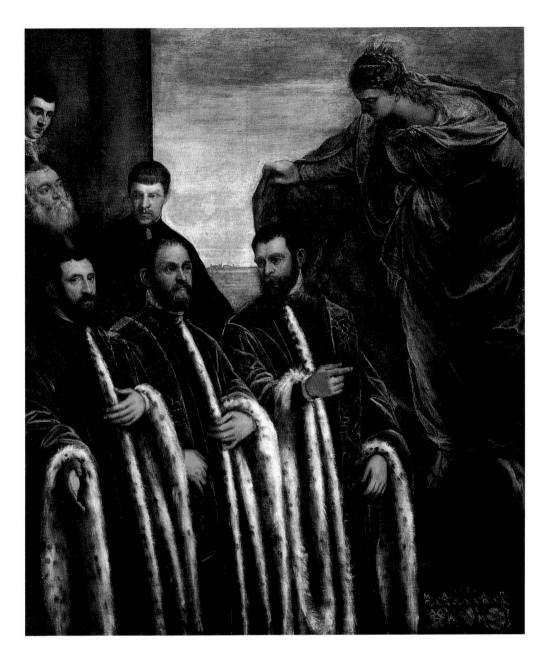

109. JACOPO AND DOMENICO TINTORETTO
S. Giustina and the Treasurers, 1580. Oil on canvas,
7′1″ x 6′ (2.2 x 1.8 m). Museo Civico Correr (on deposit
from the Gallerie dell'Accademia), Venice.

The painting was originally paired with *St. Mark and the
State Chamberlains*, now in Berlin, and the two works once
flanked Carpaccio's *Lion of St. Mark* (see FIG. 54, page 81)
in the Palazzo dei Camerlenghi at the Rialto.

110. PARIS BORDONE
The Chess Players,
1550–55. Oil on canvas,
44 x 71¼" (1.1 x 1.8 m).
Staatliche Museen
Preussischer Kulturbesitz,
Berlin.

Several chess pieces
tumble onto the lap of the
man on the right,
suggesting that the
vicissitudes of fortune may
upset the most well-
established hierarchy.

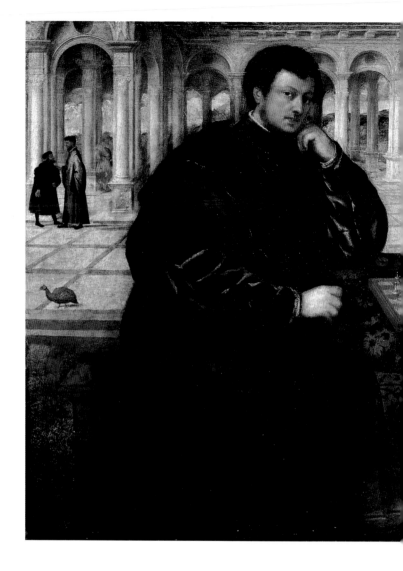

depicted as individuals, with their faces well differentiated, they
are identified neither by name nor by emblem. Indeed, their
personal identities are not at issue here. As members of the per-
manent bureaucracy who ensured the smooth operation of the
government while their noble employers rotated in and out of
office, the secretaries were included in the painting as essential,
but subordinate, members of the body politic.

Paris Bordone's *The Chess Players,* a rare double portrait of
two gentlemen engaging in a game of chess, portrays another aspect
of patrician life (FIG. 110). The players sit in the garden of a
country villa, although the classical loggia to the rear would appear
to be more a product of the artist's fancy than an existing struc-

ture. Behind two men engaged in conversation at the far left, a
falconer is visible inside the loggia. Under a tree in the right back-
ground, a group of four ladies is seated on the grass around
their own chessboard, while at a table nearby a group of four men
play at cards, an activity that was considered a distinctly lower
form of entertainment and often censured. The simplest reading
of the work would define it as a straightforward genre portrait,
aiming to commemorate the pair in the foreground in an aris-
tocratic activity known to exercise the rational faculties and praised
for its capacity to chase away boredom. With the open-air setting,
it might also be seen as a sophisticated culmination of the taste for
the countryside that had emerged in the early years of the century.

Yet the scene may not be as detached from urban life as would appear at first glance. As one scholar has observed, a further key to interpreting it may be found in the *Libro di giuocho di scacchi*, a thirteenth-century treatise on chess written by a Dominican monk. Printed in Florence in 1493 and in Venice in 1534, it circulated widely and could well have been known to Bordone or to his patron. The subtitle of the Florentine version – "on the customs of men and the offices of nobles" – is prefaced in the Venetian edition with an additional explanatory phrase: "A new work which teaches about the true government of men and women of every degree, state, and condition."

In the treatise, the game of chess is presented as a political allegory of the civil life, with the chessboard itself a metaphor of the well-ordered state in which each piece has its correct role and place. At the top of the hierarchy are the "noble chess pieces": the king, queen, and knights who stand for themselves, along with the castles as "vicars of the king" and the bishops who denote the judges and assessors. Below this upper stratum are the "common chess pieces" or pawns, who represent the popular classes, from notaries and medical doctors down to tavernkeepers and manual laborers. The arrangement of the pieces on the board stresses the interdependence of the orders: "it should be known that the commoners are placed in front of the nobles, because the commoners are in a certain way the crown of the nobility."

In Bordone's painting, the bearded player on the right holds a castle in his hand and moves to checkmate his younger opponent, very likely his own son. In so doing, he instructs him on his role in "the true government of men and women of every degree, state and condition." Following this line of argument, the figures in the background become more than just a supporting cast for the portrait of a comfortable lifestyle. Rather, they represent the idle pleasures that the young man should put aside as he embarks upon a life of public service, the pre-ordained civic role of every Venetian patrician adult male.

The Feminine Ideal

A woman's role in Renaissance Venice was another matter altogether. She had only one place in official public life: as an adornment of the city. On most ceremonial occasions, women were, indeed, part of the spectacle, but primarily as escorts for noble visitors and as viewers who filled the windows of the *piano nobile*. In each case they were both subject and object: whilst part of the crowd of spectators who were necessary for any ceremonial event,

they were also ornaments to be seen. Sanudo wrote: "The women are truly most beautiful; they go about with great pomp . . . and when some grand lady comes to Venice, they go out to meet her with 130 and more women, adorned and dressed with jewels of the greatest value and quality." The sumptuousness of their apparel and the costliness of their jewelry were thus not just visible signs of the individual wealth of their husbands; they were also to be understood as emblems of the wealth and power of the city of Venice itself.

Female portraiture developed along the same lines as portraits of men. Lotto's *Portrait of a Lady* represents the culmination of the quattrocento tradition of veristic, "topographical" portraiture that sought to "map" an individual's features (FIG. 103, page 143). With her auburn hair pulled back and tamed by a confining snood, the sitter is almost certainly a married woman of unimpeachable respectability – indeed, a veritable icon of the virtuous matron. Her direct gaze bespeaks an absence of guile, and the veil covering the shoulders of her fashionably low-cut gown attests to her modesty. The dark background projects her forward as she addresses the viewer, whether male or female, in a visual dialogue as an equal participant who has nothing to hide.

With Giorgione's *Laura*, painted around the same time, the individual portrayal of women in Venice moves into a new phase. Now the viewer is struck by the sitter's evasiveness and sensuality more than by her forthright character (FIG. 111). Indeed, the sitter represents a new vision of female beauty. Since the seventeenth century she had been identified with Petrarch's beloved, the virtuous Laura, because of the laurel branch behind her. More recently, scholars have held that her bare breast could not be a sign of virtue, but rather of wantonness, and that she must be one of the courtesans for which Venice was so famous. However, a recent study proposes that the debate about Laura's profession – or lack thereof – misses the mark and argues that the most interesting question here is not who or what the woman was, but how she is presented. Laura grasps the lapel of her coat, but the direction of her gesture is ambiguous. Whether she is concealing or revealing herself is unclear, but the point is that *she* is in control and able to determine the viewer's degree of access. As to the coat itself, it is a gendered garment. It would have been part of a man's wardrobe in that period, for women wore cloaks or shawls and not coats as outer garments. The artist has thus set up an opposition between a nude female body and a masculine public garment. The result is a subtle eroticization based upon a deliberate ambiguity.

111. GIORGIONE
Laura, 1506. Oil on canvas over wood, 16 x 13″ (41 x 33.5 cm). Vienna, Kunsthistorisches Museum.

The only clue to the patronage of the work is an inscription on the back of the painting. It states that Giorgione completed it on 1 June 1506, having painted it at the request of a "messer Giacomo" about whom nothing further is known.

The laurel branch is surely a metaphor, but again the meaning is elusive. While it may well have referred to the name of the sitter, laurel was also associated more broadly with poets and poetry. Petrarch's Laura was his creation, and laurel was an emblem of her chastity, just as it was an emblem of his poetic genius. Whether or not Giorgione's sitter wrote poetry is unknown, but her gesture could well be a metaphor for the activity of the poet, for he, too, conceals and reveals himself. And yet, self-revelation, whether physical or intellectual, was not considered seemly in a woman. Indeed, Laura's ambiguous gesture – at once threatening and exciting – was surely a gesture of seduction toward the male viewer. Though dangerous, the gesture is, however, tempered by Laura's sensuality. An intentional juxtaposition of textures heightens our sense of her physical presence, with her smooth breast caressed by the fur collar on her coat and encircled by a filmy veil. Her hair is pulled back severely, but wispy tendrils escape from it. So she is "just a woman."

The visual address of this work thus depends on a play of ambiguities and contradictions. As such, it would have challenged traditional views about female behavior. Women had long been judged by the single standard articulated by Ludovico Dolce: "But in a woman one does not look for profound eloquence or subtle intelligence, or exquisite prudence, or talent for living, or administration of the republic or justice, or anything else except chastity." At least in theory, there was no room for ambiguity. However, a new role was being explored by some women in this period: the courtesan. Unmarried, often well educated, literate, and musically gifted, courtesans began to move around the public spaces of Venice, while respectable women watched life from the windows of the *piano nobile* of the family palace. According to the best estimates, there were around ten thousand courtesans in the city – perhaps ten percent of the population – during the period when Giorgione painted *Laura*. What was particularly troubling about the courtesan was not her sexual morality as such, but her autonomy and independence. So Giorgione's multivalent portrait may well have been an inspired response to the ambiguity of a new middle ground for women who were neither ladies nor common prostitutes. We are reminded of the role of art as a mediating device between the ideal and the real state of affairs in a society, between traditional attitudes and new social categories.

Giorgione opened the way to a new genre of female portraiture in which the identities of the sitters are equally indeterminate. The sculptor Simone Bianco (doc. 1512–d. after 1553) soon translated the concept into marble with his *Bust of a Young Woman* (FIG. 112). Striking a careful balance between the ideal and the particular, the sculptor followed the classicism that Giorgione had applied to painting. Skillful carving renders the maiden's flesh seemingly soft and malleable and her chemise of a gossamer lightness. There is also a play between the prestige of the antique and fashions of the present. While classical nudity could have provided the original inspiration for revealing the maiden's bare breast, her chemise is contemporary Venetian. However, here the sitter is more a passive object of display than an independent agent who plays a role in her own self-presentation. Her dreamy expression suggests surrender and a sensuality that gains its power from its lack of definition.

112. SIMONE BIANCO
Bust of a Young Woman,
early 16th century. Marble,
height 17″ (43 cm).
Skulpturengalerie, Berlin-
Dahlem.

The sitter's expression derives from Tullio Lombardo's sculpted portrayals of women in the 1490s. Bianco made a number of portrait busts in both marble and bronze. Those of males were typically clothed in antique togas.

113. PALMA VECCHIO
Portrait of a Woman (La Bella), c. 1520.
Oil on canvas, 37$\frac{1}{2}$ x 31$\frac{1}{2}$" (95 x 80 cm).
Fundación Colección Thyssen-Bornemisza, Madrid.

The painting was once attributed to Titian because
of the sitter's resemblance to the sumptuously
dressed figure in his *Sacred and Profane Love*, but
the style is that of Palma. The letters on the parapet,
AM.B / N D, have not been deciphered.

Palma Vecchio's *Portrait of a Woman*, now known as *La Bella*, has an even more fluid character (FIG. 113). It may be asked whether this is a true and proper portrait of a sentient being or an image of ideal femininity. La Bella's flawless white skin and delicate features are complemented by the elaborate arrangement of her dark golden hair. With one plump hand caressing the ringlets that cascade over her right shoulder and the other grasping a box filled with jewelry, she might be seen as a *Vanitas* figure – an allegory of vanity. As with *Laura*, her degree of respectability cannot be fixed with certainty. Although she is expensively clothed in a sumptuous gown of red and blue silk, her voluminous sleeves are pulled down to expose her chemise. If we compare her to Lotto's *Portrait of a Lady* we immediately see how much more approachable – and touchable – she appears to be. Although confined behind a parapet and thus inaccessible, she invites a lingering examination. She too looks out at the viewer, but from an angle that blunts the intensity of her gaze. Her lips parted, she seems about to respond to the spectator who would possess her, if only visually. Indeed, Palma – like Giorgione – makes a direct appeal to the sense of touch with a whole range of textures: the soft hair, the plump shoulders

114. TITIAN
Lady in a Blue Dress (*La Bella*), 1536. Oil on canvas, 39½ x 29½" (100 x 75 cm). Florence, Pitti.

that seem all the more bare by contrast to the filmy camisole, the huge taffeta sleeve whose crisp texture gives it a faceted quality, the heavy quilted sleeves, the hard edges of the parapet in front and the pillar in the background. But much of the erotic power of this work lies in its restraint, for the lady is more than just a body. There is intelligence in her gaze, and Palma maintains a sensitive equilibrium between suggestion and invitation.

Like Giorgione's *Laura*, Palma's sitter may well have been a courtesan, but here too the ambiguity remains, and it is probably intentional. A similar fluidity is true of many of Titian's portraits of women, such as his *Lady in a Blue Dress*, also known as *La Bella* (FIG. 114). Her costume and demeanor are characteristic of the growing formality of Venetian life just a generation later than Palma's more intimate *La Bella*. Adorned with a simple gold

chain necklace and decorously encased in a heavy gown of embroidered blue-green satin that flattens her bosom, she would appear to be the image of aristocratic propriety and perhaps the portrait of a noble wife; and yet the evidence suggests otherwise. The same sitter seems to have been the model for several of Titian's paintings of nudes, and this particular work was in his studio when Francesco della Rovere, the Duke of Urbino, wrote to his agent in Venice, asking him to buy "the portrait of that lady in the blue dress." The letter offers clues to contemporary attitudes about these paintings of beautiful women. That the canvas was in the artist's shop and available for purchase, along with the duke's implicit acknowledgement that the identity of the sitter was unknown to him and of no particular interest, suggests that it was not commissioned by a patron to portray a specific individual. Furthermore, the magnificent dress seems to have been as important as the sitter to the prospective buyer.

In all likelihood, many such paintings were made as objects of contemplation. They were not portraits in the modern sense – that is, visual commemorations of specific individuals – but portraits only in a conceptual sense, albeit with the features of a real living woman. Neo-platonic ideas expressed by the Venetian poet, Pietro Bembo, in the fourth book of *The Courtier* written by Baldesar Castiglione, provided a rationale for the appreciation of such images by the admiring male viewer: "By the ladder that bears the image of sensual beauty at its lowest rung, let us ascend to the lofty mansion where heavenly, lovely, and true beauty dwells, which lies hidden in the inmost secret recesses of God, so that profane eyes cannot behold it." As physical embodiments of the abstract idea of perfect beauty these painted and sculpted images of Venetian beauties could thus serve as the essential first step toward the contemplation of the divine.

The Cult of the Family

And yet, however prominent the courtesan may have been in Venetian public life, most women were destined to become wives and mothers or to enter convents. With the family the ideal – indeed, the fundamental – unit of civic life, portraiture was also used to commemorate familial relationships.

The Freschi were a most respectable *cittadino* family, whose male members enjoyed brilliant careers in the state bureaucracy. During the course of the fifteenth century, they began to compile a chronicle of family events: marriages, births, christenings, and deaths; dowry contracts; and significant career assignments. Around

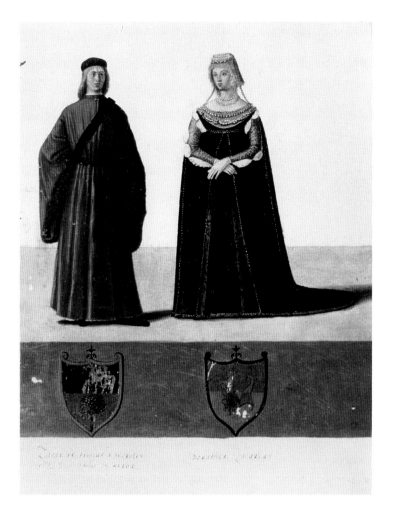

115. *Zaccaria Freschi and Dorothea Zaccaria*, from the *Cronaca di famiglia Freschi*, c. 1500. Illuminated manuscript. Biblioteca Nazionale Marciana, Venice.

Dorothea died in 1500 giving birth to her tenth child, a tragic event that was duly recorded in the chronicle. Her untimely death – she would only have been in her mid-thirties at the time – may have provided the occasion for the illumination of the manuscript.

1500, the parchment manuscript was illustrated with a series of six miniatures that provided a visual document of marriages over three generations. Zaccaria Freschi, whose father and grandfather were both depicted with their respective wives, appears with Dorothea Zaccaria, whom he married in 1486 in a lavish wedding with "a large number of eminent men, all opulently dressed" in attendance (FIG. 115). The daughter of an admiral of the Arsenal, a high-ranking *cittadino* office, she brought with her a dowry of 850 ducats. While her husband Zaccaria wears the red toga allowed to a secretary of the Council of Ten, Dorothea's dress and hairstyle are similar to those seen in Carpaccio's painting of *Two Venetian Ladies* (see FIG. 94, page 131).

Both husband and wife are accompanied by the coats of arms of their respective families, acknowledging that a marriage is the joining together of two lineages. And yet, at marriage a woman

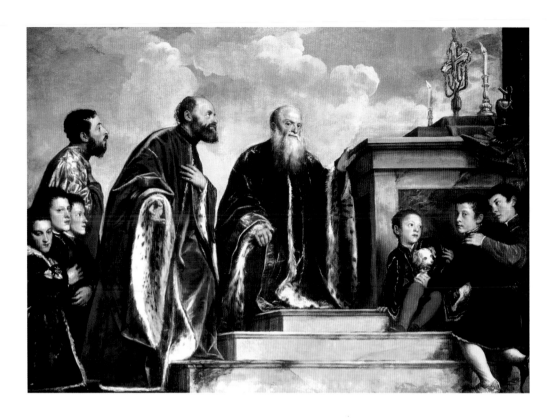

116. TITIAN
The Vendramin Family before the Reliquary of the True Cross, 1543–47. Oil on canvas, 6'9" x 9'10½" (2.1 x 3 m). National Gallery, London.

Behind Andrea are his oldest son Leonardo, already a bearded twenty-year-old when the painting was probably begun, and Bartolo (age fifteen), Francesco (fourteen), and Luca (thirteen). The more lively younger sons were on the opposite side in front of the altar: Federigo (eight), who holds a dog, Filippo (nine), and Giovanni (eleven).

becomes part of her husband's genealogy while bringing to him links from the male members of her own natal family. The equivalence granted to women in the Freschi chronicle is unusual and may be explained by the family's *cittadino* status. The patrician caste, by contrast, was perpetuated by a patriarchal system wherein nobility was inherited only through the male line. While patricians were careful to keep records of their family trees, they generally did not cite the first names of the brides who married into the family. In a typical patrician genealogy, Dorothea would have been listed only as "the daughter of Antonio Zaccaria."

The central importance of the male lineage to the patriciate is eloquently expressed in Titian's painting, *The Vendramin Family before the Reliquary of the True Cross* (FIG. 116). The work was listed in an estate inventory as "a large picture in which are portrayed the miraculous cross with ser Andrea Vendramin with seven sons and messer Gabriele Vendramin, with its ornament of gold, made by the hand of ser Titian." Andrea and Gabriele were brothers, descendents of the Andrea Vendramin who was Guardian Grande of the Scuola di S. Giovanni Evangelista in 1369, when the confraternity had received the relic of the True Cross from Philippe de Mezières, the Grand Chancellor of Cyprus – a

high civil official who served under the king of the island. This early Vendramin also took part in one of the miracles for which the True Cross would become famous. The event was commemorated by Gentile Bellini in *The Miracle of the Cross at the Bridge of S. Lorenzo* (see FIG. 82, page 120). Titian's later depiction of Gabriele and Andrea Vendramin, along with Andrea's sons, in attitudes of pious devotion to the True Cross, thus refers by implication to a distinguished family history and to the special relation to the divine that the Vendramins had enjoyed through the centuries.

Significantly, Andrea – the bearded figure in the foreground dressed in red senatorial robes – is portrayed with his seven sons, but not with the seven daughters who are recorded in the sources. The white-bearded Gabriele Vendramin, though set further back in the scene, holds the place of honor in the center of the canvas. He was a cultivated man who gathered around him the leading intellectuals and artists of the city. In addition to a renowned art collection that included Giorgione's *Tempest* and the drawing-book of Jacopo Bellini now in the British Museum, he had acquired a distinguished collection of antiquities and housed them in a "*camerino delle anticaglie.*"

Titian's composition is a masterful solution to the problem of portraying no less than nine figures in a single scene, while preserving the individual character of each of them. Adapting the traditional formula of procession and arrival that had long been used for votive paintings, he substitutes the reliquary of the True Cross for the holy figures that would normally be located at one side. But he avoids the frieze-like arrangement that is typical of such scenes and gives the composition depth and rhythm by placing Gabriele on the altar staircase in the center and clustering the figures in groups to each side of him.

The colors are varied and carefully arranged to unify the entire pictorial field. Against the dominant ambient colors of the cloudy soft-blue sky and the buff-colored altar, Gabriele and his six youngest nephews – all dressed in black – provide a stable armature against which the red costumes of the other figures are contrasted. While the rich dark-red of Andrea's robe is heightened by the satiny rose-hued garments of his son Leonardo behind him and by the pinkish stole draped over Gabriele's right arm, it is subdued by the brilliant red stockings of little Federigo who sits on the steps opposite.

In his will, written in 1548, a year after his brother Andrea's death, Gabriele left his art collection to his nephews and, in a classic statement of the patrician ethos, gave them the following advice:

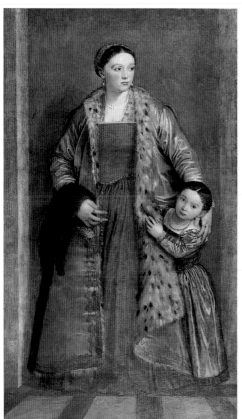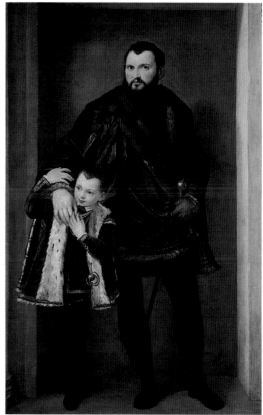

In the course of your lives you should follow those three things
through which you can glorify your family and your country.
The first is that you master navigation and that you put all
your mind to the study and mastery of naval warfare; the sec-
ond is that you do not abandon the study of letters; the
third is that you take up the trading of merchandise and never
leave debts unpaid.

In contrast to Titian's *Vendramin Family*, Veronese's pendant por-
traits of an aristocratic couple in Vicenza accorded decidedly equal
treatment to the portrayal not only of husband and wife, but
also of son and daughter: *Livia da Porto Thiene with her Daugh-
ter Porzia* and *Giuseppe da Porto with his Son Adriano* (FIGS 117 and
118). Indeed, their marriage in 1545 would have been seen as a bril-
liant match uniting two distinguished clans. Giuseppe was a wealthy
nobleman and a knight of the Holy Roman Empire, while Livia
was the daughter of one of the city's leading families. Full-
length pendant portraits of married couples had recently become

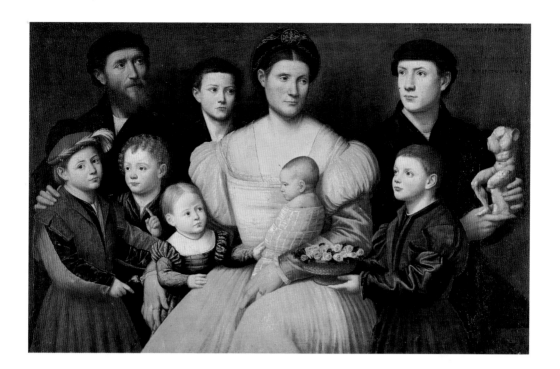

fashionable in Verona and Vicenza, but they never took hold in Venice. The prominence enjoyed by Terraferma wives in family portraiture may derive from feudal traditions and more liberal inheritance rights accorded daughters.

Veronese's portraits were probably commissioned to flank a window in a new family palace designed by Palladio that was completed in 1552. Assuming a common light-source, Livia's painting would have been on the left, with her glance directed toward her husband while Porzia looks intently at the viewer with child-like candour from the security of her mother's protective embrace. The relationship to the beholder is reversed in the other painting. Here it is the father, Giuseppe, who addresses the viewer, while his son Adriano gazes fondly back at his little sister. Looked at together, the portraits celebrate dynastic values, as well as the genuine affective bonds of the conjugal family.

Bernardino Licinio (c. 1490–c. 1550), a Venetian-born artist whose family came from the Terraferma city of Bergamo, portrayed the family of his older brother Arrigo, also a painter (FIG. 119). A Latin inscription, probably added later by Bernardino's nephews, documents the artist's intentions and attests to his authorship: "Here Licinio portrayed his brother with all his family and thereby prolonged life for them with their image, for himself with his art." And yet, while the inscription emphasizes patriarchy,

119. BERNARDINO LICINIO *Portrait of Arrigo Licinio and his Family*, c. 1535– 40. Oil on canvas, 46½ x 65" (1.2 x 1.7 m). Galleria Borghese, Rome.

The painting is inscribed in the upper right-hand corner: *EXPRIMIT HIC FRATREM TOTA CUM GENTE LYCINUS / ET VITAM HIS FORMA PROROGAT ARTE SIBI.* The artist's signature is below: *B. LYCINII OPUS.*

the painting itself celebrates maternity. Placing his brother in the left background, Bernardino made his sister-in-law, Agnese, a veritable icon of motherhood. Holding an infant and surrounded by five sons and a daughter, she is the centerpiece of the painting. The ages of her children, spanning nearly twenty years, attest to a life of frequent pregnancies.

The oldest son, Fabio, holds a statuette of the Belvedere Torso, one of the prize antiquities of the papal collection in the Vatican palace; trained as a goldsmith, he would later become an etcher. Directly in front of him is his younger brother Giulio, who offers his mother a basket of roses; he later became a painter and worked as Bernardino's assistant. Camillo, standing between his parents, was to become a famous physician. The other children do not appear in later documents and may have died in childhood. The portrait affirms the central role of the mother in an artisan family and celebrates the individuality of each of its members.

Several decades later, Veronese painted what might be considered the most comprehensive image of family solidarity of the Venetian cinquecento. The *Presentation of the Cuccina Family to the Madonna* derives its format from votive paintings hung in public offices and is unusually large for a private commission (FIG. 120). Flanked by an angel and SS. John the Baptist and Jerome, the Madonna and Child are seated in front of a sumptuous brocade curtain at the left end of the canvas in a holy space demarcated by a pair of monumental marble columns. Kneeling on the steps to the right of the columns in decidedly worldly space are Alvise Cuccina and his wife Zanetta, surrounded by six sons and their daughter, Marietta. The infant held by the nurse at the far right would have been little Zuanbattista, who was born in late 1571 or early 1572.

In accordance with Venetian custom intended to preserve the patrimony, Alvise's two brothers remained unmarried and would have been part of his family. Indeed, they too are participants in the scene. Zuanantonio, who stands above Alvise, looks out from behind a pillar; but Antonio, kneeling on the right, plays a more prominent role, for he is accorded special attention by the three theological virtues who present the family to the Christ child. Faith, a queenly figure clothed in white who holds a chalice, takes him by the hand; Hope bows her veiled head and gestures toward the holy figures; and Charity, wearing a

120. PAOLO VERONESE *Presentation of the Cuccina Family to the Madonna*, 1571. Oil on canvas, 5'5³/₄ x 13'7³/₄" (1.7 x 4.2 m). Staatsgalerie, Dresden.

Veronese painted three other large canvases (also in Dresden) for the Cuccina palace (now the Palazzo Papadopoli): *The Adoration of the Magi, The Wedding Feast at Cana,* and *The Road to Calvary.*

red gown, supports him. It is probable that the painting was made for the family palace shortly after Antonio's death in 1572. It would thus record not only the family's religious piety, but also their hope for Antonio's salvation.

Alvise and his brothers were only the second generation of the family to live in Venice, their father and uncle having moved there from Bergamo shortly before mid-century. Having amassed a fortune from their trading activities, the family thus moved in that ambiguous social space of rich *cittadini* who would never be welcomed into the Venetian patriciate. Though the Cuccina family belonged to a higher social class than Arrigo Licinio and his family, here, too, their Veneto origins may well account for the prominent role accorded the mother and daughter in the composition. The painting documents their wealth, their fecundity, and, in the right background, their newly built palace on the Grand Canal.

Portraits are one of our best links to the men and women who inhabited the overlapping worlds of the Venetian past: displaying public faces in private spaces, asserting pious intentions in secular venues, proclaiming patrician ideals in *cittadino* palaces, presenting versions of the ideal self. As such, they bear final testimony to the tastes, values, and aspirations that helped to form the singular visual culture of Renaissance Venice.

	Historical Events	Monumental Venice
Before 1400	**421** Legendary foundation of Venice **697** Election of first doge (*duca*) **828/29** Relics of St. Mark brought to Venice **1177** Peace of Venice **1204** Fourth Crusade and Sack of Constantinople **1297** *Serrata*: "lock-up" of Great Council and establishment of hereditary patriciate **1378–81** War of Chioggia; Venice dominates Mediterranean	**C 9th** San Marco built (begun c. 829) on the model of chu of the Holy Apostles in Constantinople; reconstruct in the 10th and 11th centuries **C 12th-13th** San Marco receives major mosaic decoration First Rialto bridge links two sides of Grand Canal **1340** South wing of Doge's Palace and Great Council Ha begun **1345** Doge Andrea Dandolo has Pala d'Oro remade
1400-1450	**1404–5** Venice annexes Bassano, Belluno, Vicenza, Padua, Verona; becomes major power in the Terraferma **1420** Venice acquires Udine and Friuli **1425–54** Wars in Lombardy: Venice acquires Peschiera, Brescia, Bergamo, Cremona, and Ravenna	**1419** Great Council Hall decoration completed **1424** Doge Francesco Foscari begins construction of west wing of Doge's Palace; **1438–43**: Porta della Carta; **1438–1480s**: Arco Foscari
1450-1500	**1453** Fall of Constantinople to Ottoman Turks **1469** First printing press licenced in Venice **1479** Treaty with Ottoman Sultan Mehmed II revitalizes Aegean trade **1489** Venice acquires Cyprus **1494** Italy invaded by King Charles VIII of France **1499** Sea battles with Turks; Venice loses Lepanto, Modon, and Corone **1499** Portuguese discover sea route to India	**1451** Cappella dei Mascoli, San Marco, *Life of the Virgin,* mosaic decoration completed **1481–88** Andrea Verrocchio and Alessandro Leopardi, *Equestrian Monument of Bartolomeo Colleoni* **1481–89** S. Maria dei Miracoli **1485–c. 1493** Scala dei Giganti, Doge's Palace **1487** Entrance court, Scuola Grande di S. Giovanni Evangelista; **1492–c. 1510** decoration of *albergo* wit *Miracles of the True Cross* **1487–95** Facade, Scuola Grande di S. Marco; **1504–c. 1534** decoration of *albergo* with *Life of St. Mark* **1499** Torre dell'Orologio
1500-1550	**1508–17** Wars of the League of Cambrai **1509** Battle of Agnadello; Venice defeated by armies of pope, emperor, France, and Spain **1517** Venice regains Terraferma possessions **1527** Sack of Rome by armies of Emperor Charles VI; artists and intellectuals flee to Venice	**1500** Jacopo de' Barbari, woodcut *View of Venice* **1504** Alessandro Leopardi, three bronze flagpole bases or Piazza San Marco **1516–60** Scuola Grande di S. Rocco builds new meeting hou **1537–66** Roman *renovatio* of Doge Andrea Gritti; Jacopo Sansovino builds Loggetta (completed 1546), Biblioteca Marciana (1564), and Zecca (Mint; 1566)
After 1550	**1556** Office of *provveditori al beni inculti* established for improvement of agriculture **1571** Victory of Lepanto; Venetian and papal forces defeat Turks, but Venice loses Cyprus **1797** Collapse of the *Serenissima*; fall of Venice to forces of Napoleon	**1577** Great Council Hall destroyed by fire; proposal by Palladio for classical plan rejected. Architect Antoni da Ponte reconstructs it on original plan in less than one year.

Renaissance Doges	Painting	Portraits
43–54 Andrea Dandolo 54–55 Marin Falier 55–56 Giovanni Gradenigo 56–61 Giovanni Dolfin 61–65 Lorenzo Celsi 65–68 Marco Cornaro 68–82 Andrea Contarini 82 Michele Morosini 82–1400 Antonio Venier	1350 Paolo da Venezia, S. Chiara Polyptych c. 1350 Last Judgement, frontispiece of the Mariegola of the Scuola di S. Giovanni Evangelista.	
00–13 Michele Steno 14–23 Tomaso Mocenigo 23–57 Francesco Foscari (deposed)	c. 1430s–60s Jacopo Bellini, two albums of drawings 1446 Antonio Vivarini and Giovanni d'Alemagna, Madonna and Child and the Four Fathers of the Church	
57–62 Pasquale Malipiero 62–71 Cristoforo Moro 71–73 Nicolò Tron 73–74 Nicolò Marcello 74–76 Pietro Mocenigo 76–78 Andrea Vendramin 78–85 Giovanni Mocenigo 85–86 Marco Barbarigo 86–1501 Agostino Barbarigo	1465–67 Fra Antonio da Negroponte, Madonna and Child 1467 Giovanni Bellini, Pietà (Brera) 1474 Gentile and Giovanni Bellini begin cycle of Peace of Venice of 1177 in Great Council Hall 1487 Giovanni Bellini, Madonna of the Little Trees 1495 Carpaccio, Dream of St. Ursula; c. 1495 Two Venetian Ladies on a Terrace and Hunting in the Lagoon	1458 Zuan Boldù, Self-Portrait medal 1465 Gentile Bellini, S. Lorenzo Giustiniani 1485–90 Giovanni Bellini, Portrait of a Young Senator
01–21 Leonardo Loredan 21–23 Antonio Grimani 23–38 Andrea Gritti 39–45 Pietro Lando 45–53 Francesco Donato	1504 Carpaccio, Birth of the Virgin 1505 Giovanni Bellini, S. Zaccaria Altarpiece 1506 Albrecht Dürer, Feast of the Rosegarlands 1506 Lorenzo Lotto, St. Jerome in the Wilderness c. 1508–09 Sebastiano del Piombo, Judgement of Solomon c. 1510 Titian, Pastoral Symphony; Christ Carrying the Cross; 1512 Gypsy Madonna 1516 Carpaccio, Lion of St. Mark c. 1540 Bonifazio de' Pitati, God the Father above Piazza San Marco	c. 1501 Giovanni Bellini, Doge Leonardo Loredan 1506 Giorgione, Laura c. 1506 Lorenzo Lotto, Portrait of a Lady; 1506–08 Portrait of a Young Man with a Lantern c. 1512 Titian, Portrait of a Man in Blue c. 1520 Palma Vecchio, La Bella 1527 Lorenzo Lotto, Portrait of Andrea Odoni c. 1535–40 Bernadino Licinio, Portrait of Arrigo Licinio and his Family 1536 Titian, Lady in a Blue Dress (La Bella); 1543–47 The Vendramin Family; c. 1545 Portrait of Pietro Aretino
53–54 Marcantonio Trevisan 54–56 Francesco Venier 56–59 Lorenzo Priuli 59–67 Girolamo Priuli 67–70 Pietro Loredan 70–77 Alvise I Mocenigo 77–78 Sebastiano Venier 78–85 Nicolò da Ponte 85–95 Pasquale Cicogna 95–1605 Marino Grimani	c. 1550 Jacopo Bassano, Lazarus and the Rich Man; 1554 Pastoral Landscape 1562–3 Paolo Veronese, Marriage Feast at Cana 1564–87 Jacopo Tintoretto, Scuola Grande di S. Rocco 1565 Titian, Time Governed by Prudence; 1570s Pietà 1579-1620 Redecoration of the Doge's Palace by Veronese, Jacopo and Domenico Tintoretto, Francesco Bassano, Jacopo Palma il Giovane, and others	1550–55 Paris Bordone, The Chess Players c. 1556 Veronese, Giuseppe da Porto with his son Adriano and Livia da Porto Thiene with her daughter Porzia c. 1570 Titian, Self-Portrait (Prado, Madrid) Veronese, Portrait of a Member of the Soranzo Family; 1571 Presentation of the Cuccina Family to the Madonna 1580 Jacopo and Domenico Tintoretto, S. Giustina and the Treasurers

Bibliography

Following a basic list of general works in English dealing with Venetian art and culture during the Renaissance, primary sources and specialized studies drawn upon for the views presented in this book are cited by chapter sections in the order in which they relate to the discussion.

SELECTED GENERAL WORKS

History, Culture, and society

D.S. Chambers, *The Imperial Age of Venice, 1380–1580* (London: Thames and Hudson, 1970); David Chambers and Brian Pullan, with Jennifer Fletcher, eds, *Venice: A Documentary History, 1450–1630,* (Oxford and Cambridge, Mass.: Blackwell, 1992); J.R. Hale, ed., *Renaissance Venice* (London: Faber and Faber, 1973); Christopher Hibbert, *Venice: The Biography of a City* (New York and London: W.W. Norton and Company, 1989); F.C. Lane, *Venice: A Maritime Republic* (Baltimore: Johns Hopkins University Press, 1973); Oliver Logan, *Culture and Society in Venice, 1470–1709: The Renaissance and its Heritage* (London: B.T. Batsford, 1972); Giulio Lorenzetti, *Venice and Its Lagoon,* trans. John Guthrie (Trieste: Edizioni Lint, 1975); Pompeo Molmenti, *Venice: Its Individual Growth from the Earliest Beginnings to the Fall of the Republic,* trans. H. F. Brown, 6 vols (London, 1906–08); John Julius Norwich, *A History of Venice* (London: Penguin Books, 1982).

Art and Architecture

Bruce Boucher, *The Sculpture of Jacopo Sansovino* (New Haven and London, 1991); Patricia Fortini Brown, *Venetian Narrative Painting in the Age of Carpaccio* (New Haven and London: Yale University Press, 1988); idem, *Venice & Antiquity: The Venetian Sense of the Past* (New Haven and London: Yale University Press, 1997); Deborah Howard, *The Architectural History of Venice* (London: B.T. Batsford, 1980); Peter Humfrey, *The Altarpiece in Renaissance Venice* (New Haven and London: Yale University Press, 1993); idem, *Painting in Renaissance Venice* (New Haven and London: Yale University Press, 1995); Norbert Huse and Wolfgang Wolters, *The Art of Renaissance Venice* (Chicago: University of Chicago Press, 1990); Ralph Lieberman, *Renaissance Architecture in Venice* (New York: Abbeville Press, 1982); James McAndrew, *Venetian Architecture of the Early Renaissance* (Cambridge, Mass., and London: the MIT Press, 1980); Jane Martineau and Charles Hope, eds, *The Genius of Venice, 1500–1600* (London: Weidenfeld and Nicolson, 1983); David Rosand, *Painting in Cinquecento Venice: Titian, Veronese, Tintoretto* (New Haven and London: Yale University Press, 1982); Antonio Salvadori, *Architect's Guide to Venice* (London and Boston: Butterworth Architecture, 1990); Giovanna Nepi Sciré and Francesco Valcanover, *Galleries of the Accademia of Venice* (Milan: Electa, 1985); John Steer, *A Concise History of Venetian Painting* (London: Thames and Hudson, 1970); Johannes Wilde, *Venetian Art from Bellini to Titian* (Oxford: Clarendon Press, 1981).

CHAPTER ONE

Francesco Petrarch, *Familiares* XXIII, 16; *Seniles* IX; Fritz Saxl, *Lectures* (London: The Warburg Institute, 1955), I, pp. 139–49; Felice Fabri [Felix Faber], *Venezia nel MCDLXXXVIII (Venice: Tipografia dell'Ancora, 1881).*

An Opportune Position

Marcantonio Sabellico, *Del Sito di Venezia (1502),* ed. G. Meneghetti (Venice: Stamperia già Zanetti, 1957), p. 10; Francesco Sansovino, *Delle cose notabili della città di Venetia* (1561; Venice: Lucio Spineda, 1602), p. 1; Marin Sanudo, "Praise of the city of Venice, 1493," in Chambers and Pullan, *Venice: A Documentary History,* pp. 4–20; Pero Tafur, *Travels and Adventures, 1435–39* (New York and London: Broadway Travellers, 1926), pp. 156–72; Juergen Schulz, "The Printed Plans and Panoramic Views of Venice (1486–1797)," *Saggi e memorie di storia dell'arte* 7 (1970), pp. 5–182.

A Favored Emporium

Juergen Schulz, "Jacopo de' Barbari's View of Venice: Map Making, City Views, and Moralized Geography Before the Year 1500," *Art Bulletin* 60 (1978), pp. 425–74; Otto Demus, *The Church of San Marco in Venice: History, Architecture, Sculpture,* Dumbarton Oaks Studies, 6 (Washington, D.C.: Dumbarton Oaks, 1960); Michael Jacoff, *The Horses of San Marco and the Quadriga of the Lord* (Princeton: Princeton University Press, 1992); Deborah Howard, "Venice and Islam in the Middle Ages," *Architectural History* 34 (1991), pp. 59–74; Martino da Canal, *Les Estoires de Venise: Cronaca veneziana in lingua francese dalle origini al 1275,* ed. Alberto Limentani (Florence, 1972); *The Treasury of San Marco, Venice,* The Metropolitan Museum of Art (Milan: Olivetti, 1984), pp. 117–23.

The Byzantine Paradigm

Otto Demus, *The Mosaics of San Marco in Venice. I: The Eleventh and Twelfth Centuries* (Chicago and London: University of Chicago Press, 1984); Rosand, *Painting in Cinquecento Venice,* pp. 1–46; Michelangelo Muraro, *Paolo da Venezia* (University Park and London: Pennsylvania State University Press, 1970); Rona Goffen, *Giovanni Bellini* (New Haven and London: Yale University Press, 1989).

A City of Immigrants

Dennis Romano, *Patricians and Popolani. The Social Foundations of the Venetian Renaissance State* (Baltimore and London: Johns Hopkins University Press, 1987); Brian Pullan, *Rich and Poor in Renaissance Venice: the Social Institutions of a Catholic State, to 1620* (Oxford and Cambridge, Mass.: Harvard University Press, 1971); Chambers and Pullan, *Venice: A Documentary History,* pp. 206–17, 239–352.

CHAPTER TWO

Erwin Panofsky, *The Life and Art of Albrecht Dürer* (Princeton: Princeton University Press, 1955), pp. 107–13; Humfrey, *The Altarpiece in Renaissance Venice,* pp. 120–21, 262–66.

The World of the Guilds
Rosand, *Painting in Cinquecento Venice*, pp. 4–14; Richard Mackenney, *Tradesmen and Traders, the World of the Guilds in Venice and Europe, c. 1250–c. 1650* (Totowa, N.J.: Barnes and Noble Books, 1987).

The Problem of Authorship
Johannes Wilde, "The Hall of the Great Council of Florence," *Journal of the Warburg and Courtauld Institutes* 7 (1944), pp. 65–81; Michelangelo Muraro, "The Statutes of the Venetian *Arti* and the Mosaics of the Mascoli Chapel," *Art Bulletin* 43 (1961), pp. 263–74; Carlo Bertelli, "The Tale of Two Cities: Siena and Venice," in Henry A. Millon and Vittorio Magnago Lampugnani, eds., *The Renaissance from Brunelleschi to Michelangelo. The Representation of Architecture* (Milan: Bompiani, 1994), pp. 373–97; Giorgio Vasari, *Lives of the Artists,* trans. George Bull (Harmondsworth: Penguin Books, 1987), I, pp. 232–40.

Artistic Dynasties
Brown, *Venetian Narrative Painting*, pp. 99–133; Bernhard Degenhart and Annegrit Schmitt, *Jacopo Bellini* (New York: George Braziller, 1984); Colin Eisler, *The Genius of Jacopo Bellini: The Complete Paintings and Drawings* (New York: Abrams, 1989).

The Artist as Individual
David Rosand, "Titian and the Critical Tradition," in *Titian: His World and His Legacy*, ed. David Rosand (New York: Columbia University Press, 1982), pp. 1–39.

CHAPTER THREE

Howard, *Architectural History of Venice*, pp. 79–85; Wolfgang Wolters, *Storia e politica nei dipinti di Palazzo Ducale*, (Venice: Arsenale Editrice, 1987; Stuttgart 1983), particularly pp. 47–57, 126–38, 173, 188–91, 223–33, 281–96.

More Perfect than Rome
Umberto Franzoi, *Storia e leggenda del Palazzo Ducale di Venezia* (Venice: Edizioni Storti, 1982); Juergen Schulz, "Tintoretto and the First Competition for the Ducal Palace Paradise," *Arte Veneta* 34 (1980), pp. 112–26; Staale Sinding-Larsen, "Christ in the Council Hall. Studies in the Iconography of the Venetian Republic," in *Acta ad archaeologiam et artium historiam pertinentia* 5 (Rome: "L'Erma" di Bretschneider, 1974); Robert Finlay, *Politics in Renaissance Venice* (New Brunswick: Rutgers University Press, 1980).

Emblematic Occasions
Brown, *Venetian Narrative Painting*, 1988; Edward Muir, *Civic Ritual in Renaissance Venice* (Princeton University Press, 1981), pp. 103–34; Harold E. Wethey, *Titian: III, The Mythological and Historical Paintings*, (Oxford: Phaidon, 1975), pp. 225–33.

Primus inter pares
Finlay, *Politics in Renaissance Venice*; Stella Mary Newton, *The Dress of the Venetians, 1495–1525* (Aldershot: Scolar Press, 1988), pp. 24–31.

Symbols of State
David Rosand, "Venetia Figurata: The Iconography of a Myth," in *Interpretazioni veneziane. Studi in onore di Michelangelo Muraro*, ed. David Rosand (Venice: Arsenale Editrice, 1984), pp. 177–96; Patricia Fortini Brown, "The Self-Definition of the Venetian Republic," in *City-States in Classical Antiquity and Medieval Italy*, ed. Anthony Molho, Kurt Raaflaub, and Julia Emlen (Stuttgart: Franz Steiner Verlag, 1991), pp. 511–48; Bertrand Jestaz, "Requiem pour Alessandro Leopardi," *Revue de l'Art* 55 (1982), pp. 23–34.

A City Joyous and Triumphant
Muir, *Civic Ritual in Renaissance Venice,* pp. 119–34; Patricia Fortini Brown, "Measured Friendship, Calculated Pomp: The Ceremonial Welcomes of the Venetian Republic," in *"All the world's a stage . . ." Art and Pageantry in the Renaissance and Baroque*, ed. Barbara Wisch and Susan Scott Munshower (University Park: University of Pennsylvania Press, 1990), pp. 136–86; idem, *Venice & Antiquity*, Chapter 8.

CHAPTER FOUR

Humfrey, *The Altarpiece in Renaissance Venice*, pp. 213–16; Sandra Moschini Marconi, *Gallerie dell'Accademia di Venezia-Opere d'arte del secolo XVI* (Rome, 1962), pp. 46–47.

Holy Protectors
Edward Muir and Ronald F.E. Weissman, "Social and Symbolic Places in Renaissance Venice and Florence," in *The Power of Place*, ed. John Agnew and James Duncan (London and Boston: Allen and Unwin, 1989); Alberto Rizzi, *Scultura esterna a Venezia* (Venice: Stamperia di Venezia, 1987), pp. 73–78, 99; Antonio Niero, "Il culto dei santi nell'arte popolare," in *Santità a Venezia*, ed. A. Niero, G. Musolino, S. Tramontin (Venice: Edizioni dello Studium Cattolico Veneziano, 1972), pp. 229–89; Patricia H. Labalme, *Bernardo Giustiniani. A Venetian of the Quattrocento* (Rome: Edizioni di Storia e Letteratura, 1969), pp. 239–45.

Corporate Spirituality
Brown, *Venetian Narrative Painting*; idem, "Honor and Necessity: The Dynamics of Patronage in the Confraternities of Renaissance Venice," *Studi Veneziani*, n.s., 14 (1987), pp. 179–212; Jaynie Anderson, "*Christ Carrying the Cross* in San Rocco: its commission and miraculous History," *Arte Veneta* 31 (1977), pp. 186–88; David Rosand, *Titian* (New York: Harry N. Abrams, 1978), p. 64; William Wixom, "A Venetian Mariegola Miniature," *Bulletin of the Cleveland Museum of Art* 48 (1961), pp. 206–11.

The Splendor of Holiness
Francesco Sansovino, *Venetia città nobilissima et singolare descritta in XIIII libra*, with additions by Giustiniano Martinioni, 2 vols (Venice: Steffano Curti, 1663; repr. Venice: Filippi Editore 1968), I, p. 288; Rosand, *Painting in Cinquecento Venice*, pp. 158–71.

The Face of Poverty
Chambers and Pullan, *Venice: A Documentary History*, pp. 295–321; Francesco Valcanover, *Jacopo Tintoretto and the*

Scuola Grande of San Rocco (Venice: Edizioni Storti, 1983); Rosand, *Painting in Cinquecento Venice*, pp. 206–18.

The Lure of the Antique
Charles Mitchell, "Archeology and Romance," in *Italian Renaissance Studies: A Tribute to the late Cecilia M. Ady*, ed. E.F. Jacob (London, 1960), pp. 468–83; Peter Humfrey, *Cima da Conegliano* (Cambridge: Cambridge University Press, 1983), pp. 36, 138–39; Michael Hirst, *Sebastiano del Piombo* (Oxford: Clarendon Press, 1981), pp. 13–23.

Nature and Transcendence
Goffen, *Giovanni Bellini*, pp. 23–66; Eugene F. Rice, Jr., *Saint Jerome in the Renaissance* (Baltimore and London: The Johns Hopkins University Press, 1985), pp. 75–84; David Rosand, "Giorgione, Venice and the Pastoral Vision," in Robert C. Cafritz, Lawrence Gowing, and David Rosand, *Places of Delight. The Pastoral Landscape* (Washington, D.C.: Phillips Collection, 1988), pp. 20–81; Beverly Louise Brown and Paola Marini, *Jacopo Bassano c. 1510–1592* (Fort Worth: Kimbell Art Museum, 1993), pp. 308–10.

CHAPTER FIVE

Alvise Zorzi, *Venetian Palaces* (New York: Rizzoli, 1990); Umberto Franzoi and Mark Smith, *The Grand Canal* (Venice: Arsenale Editrice, 1993).

A Noble Facade
Howard, *Architectural History of Venice*; Alberto Rizzi, *Scultura esterna a Venezia* (Venice: Stamperia di Venezia Editrice, 1987), pp. 21–39; Francesco Valcanover, et al, *Pittura murale esterna nel Veneto. Venezia e provincia* (Bassano: Ghedina e Tassotti Editori, 1991).

Domestic Space
Elena Bassi, *Palazzi di Venezia* (Venice: Stamperia di Venezia Editrice; rev. edn, 1987); Paolo Maretto, *La casa veneziana nella storia della città dalle origini all'Ottocento* (Venice: Marsilio Editori, 1986); Giuseppe Mazzariol and Attilia Dorigato, *Interieurs Venitièns* (Paris: Bibliothèque des Arts, 1991).

The Art of Living
Canon Pietro Casola's Pilgrimage to Jerusalem in the Year 1494, ed. and trans. Mary Margaret Newett (Manchester: University of Manchester, 1907); Peter Thornton, *The Italian Renaissance Interior, 1400–1600* (London: Weidenfeld and Nicolson, 1991); *Una città e il suo museo. Un secolo e mezzo di collezioni civiche veneziane* (Venice: Museo Correr, 1988), pp. 229–30; Sabba da Castiglione, "On Collections," in Robert Klein and Henri Zerner, *Italian Art, 1500–1600: Sources and Documents* (Englewood Cliffs, N.J.: Prentice-Hall, 1966), pp. 23–25.

A Woman's World
Jan Lauts, *Carpaccio* (London: Phaidon Press, 1962); Hugh Tait, *The Golden Age of Venetian Glass* (London: British Museum Publications, 1979); Flavia Polignano, "Maliarde e cortigiane: titoli per una *damnatio*. Le Dame di Vittore Carpaccio," *Venezia Cinquecento* 2:3 (1992), pp. 5–23; Augusto Gentili and Flavia Polignano, "Vittore Carpaccio, *Due Dame*

veneziane," and Sabina Vedovello, "L'intervento di restauro," in Attilia Dorigato, ed., *Carpaccio, Bellini, Tura, Antonello e altri restauri quattrocenteschi della Pinacoteca del Museo Correr* (Milan: Electa, 1993), pp. 74–81, 177–85; Timothy Wilson, *Ceramic Art of the Italian Renaissance* (London: British Museum Publications, 1987), pp. 108–11; idem, "Maiolica in Renaissance Venice," *Apollo* 125 (March 1987), pp. 184–9.

An Antique Ambience
John Shearman, *The Early Italian Pictures in the Collection of Her Majesty the Queen* (Cambridge: Cambridge University Press, 1983), pp. 144–8; [Marcantonio Michiel], *The Anonimo*, ed. George C. Williamson (New York and London: Benjamin Blom, 1903 [1969 repr.]), pp. 102–06; Charles Hope, "Classical antiquity and Venetian Renaissance subject matter," in *New Interpretations of Venetian Renaissance Painting*, ed. Frances Ames-Lewis (London: Birkbeck College, University of London, 1994), pp. 51–62; Manfred Leithe-Jasper, *Renaissance Master Bronzes from the Collection of the Kunsthistorisches Museum Vienna* (Washington, D.C.: Scala Books and Smithsonian Institution, 1986), p. 146.

An Aesthetic of Escape
Jonathan J.G. Alexander, ed., *The Painted Page. Italian Renaissance Book Illumination* (Munich and New York: Prestel, 1995); Paul Holberton, "The *Pastorale* or *Fête Champêtre* in the Early Sixteenth Century," in Joseph Manca, ed., *Titian 500* (Washington, D.C.: National Gallery of Art, 1993), pp. 245–62; David Rosand, "Giorgione, Venice, and the Pastoral Vision," in *Places of Delight: The Pastoral Landscape*, ed. Robert C. Cafritz, Lawrence Gowing, and David Rosand, pp. 21–88; Terisio Pignatti, *The Golden Century of Venetian Painting* (New York: George Braziller, 1979), pp. 142–53.

CHAPTER SIX

Peter Burke, "The Presentation of self in the Renaissance portrait," in his *The Historical Anthropology of Early Modern Italy* (Cambridge: Cambridge University Press, 1987), pp. 150–67; John Pope-Hennessy, *The Portrait in the Renaissance* (Princeton: Princeton University Press, 1966); Lorne Campbell, *Renaissance Portraits* (New Haven and London: Yale University Press, 1990); Cecil Gould, *The Sixteenth Century Italian Schools* (London: National Gallery, 1975; repr. 1987), pp. 281–87; Newton, *The Dress of the Venetians*.

The Aristocratic Ideal
Marin Sanudo, "Praise of the city of Venice, 1493," in Chambers and Pullan, *Venice: A Documentary History*, pp. 4–20; Sabellico, *Del sito di' Venezia città (1502)*, p. 18; Vasari, *Lives of the Artists*, II, p. 68; Cecil Gould, *The Sixteenth Century Italian Schools* (London: National Gallery, 1975; repr. 1987), pp. 280–83; David Rosand, *Titian* (New York: Harry N. Abrams, 1978), pp. 78–79; Luba Freedman, *Titian's Portraits Through Aretino's Lens* (University Park: Pennsylvania State University Press, 1995), pp. 62–67.

The Social Hierarchy
Martineau and Hope, *Genius of Venice*, pp. 217, 238; Augusto

Gentili, "'De costumi degl'huomini et degli offitii de nobili': I giocatori di scacchi, la fonte, l'allegoria," in *Paris Bordon e il suo tempo* (Treviso: Edizioni Canova, 1985), pp. 125–32; *Paris Bordon* (Milan: Electa Editrice, 1984), pp. 92–93.

The Feminine Ideal
Patricia Simons, "Portraiture, Portrayal, and Idealization: Ambiguous Individualism in Representation of Renaissance Women," in *Language and Images of Renaissance Italy*, ed. Alison Brown (Oxford: Clarendon Press, 1995), pp. 263–311; Anne Christine Junkerman, "The Lady and the Laurel: Gender and Meaning in Giorgione's *Laura*," *Oxford Art Journal* 16/1 (1993), pp. 49–58; Ursula Schlegel, "Simone Bianco und die venezianische Malerei," *Mittellungen des kunsthistorisches Instituts in Florenz* 23 (1979), pp. 187–96; Alison Luchs, *Tullio Lombardo and Ideal Portrait Sculpture in Renaissance Venice, 1490-1530* (Cambridge, Cambridge University Press, 1995) pp. 103-12; Philip Rylands, *Palma*

Vecchio (Cambridge: Cambridge University Press, 1992), pp. 89–110; Baldesar Castiglione, *The Book of the Courtier*, trans. Charles S. Singleton (Garden City, N.Y.: Anchor Books, 1959), p. 355.

The Cult of the Family
"Memorie dell'illustre Famiglia de' Freschi Cittadini Originarij Veneti": Biblioteca Nazionale Marciana, MS. Ital., cl. VII, 165 (8867); Salvatore Settis, *Giorgione's Tempest. Interpreting the Hidden Subject* (Chicago: University of Chicago Press, 1990), pp. 142–46; Martineau and Hope, *The Genius of Venice*, p. 174; *I Pittori Bergameschi: Il Cinquecento*, Banca Popolare di Bergamo (Bergamo: Poligrafiche Bolis, 1975), I, pp. 429–30; W.R. Rearick, *The Art of Veronese, 1528-1588* (Washington, D.C.: National Gallery of Art, 1988), pp. 38–40; Eric M. Zafran, *Fifty Old Master Paintings from The Walters Art Gallery* (Baltimore: Walters Art Gallery, 1988), pp. 62–63.

Picture Credits

Index